Further Praise for *Acts of*

"What an uplifting read. . . . We he[]
arts contribute to the national economy. In this passionate
and timely book, Amber Massie-Blomfield inspires the reader
to resist the very basis of that question, sharing the beauty,
anger, and invention with which artists have defended and
expanded our idea of what it means to be a social species.
Massie-Blomfield's reflective, joyful, and rousing argument
is seriously hopeful encouragement."
—Toby Jones, star of *Mr Bates vs The Post Office*

"I loved this book and found it an essential and inspiring
read. A brilliantly written and detailed account of those
who have taken up creative, imaginative, and spiritual arms
to oppose the forces of war, injustice, discrimination, and
inequality. It's a must-read for our times, a call, an inspira-
tion, and a road map for a better way of being."
**—Juliet Stevenson, star of *Truly, Madly,
Deeply* and *Bend It Like Beckham***

"Artists can be the guardians of truth. While politicians may
retreat in the hope of a later advance, artists can stand on
principles. Through their work and public commitments,
they are part of the struggle for social and economic justice,
universal human rights, and for the protection of the earth's
riches, a common treasury for us all to share in equality and
peace. Amber Massie-Blomfield's book tells the stories of
some of the most notable artists whose work has made a
lasting contribution in this epic battle."
**—Ken Loach, director of *Cathy
Come Home* and *I, Daniel Blake***

"A passionate and personal exploration of the tricky relationship between art and activism around the world, full of surprising stories of hope and resistance in dark times."

—**Dorian Lynskey, author of *33 Revolutions**
per Minute: A History of Protest Songs,*
from Billie Holiday to Green Day

"A diverse, global tapestry of artistic defiance in the face of conflict and oppression. Massie-Blomfield brings to light artists who persisted in creating meaning from senselessness, bringing solace amid strife, and keeping hope alive through expression. For those already convinced of art's political potential, *Acts of Resistance* serves as inspiring affirmation. For open-minded skeptics, it provides compelling grounds to reconsider dismissed possibilities. For all, it illuminates how creative spirits everywhere remain undimmed, even facing history's harshest glares. *Acts of Resistance* is ultimately a wonderful and important tribute to artistic perseverance against the odds."

—**Nitin Sawhney, Mercury Music**
Prize–nominated musician

ACTS OF RESISTANCE

ALSO BY AMBER MASSIE-BLOMFIELD
Twenty Theatres to See Before You Die

ACTS OF RESISTANCE

The Power of Art to Create a Better World

Amber Massie-Blomfield

W. W. NORTON & COMPANY

Independent Publishers Since 1923

First published in Great Britain in 2024 by Footnote Press Limited.

For information about special discounts for bulk purchases, please contact W. W. Norton Special Sales at specialsales@wwnorton.com or 800-233-4830

Manufacturing by Lakeside Book Company
Production manager: Daniel Van Ostenbridge

ISBN 978-1-324-07875-3 (pbk.)

W. W. Norton & Company, Inc., 500 Fifth Avenue, New York, N.Y. 10110
www.wwnorton.com

W. W. Norton & Company Ltd., 15 Carlisle Street, London W1D 3BS

10 9 8 7 6 5 4 3 2 1

For Juniper. Our act of hope.

'All Power to the Imagination'
– Paris Graffiti, May 1968

'The role of the artist is to make the revolution irresistible'
– Toni Cade Bambara

Contents

Introduction

Imagine, for a moment, that art can change the world. Not only that it can, but that it has, over and over again, and that it will do still – in a manner that can be as explosive as a battle or as creeping as a whisper. Acknowledging this fact would be the beginning of something: it would help us to recognise the power that each of us has in our own hands. Creativity isn't the preserve of those trained in academies, or whose work is hung in marble halls. If you've ever sketched a picture, baked a cake, sung karaoke, made a protest placard, written a limerick, planted a flower, boogied to your favourite tune, you possess it.

I have carried this belief with me for a long time. As a child, I remember watching a news report about the levels of pollution in the ocean. Incensed and certain I had to do something, I fetched my crayons and crafted a poster featuring a whale vomiting various bits of rubbish I'd gleaned from the recycling. I sent it off to the iconic children's TV show *Blue Peter* where, thrillingly, it was shown on national television. Nothing was changed then, at least nothing I could put my finger on, but looking at the screen and understanding

that – if only for a moment – my slipshod artwork, which even now looked messier than I'd intended and had possibly lost an important bit of crisp packet in transit, was being beamed into millions of homes around the country, gave me a sense of possibility. The next day a friend at school came up to me. She'd seen my poster and wanted to know what she could do to help.

I spent my teens ferociously trying to express my sense of righteousness through my creativity, staging plays to raise money for former child soldiers in Uganda and crafting feminist sculptures from dismembered Barbie dolls. I was very serious about art, in a way that was unfashionable then and perhaps is still unfashionable now. Later, when I went to drama school, the tendency among some of my peers was to see the 'industry' we were preparing ourselves for as a money-making business like any other, no different to advertising or hotel management. But I was certain that art's purpose was more significant, though I was still figuring out the reasons why.

Once, an artist called Jo Wilding came in to speak to us. She was a human rights lawyer, and she was also a clown. She first visited Iraq as a foreign observer during the war in 2003, but when she returned, she brought the circus with her – a juggler, a stilt walker and a roadie. They'd spent months touring squatter camps and orphanages, blowing bubbles and performing magic tricks for children who were at risk of forgetting how to smile. During the siege of Fallujah, they got trapped at an under-resourced medical centre, and ended up going out in the battered-up ambulance, fetching the injured and using their foreign privilege to get medical supplies past the US troops. In between, she made handkerchiefs disappear and crafted balloon animals for the injured children.

A clown in the middle of a war zone is a *Daily Mail* head-
line waiting to happen. We had all seen Fallujah on our TV
screens, the rubble where the buildings used to stand. How
could her actions have made a difference? And yet, that day,
no one in the class was talking about box-office takings or
sponsorship deals. The image of those soap bubbles in the
air of the ruined streets stayed with me. Amid all the mess
my government had made in that place, they struck me as
something gracious and good.

* * *

Could I have believed it, if I hadn't experienced certain
transformations myself? In those years I was almost breath-
less with it, the exhilaration of being twenty years old and
living in London for the first time, making experimental art
with my mates and feeling new horizons open up to me. The
live art scene was unapologetically queer and sometimes
grotesque and sometimes unbelievably tender, creating inti-
macies between strangers for which I was unprepared. I'd
stay out all night at art raves in disused railway arches or go
to cheap matinee screenings of old indie movies, my expanding
sense of the possibilities of culture muddling with the elation
of kissing strangers outside gallery bars or crossing the city
with my head nodding against the night bus window as dawn
broke, the pulse of the small hours music still throbbing in
my chest.

I spent the summer of 2005 in New York, working as the
assistant to interdisciplinary artist Joe Shahadi, making a short
film based on the Oedipus myth called – of course! –
Motherfucker. He sent me home each evening with dense

theory books to mark up for him. That July was unbelievably hot, and I'd sunbathe on the roof of the tiny Williamsburg studio I'd rented, reading and scribbling notes, before heading out to shows at cool Off-Off-Broadway venues. I saw legends of the New York scene – The Wooster Group, Laurie Anderson, Richard Foreman. Performance art collective La Pocha Nostra created 'Chicano cyberpunk performances'. In the show I saw, they invited their (mostly white) audience to inscribe their 'racial fantasies' upon their bare bodies in lipstick. I watched, transfixed and horrified, as those around me stepped forward. There wasn't anything I could possibly write, I told myself, lingering on the fringes of the room and refusing my part in the performance. When I returned home that autumn I carried the show with me, unable to shake the feeling I'd got something wrong.

A couple of years later I volunteered to take part in a dance show at London's Barbican Centre. Nic Green's *Trilogy* was about how women's bodies are typically presented in the media – airbrushed, sexualised – and how rarely we see them as they really are – functional, wobbly, powerful, lazy, individual, ordinary. When our cue came, those of us who had volunteered invaded the stage – all 120 of us – completely naked, and for six minutes performed a dance routine to over 1,000 audience members.

I watched a video of it again recently. Line after line of us streaming onto the stage as Pixies' bone-shaking *Into the White* blasts from speakers. Bodies fill the screen. The audience roars; a single peal of laughter soars upwards, climbing in a note of disbelief and delight. The dance routine is simple: a series of arm gestures, almost akin to those of an air steward. Head bangs and floor rolls and 240 feet stamping. Plenty of

wobbling. But the energy is almost tangible. Pure unalloyed joy, an energy to make the ground rattle. I tried to spot myself, but it was impossible. As soon as I alighted on a figure that might be me, she'd vanish again, into the crowd. By the end, the entire audience is on its feet, screaming, whooping and cheering. Later that evening, many of them would strip off themselves and join us on stage.

As I forged a sense of who I was and how I related to the world, these encounters turned the abstract argument for art as a political force into something tactile, worn on the skin and carried beneath its surface.

Of course art could be a force for change. It had changed me.

* * *

Actually, I don't think now that 'change' is the right word for what those experiences did to me. Instead, what the artworks that I loved had in common was their refusal to accept prevalent ways of articulating the world as fact: they offered alternative languages, and in so doing permitted me to find my own register. Jo Wilding, refusing to accept that the laughter of those children was less valuable than the wealth of oil companies. Nic Green, refusing to accept that the typical portrayal of women's bodies in the media was healthy or even true.

So I put a different word now to what art makes possible, and that word is resistance. *Resistere*, the Latin, is 'to take a stand'. Resistance, this suggests, is creative, requiring presence, self-expression, finding ways to make your opposition heard. But the word does not give up all its secrets easily. A noun full of action; a word forged in opposition, shaped by what

it negates – because to be legible to power is often to fail, resistance has always been characterised by reinvention, creativity; as if the element of surprise were critical not only to its means, but its sense. In physics, resistance is the force that slows the flow of electricity, and that idea is useful in considering schemes of political resistance too. The resistance I write of troubles the easy current of power, the light that sparks where static builds.

Power, as the political and literary philosopher Michel Foucault had it, 'reaches into the very grain of individuals, touches their bodies and inserts itself into their actions and attitudes, their discourses, learning processes and everyday lives'. His understanding of disciplinary societal structure took its form from the panopticon: a work of architecture employed in prisons, which allows a central guard to observe the prisoners without the prisoners knowing whether or not they are being watched. Whether the guard is watching them becomes immaterial. The possibility that they might be is enough to make the prisoners behave compliantly. In effect, the prisoners begin to survey themselves.

Under constant observation, we police our own behaviour, even our own thoughts – the metaphor is easy enough to grasp in the age of social media, CCTV and Alexa devices. Understood in this way, the resistance to power that manifests in street marches and sit-ins begins here – with the internal monologue rewritten. It starts with the imagination.

* * *

This is a book about art as a means of resistance, and it is born of that early instinct I have never quite shaken off. We

have more reason to contemplate the tools of resistance at our disposal than anyone would wish for. I began planning this book in 2018. Everything seemed bleak that year. We might have been basking in the rays of the hottest UK summer ever, but the planet was burning; Trump was building immigration camps for kids on the Mexican border. Facebook was trading in our secrets and Brett Kavanaugh was in the process of proving there was no reason why allegedly committing sexual assault should stand in the way of a glittering career as a Supreme Court judge.

As for Brexit: whichever side of the debate you came down on, it would be hard to deny that the sense of relative peace and security in Britain that many in my generation had grown up enjoying had been destabilised. The pound was down and, like something from a bad made-for-TV thriller, the government was stockpiling food – a precaution against 'crashing out' of the EU. My boyfriend at the time worked for the British government, one of the legion solicitors employed to draft the new legislation Britain would require after our departure. He'd go to his office each morning and, finding the work he'd done yesterday rendered irrelevant by the new edicts from whoever happened to be his minister that day, would begin all over again. 'Don't worry,' he reassured me, as he wrapped his meatloaf sandwiches in tinfoil for lunch. 'The world is always on the cusp of total disaster.' I broke up with him. Now was not the time for such cold comforts.

Then again, at least he was doing something – or trying to. By then, I was working at a little theatre just off London's Euston Road. It was a run-down place, a place where the windows rattled constantly as the city's traffic thundered by

on its way to somewhere more important. 'Executive director' was a rather grand title for what I mostly did, which was fix broken toilets and worry about how we could scrape together the money to carry on. All around us shiny new turrets of commerce were springing up – Facebook was directly opposite, and along the street they were beginning work on the new terminus for the vast and controversial national rail project HS2, which, it was promised, would turn this corner of London into a thriving hub of transport and Pret a Manger outlets. An impasse with our landlords at the council, however, meant that our theatre had managed to ward off the advances of beady-eyed property speculators who saw the commercial potential in a building so obviously 'ripe for development'. Transfixed in legal limbo, the theatre had changed little in the last twenty years, except everything was shabbier, more things leaked and the lift refused to work.

Each night, up to sixty audience members – but more often twenty or thirty – would take their seats to watch whatever experimental performance piece was *plat du jour*. No one came here to catch a Shakespeare play or the latest from Andrew Lloyd Webber. Instead, our theatre was a home for the weirdos and the freaks of the city, a place where, if you could expect anything other than the unexpected, it was beatboxers and drag kings and naked people covered in body paint. There was something glorious in the defiant spirit of it, how ridiculous it all seemed. No one here was going to get famous or make any real money from what they did. We carried on regardless.

Why were we all clinging on? I had always taken for granted that what we were doing mattered. But now, as the ground wobbled beneath my feet, I felt old certainties topple.

Questions I hadn't thought about for some time burned through my mind. What is the political purpose of the arts? And what moral responsibility do artists have? Why, even under the most oppressive circumstances, do people create art against the odds? Can art ever make a difference to the world? Does what we're doing here really matter at all?

* * *

This book is my attempt to answer these questions. The notion that art, in all its forms, can be a powerful force of resistance, is one that I have always held to be true. It is an idea that many people who love art dearly, as I do, hold close to their hearts. We believe art matters because we have felt it ourselves. But if, as John Berger has it, 'love is the best guarantee against idealisation', we owe it to art, and ourselves, to hold this notion up to the light.

By doing so here, it isn't my intention to persuade critics who see art as something peripheral to the healthy functioning of society. I am sure that the love of art is faith of a sort, something of which you can't be convinced but must feel in your bones. Instead, it is to fortify myself and, I hope, you, with evidence that artistic actions can make, and have made, a political impact. In *Hope in the Dark*, Rebecca Solnit writes: 'the victories matter, and remembering them matters too'. She threads a line between the stories we hear from the past and what we understand ourselves to be capable of now. Looking to our predecessors can be a source of strength; it also reminds us of our responsibilities.

A word about what I mean by 'art', a term that brings so much baggage with it and has, over the years, been a means

by which so many arbiters of 'good taste' have made everyone else feel stupid or excluded. The understanding of 'Art' (with a capital A) that prevails in Eurocentric[1] cultures is an invention of the mid-eighteenth century, when the understanding of the work of the 'artisan' as a skilled craftsperson whose product was part of everyday life – bakers, potters, weavers, shoemakers and poets all captured by the same term – gave way to the appreciation of what was called 'the fine arts': those forms of expression created through the perspiration of the individual genius, inhabiting a sphere slightly set apart from reality, and whose appreciation was an expression of refinement, education and – often – social class.

The *Oxford English Dictionary* clings to this, defining 'art' as 'Any of various pursuits or occupations in which creative or imaginative skill is applied according to aesthetic principles (formerly defined in terms of 'taste'); the various branches of creative activity, as painting, sculpture, music, literature, dance, drama etc.' This definition underlines the problem: *whose* aesthetic principles, and *whose* taste? Often, artists themselves have pushed at the boundaries of what is considered art; this in itself an expression of resistance, the neat perimeters imposed by the academy and the institution seeming to correlate to the structures of oppression they're confronting. Which hasn't made my job easy.

[1] I am using the term 'Eurocentric' throughout the book to identify the worldview that centralises white ideas and perspectives – and that emerged, historically, from Europe. As I use it here, the term also captures countries such as the United States and Australia where, due to the legacy of colonialism, this worldview still dominates. Often the term that gets used in this context is 'Western': among the several objections I have to this term is the fact that we live on a globe.

I've found my way into my subject matter through the forms of expression most typically recognised as 'the arts' in Eurocentric cultures – including here literature, visual art, theatre, dance, music, film and photography – but I have travelled with these artists as they've breached the constraints placed around them. Often, the art I write of manifests far from the professionally curated contexts where we're taught to seek it out: alongside artworks that are comfortably enthroned in the twentieth-century canon, my scope includes dancing in the street, the theatricality of clowns at protest marches, the commonplace literary endeavours of joke telling and limerick writing. Nor do I reserve the term 'artist' only for those with degrees or professional credits to their name – I believe we are all made artists at the moment we apply our creativity. As I have written this book, I have imagined that you, my reader, might be here because you're curious about what you can do with your creativity, just as I am – and when I sometimes use the phrases 'we' and 'you', this group of creative and politically inquisitive people is who I have in mind.

I am interested in how art and artists have shaped social movements, and how artistic expression has been a defiant form for those facing their voice being silenced. By allowing for such a breadth of examples, I hope to awaken a feeling for the magma of creativity that lies within humanity. The fire-hot potential in all of us.

* * *

I wrote this book on shifting sands. In the beginning I planned to travel, to visit the places where these artists worked, and

meet them or the people whose lives were touched by what they did. I made it to Sarajevo, to spend time exploring the importance of the arts during the siege of the city – particularly the production of *Waiting for Godot* directed by writer and philosopher Susan Sontag – and Jersey, to delve into the remarkable story of artist Claude Cahun's resistance to the Nazi occupation of the island.

Soon after, Covid-19 arrived, and my sphere of research shrunk down to the four walls of my study. It would have been easy to give up on writing, and it felt hard, sometimes, to struggle on with it against the fever-pitch anxiety of those early days, as we watched news footage from overcrowded Italian hospitals knowing we were only a few weeks behind them, although life was not as hard for those like me who only had to deal with the sudden listlessness of life in lockdown, without any great fears of poor health or financial insecurity, and a garden where I could spend the astonishingly vibrant spring evenings drinking too much wine.

Each morning I went to the local shop, fetching pints of milk and loaves of bread – and sometimes bottles of gin – for those in my street who were shielding. I was grateful for that stolen slice of day, an extra excuse to leave the house. Everything was sharpened: the warmth of the sun, the purple of the magnolia buds. There were other things too. As the weeks passed, chalk drawings started appearing on the pavement; an impromptu gallery materialised on a garden fence, displaying artworks by local residents pegged to a stretch of string. I was missing my professional work as a theatre producer, the projects that had fallen by the wayside, but it was as if our strange circumstances had made us all amateurs. I may not have been putting on any new shows, but I did

write bad poems and bake experimental cakes and sing karaoke with my boyfriend in the living room. One afternoon I spent hours in a dilapidated railway arch with strangers painting a twenty-four-metre-long protest banner with the words OIL = DEATH. A few days later we dressed up in green, dropped it over Westminster Bridge outside the Houses of Parliament, then assembled outside Shell's London HQ and danced chaotically to the Bee Gees' 'Stayin' Alive'. I had nowhere more important to be.

Witnessing this outpouring of creativity made me understand something about art I hadn't previously grasped. In times of genuine crisis, people don't shrink away from art and strip their lives back to the essential elements for physical survival. In fact, the opposite is true: it is when we are really struggling that we have the greatest need for art.

So I carried on. At my desk, the planet opened up to me. When you can't go much further than a mile or so from your front door, Bolivia seems no further afield than Borough, Texas than Tunbridge. This was a different kind of travel, with places pieced together through the glitchy landscapes of Google Street View, YouTube videos, and comments on Tripadvisor. Stories told by people in the next room of Zoom calls, tantalisingly close in the sudden banal domesticity of the screen's window on their home environment, full of demanding pets or intriguing bookshelves. I decided to use this unexpected liberation as an opportunity to extend the scope of my research. I read about so many remarkable moments in history, not all of which I've been able to include here – about the Syrian death metal scene and Shostakovich in Leningrad, Bruce Springsteen in the Eastern Bloc and the Malian desert blues. I read about how Marsha P Johnson

kicked off Stonewall clad in a floral halo and how the comic book *Martin Luther King and the Montgomery Story* gave strength to protest movements in Latin America, South Africa and the Middle East.

Far from a comprehensive history of arts and political resistance, this book is unapologetically the culmination of this pursuit of my curiosity. Gathered from across the globe, it covers a wide range of artistic disciplines, political struggles and historical moments – some well known, others much less so. My examples form the basis for the exploration of a wider field of ideas that have shaped my thinking as I have delved deeper into the topic. Typically, the artists I write about have politics similar to my own, which are left wing, and hunger for a transformed society that centres health, education, care, nature and art held in common. Indeed I believe finding our way to such a society will be imperative for our survival. My position is in resistance to the neoliberalist and imperialist inclination of the British system. But the politics of the book is situational, and being a socialist does not prevent me from recognising the outrageous acts of violence and subjugation carried out in the name of communism in the last century, and the bravery of those who have stood against it. It is perhaps more instructive to say that my concern is with the struggles of the oppressed and marginalised, wherever they are.

Many of these artworks were created in circumstances far more brutal than my own. I have never known what it's like to hear shellfire from a theatre auditorium, or to fear that the consequence of writing a poem might be execution, and I never want to know. But, like Susan Sontag, I believe in the power of narratives such as these to expand our 'moral

imagination'. I listen because I have faith that their stories contain the kernel of what I myself am capable.

After all, if art doesn't contain a force capable of toppling regimes, why are the powerful so quick to shut it down? Why did they blow up the Buddhas in Bamiyan, outlaw music in Mali, imprison Pussy Riot? Why did they burn books in Egypt and China and Germany and in all the other places where ink on paper seemed so inflammatory? An idea contained in a well-honed song catches on faster than a rumour; cartoons foster the greatest foil of the despot – a laugh. Those censorious powers know something better than the people who dismiss the arts at times of crisis as trivial, superfluous to our needs. Art triumphs in the dark times because it fortifies our shared humanity. That's why art makes authority so afraid.

I have tried not to sentimentalise these stories too much. There is no real poetry in blood and human suffering. Oppression and conflict are awful contexts in which to make art, just as they are awful contexts in which to work in an office, do your weekly shop, play football, get married, raise a family and carry out all the other business involved in being alive. Certain quarters argue that oppressive circumstances lead to great art. I can only say that they are idiots. What's remarkable about the stories in this book is not that the artworks are amplified by the bleak conditions of their creation, but that they were ever created at all.

At times, though, art can make a human life more bearable, and can be a means of building the things that a person needs to survive the hardest circumstances – art can be a salve, a bridge, a rudder. This book is a testament to that idea, and to the people who have risked their lives to prove that it is so.

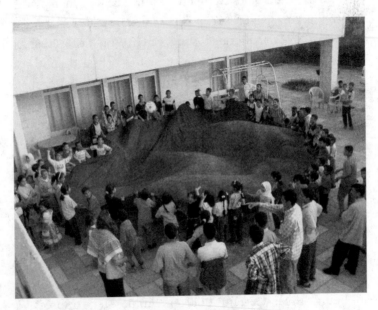
Parachute games in Nasariya, Iraq (photo by Jo Wilder)

PART I

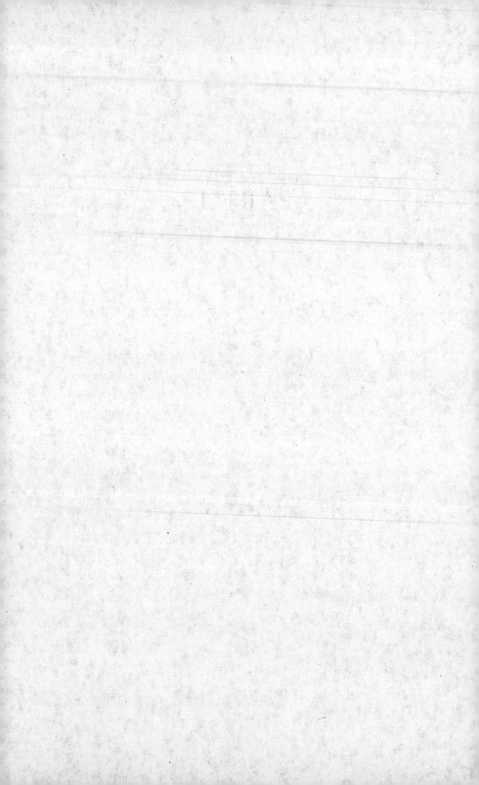

Chapter 1

THE MARCH

We marched, that day, towards the Houses of Parliament, leaving the square outside the Tate Britain and forming a procession along the Thames. Someone had brought branches to the protest, green and freshly coppiced from a managed wood, and we held them aloft like we were extras from *Macbeth,* converging on Dunsinane. As a line of figures dressed in red[1] moved past, we stopped, marking their slow, silent choreography. Smoke bombs exploded outside the Department of Transport. I looked upwards as purple and pink clouds swelled in the sky above us.

Rage pounded in my heart, rage and exhilaration. The emotional score of the protest, and soaring above it all, sweet as a lark – joy. No one tells you before you take to the street for the first time how much joy there is in protest. But you feel it, the moment you slip into the crowd and shove the

[1] The iconic and oft-photographed Red Rebel Brigade, a collective performance protest devised by circus artists Doug Francisco and Justine Squire. The group are a common feature at Extinction Rebellion protests.

sign you made from an old bit of cereal box in the air above your head. Artist and activist Fehinti Balogun once likened a protest to being at a gig by your favourite band. Standing shoulder to shoulder with those who share what you're passionate about, raising your voice to join the chant everyone else is singing. I wonder, too, if – like the crowd in an auditorium – our heartbeats began to synchronise. As if we were no longer a group of individuals but a single, vast body.

When you think of art, you might not imagine a scene like this. You might instead think of a gallery's flawless white walls. In a library, a 'silence please' notice hanging from the door. The red velvet curtain in a theatre that marks the drama's edge. You might think of art that is – and it so often is – roped off from the everyday, kept behind plate glass in halls at once astonishing and fearful in their grandeur. To become an artist so often, it seems, is to join a rarefied sphere, removed from the terrain where the political battles of the day play out, and although so many artists have professed their desire to make change, the mystery of how art moves us might infuriate those driven to direct action, feeling history slip through their fingers as artists talk smoothly over glasses of champagne at press nights and private views.

But there is an edgeland where art and activism meet, sharing the hope that to articulate human circumstances is a means of improving them. Art, in its truest sense, is not something neatly circumscribed, cut off from the rough and tumble of politics, but intimately woven into the ways we negotiate the society we wish to live in. Throughout history, artist-activists have slipped between both spheres, as if art and activism were on the same continuum – their art not

distinct from their direct action but integral to it. In the most direct examples, artists become activists by joining protest movements, bringing their creativity to give shape and form to the political demands they make. If we seek out the march, we will find them there, amid the placards, the steel drums and the figures dressed in red.

* * *

By evening, it had begun to rain. We occupied a street in Westminster, the tarmac we sat on turning slick and luminous with the city lights. A samba band played, and at either end of the street, two bamboo tripods stood, protesters perched at their apex, ten feet overhead. No traffic could pass. Police officers lined the railings, faces inscrutable.

Writers Rebel, a group of authors, poets and playwrights operating within the Extinction Rebellion Movement, had organised this action outside 55 Tufton Street – the offices of climate-sceptic 'think tank', the Global Warming Policy Foundation. Campaigner Esther Stanford-Xosei took to the makeshift stage we'd set up and began to speak. 'We all stand before history,' she said. 'Some have already cast themselves in the role of villains, some are tragic victims, some still have a chance to redeem themselves. The choice is for each individual.' The words she spoke were not her own. They belonged to the Nigerian writer and activist Ken Saro-Wiwa – more specifically, to his execution speech.

Saro-Wiwa. That was the first time I had heard of him. I think he would have appreciated the setting. Before Saro-Wiwa became involved with activism, he wrote: novels, short stories, poetry and drama, as well as being a TV producer.

His art resounded with his deep political convictions. In 1986, he published the novel *Sozaboy: A Novel in Rotten English,* a bold experiment in writing in Nigerian pidgin English that was the first of its kind; his short story collection, *A Forest of Flowers*, which received the Commonwealth Prize, gave voice to female narrators in a way that was uncommon in Nigerian literature of the time. *Basi and Company*, a low-budget soap opera shot in lurid hues, was the most popular in Nigerian history – following the capers of a luckless anti-hero, Basi, the show was shot through with Saro-Wiwa's belief in the need to overcome tribalism in the country, portraying troubles that united all working-class people in Nigeria, regardless of their tribe or ethnicity.

Unbounded by literary form, Saro-Wiwa let his pen follow his message, finding the medium that best suited it, flitting between literary and populist forms with a dexterity that few writers possess. His activism was no different – another form in which his words could meet their audience, and it was his understanding of how an idea travels, honed through his literary work, that equipped him as a brilliant political organiser.

As the leader of the Movement for the Survival of the Ogoni People (MOSOP), a non-violent action group against the exploitation of the Niger Delta by Shell, he was no stranger to protests. Oil was discovered in Nigeria in 1958. Saro-Wiwa, born in 1941, grew up a witness to the callous destruction of his homeland in pursuit of this 'black gold'. With apparent impunity, Shell transformed a lush and ecologically diverse land of verdant mangroves and vital waterways into one of the most polluted places on earth. By 1990, when MOSOP was founded, thousands of oil spills had turned

large swathes of it into a hellscape of lifeless brown waterways and towering flares that left the air redolent with the smell of crude, the land unfarmable and the water, slick with the rainbow tarnish of oil, undrinkable. Human bodies were left as broken as the land, as the spills were linked to high levels of malnutrition, infertility and cancer.

Saro-Wiwa called it a genocide. His use of the term was deliberate. He understood the power of that word, and by associating it for the first time with the actions of a private corporation, he grabbed international attention and changed the frame of reference for what was happening in the Niger Delta.

In 1993, he led 300,000 people in a peaceful march against a new Shell pipeline, the largest protest against an oil company in history. At the protest, police clashes left several protesters shot and injured; one man was killed. In the months that followed, conflicts between the Ogoni and other tribal groups flared up, apparently stoked by the government and Shell. In November 1995, Saro-Wiwa and eight other activists – the Ogoni Nine – were hanged after being found guilty of the incitement to murder of four conservative Ogoni leaders whom a mob had brutally killed in May 1994. Though the four were at odds with MOSOP over their campaign against the oil companies, the case against the Ogoni Nine is widely regarded by humanitarian organisations as a stitch-up. Shell was accused of colluding with the Nigerian government in the unjust execution of the Ogoni Nine – in 2009, on the eve of a legal action over the claims, the company agreed to a $15.5 million out-of-court settlement over the claims. (Shell director Malcolm Brinded stated at the time: 'While we were prepared to go to court to clear our name,

we believe the right way forward is to focus on the future for Ogoni people.')

The message, always, was the thing, the atom at the heart of all Saro-Wiwa did. His biographer has written of his 'unique literary voice that enabled him to bring his ideas to a mass global (and local) audience.' Saro-Wiwa wasn't allowed to read his execution speech at his death. But just before they killed him – finally, after several attempts at his execution had failed – witnesses reported that he shouted: 'You can kill the messenger but not the message.'

* * *

Can art really change anything? Or are those who write poems, novels or plays wasting the time they could be lobbying politicians, starting petitions and marching on government? The debate seems academic when confronted with the messy reality of how political change happens. Saro-Wiwa wasn't an artist, or an activist. He was both, and those personas fed each other – he was able to lead the resistance to the crimes being committed against his people because he understood how words and images work to capture the imagination and inspire action. And his politics gave his creativity purpose and direction. They were parts of the whole; indeed, I wonder if he could have become the activist he was if he hadn't first given form on the page to the injustices he saw around him.

The most successful social movements have always had a keen understanding that protest is, ultimately, a form of creative expression, just as Saro-Wiwa did. When I think of the great moments of resistance from the past, it is often

8

single, vivid snapshots, compact as a Polaroid, that travel to me through time. Rosa Parks taking her seat on a Montgomery bus and refusing to move. Emily Davison on the ground beneath the King's horse at Epsom Downs. Mahatma Gandhi, standing in his white robes at the shoreline, grasping a fistful of salt. In all of these examples, the genius of activism compares to that of a great work of art: offering a symbol for a much bigger idea that the viewer feels in her bones to be true but has never seen expressed quite so accurately before.

Art has, even more literally, been at the heart of some of the most significant protest movements of the last century. Take, for instance, the poetic, playful graffiti that appeared in the streets of France in May 1968, as a widespread uprising took hold across the nation. *Under the paving stones, the beach! Be realistic, demand the impossible! All power to the imagination!* Coined by Situationist International, a revolutionary movement of artists, intellectuals and their followers, these slogans captured their politics: fed up with capitalism, they called on citizens to reimagine social relations, fostering more authentic human connection. These ideas gained traction within the student bodies of universities in France, who began to stage protests and were soon joined by trade unions, with more than 10 million people taking part in a general strike, bringing the country to its knees for seven weeks, and forcing the government to the cusp of total collapse.

Those slogans were original, intriguing, funny and subversive – they made joining the resistance seem cool and, more importantly, they provoked vibrant dialogue across different sections of society. 'For the first time in this rigid, formal, nineteenth-century society, everyone was talking to everyone,' writes historian Mark Kurlansky in *1968: The Year*

That Rocked the World. In so doing, they were following the imperative of SI: *Talk to your neighbour!* read the graffiti on the walls. While the protests ultimately dissipated without bringing about the radical transformation of society the revolutionaries envisaged, SI's legacy is still influential today, and the story of what happened is inseparable from the poetry that, for those weeks, ruled the streets.

In my lifetime, one of the most significant protest movements has been the Arab Spring, a series of uprisings in the early 2010s that changed the political landscape of the Arabic world. In Tunisia, where the first revolution took hold in December 2010, protesters took to the streets singing the words of a song by a little-known rapper. El General had recorded his song 'Rais Lebled' and uploaded it to YouTube just a couple of weeks previously; it instantly went viral. It's bold and irresistible, an insistent thump of rage against the country's leadership. When, following the tragic self-immolation of street vendor Mohamed Bouazizi in reaction to his harassment by the authorities, protesters took to the streets to demand that President Zine El Abidine Ben Ali step down, it was the words of El General's song they chanted: *Mr President, your people are dying/ People are eating rubbish/Look at what is happening/ Miseries everywhere Mr President.* Ben Ali was ousted the following month, leading to the country's first free, democratic elections. A victory belonging to all who took to the streets, 'Rais Lebled' is widely hailed as the anthem of the revolution. Press have called El General 'The rapper who helped bring down Ben Ali'; in 2011, he appeared on the cover of *Time*, and was listed as one of 'the 100 most influential people in the world'.

When politicians fail to hear us, to represent us, as they so often do – and as they did in France and Tunisia – it falls to artists to find ways to break through, to find new ways of disrupting the status quo. James Baldwin, the great American writer and civil rights activist, once wrote that 'the artist cannot and must not take anything for granted, but must drive to the heart of every answer and expose the question the answer hides'. That might be a perfect definition of art as a means of resistance, for me – a refusal of easy certitudes, to accept, simply, the status quo. Instead, the art of resistance asks – what does it really mean to be alive right now? Where are the contradictions in how we are living? What does a truly just world look like? What's stopping it from becoming a reality?

* * *

All this is to say that, if you want to change the world, bringing your creative gifts to direct action movements is a very effective way to go about it. Because, as history reminds us, protest really does work, often against the odds and in defiance of the humble means at hand. The examples mentioned in this chapter – the protests against Shell in the Niger Delta, the campaign for women's suffrage in the UK, the non-violent 'Satyagraha' campaign for Indian independence, the civil rights movement in the US, the Arab Spring in Tunisia – all brought about victories that decisively transformed their societies. Indeed, an influential study by Harvard political scientist Erica Chenoweth in 2011, which looked at over 300 campaigns from the last century, found that, remarkably, only 3.5 per cent of a population needs to

become actively involved in a protest movement for it to be almost certain to succeed.

Their research further found that non-violent acts of resistance are twice as likely to succeed as violence. These findings are reflected in the study of American political scientist Gene Sharp, who demonstrates in his book *From Dictatorship to Democracy* how often dictatorships have fallen due to defiant, non-violent mobilisation in recent years. 'Often seen as firmly entrenched and impregnable, some of these dictatorships proved unable to withstand the concerted political, economic and social defiance of the people,' he writes, pointing to examples including the USSR, Nepal and Bolivia. A bible for non-violent protesters around the world, Sharp's book indicates that we don't all need to be willing to get arrested, chain ourselves to a bulldozer or – as in the case of the recent Just Stop Oil movement – throw tins of soup at priceless works of art in order to make a difference, valuable as such acts can be. One of the joys of resistance movements is their infinite variety. Sharp locates creativity at their heart, identifying many artistic forms – caricatures, posters, 'skywriting and earth writing', mock awards, mock elections, wearing symbols, protest disrobings, symbolic lights, displays of portraits, humorous skits and pranks, singing, mock funerals, literature advocating resistance, guerrilla theatre – as 'specific methods of non-violent action'. As much as they need political strategists, Sharp reminds us that activist movements need storytellers, banner weavers, choreographers, musicians – all the people who know how to make us sit up and pay attention.

A striking example is the activism that emerged in response to the AIDS crisis of the 1980s. It would be hard to write

about this period without mentioning ACT UP ('AIDS Coalition to Unleash Power') and, by extension, the group's artistic wing, Gran Fury. Formed in 1988, Gran Fury was a group of eleven New York-dwelling men and women, all active in the city's arts and cultural scene. Over seven years, they created a body of art-activism that was the result of a creative literacy developed in some of America's finest artistic and academic institutions, meeting with the searing rage provoked by living through the AIDS pandemic and witnessing the rampant homophobia embedded in the US government's response – and lack thereof.

This was art wrought in the inferno of grief, and most of the collective had first-hand experience. So many of the accounts I've come across of belonging to Gran Fury begin with the moment the individual discovers a loved one has contracted AIDS. Tom Kalin, one of the founding members of the group, told me about the older gay couple in his Chicago neighbourhood who welcomed him as a young gay student, inviting him to dinner parties and buying him art supplies; the sharp growth into emotional maturity when one of the couple contracted AIDS and he became the pair's support network, 'going for groceries and dealing with life'. He died just three months after contracting it, and Kalin fled to New York. 'I ran away. It's funny to think of because, of course, I went to the literal epicentre of the AIDS crisis.'

In his book *After Silence: A History of AIDS Through Its Images*, Avram Finkelstein offers a hugely moving account of the death of his partner, Don. 'There is a point when your story stops being yours,' he writes, 'at least at the moment of its telling. Mine stopped being mine way before

that, in 1981, when the first person to love me back started showing signs of immunosuppression, before AIDS even had its name . . . By 1984, Don was dead.'

These accounts point to the alchemical quality of activism when faced with life's injustice: it can transform the energy of rage into a force for good. '(I) could not think of any other way to erase the agony of it from my mind but to take to the streets,' Finkelstein writes. ACT UP was formed in 1987 from this avalanche of personal grief that had arrived so abruptly and cruelly in a community closely knitted against the prejudices of the time. That short time ago, when US television was yet to air its first gay kiss and still more than two decades before the legalisation of same-sex marriage in New York. But the gay liberation movement had been gaining momentum, and the Stonewall uprising of 1969 particularly galvanised LGBTQI+ activist groups across the USA and North America, inspiring the first Pride marches and invigorating them with a sense that change was coming. Kalin describes the liberated energy of the circles he moved in, where people were thinking differently about gender and partying at sex clubs, experiencing an exhilarating interface of politics and music, art and style. 'Something was crackling, for sure.'

The public and government response to the AIDS epidemic was the harshest possible reminder of how precarious those gestures towards liberation were. In San Francisco, a vast AIDS memorial quilt was taking shape, stitched with the names, ultimately, of nearly 110,000 people who died of AIDS – becoming the largest work of community folk art in the world. But Kalin says he joined ACT UP because he 'wanted to feel empowered. It wasn't like the quilt where I would be sadly

memorialising something . . . it's just weeping about loss and fucking someone has to be accountable for this.'

ACT UP gathered at meetings charged with all this grief and rage, an energy that they channelled into ferocious campaigning. The atmosphere was, according to Kalin, 'amazing – crackling energy. And the people were wildly attractive! Fun and witty and so smart and accomplished and – oh my God! – there's a well-known person . . . they're all just being activists in this room.' Reading the accounts of those meetings and speaking to Kalin, I have a sense of a kind of defiant euphoria, even eroticism, a contradictory state fed somehow by the fear they all felt: 'things could be sexy and terrifying,' Kalin says.

Gran Fury formed the following year, and their art was made of that energy. It is, by turns, funny and caustic and unabashed, wearing its amativeness on its sleeve, channelling the demeanour that might have been necessary for many of the members to bear those dark days. 'Read My Lips' – a poster advertising protests in 1988, showing old black-and-white photos of two sailors necking; flapper girls gazing affectionately into each other's eyes. Later, on the side of buses – three couples kissing, a mix of genders and races, images charged with joy and pleasure, and above them, a slogan: 'KISSING DOESN'T KILL: GREED AND INDIFFERENCE DO'. 'The Four Questions' – small black font on white paper, fly-posted about the city. 'Do you resent people with AIDS? Do you trust HIV-negatives? Have you given up hope for a cure? When was the last time you cried?'

On 14 September 1989, protesting the fact that antiretroviral drug AZT was one of the most expensive drugs in history, members of Gran Fury and ACT UP invaded the New York

Stock Exchange, halting the start of the day's trading for the first time ever and showering the trading floor with green 'bank notes' – bearing a small, Gran Fury signature – emblazoned with slogans: 'FUCK YOUR PROFITEERING. People are dying while you play business.' And 'White heterosexual men can't get AIDS . . . DON'T BANK ON IT.' The story ended up on the front page of the national newspapers, as if the *New York Times* was their canvas. Two days later, the drug's manufacturer, Burroughs Wellcome, reduced the price of AZT by 20 per cent.

20 per cent: a reduction from $10,000 to $8,000 annually – a figure that no doubt still meant, for many, that the drug they needed remained out of reach. But this imperfect victory was real, indicative of the broader shift in the medical field that wouldn't have happened without such activism. The actions of ACT UP and Gran Fury led to a huge increase in public spending on research into possible treatments. According to author Jack Lowery, in his book about Gran Fury, *It Was Vulgar and It Was Beautiful,* Anthony Fauci, Director of the National Institute of Allergy and Infectious Diseases, once told an ACT UP member, 'The more you're demonstrating, the more money I'm going to get to work with.' Ultimately, this research led to the creation of new treatments for HIV – such as new protease inhibitors, now taken by over 20 million people worldwide – which has transformed an HIV-positive diagnosis into something it is possible to live a long life with. 'ACT UP undeniably changed the world,' Lowery writes, 'and yet, it was a relatively small group.' How did they manage it? 'One undeniable factor is the work of Gran Fury.'

* * *

16

Our sit-in outside the Global Warming Policy Foundation, on that rainy evening, was just one moment in the astonishing, creative resistance that has been taking place under the banner of Extinction Rebellion over the last five years, calling for urgent action on the climate emergency. The campaign kicked off in October 2018 when a pink yacht called Berta, bearing the words 'TELL THE TRUTH', occupied Oxford Circus, shutting down London's main shopping street to traffic for five days. What I have loved about the Extinction Rebellion actions I have been a part of is their expansiveness: often, they have the quality of a festival, as campsites pop up in the parks of the capital, music plays, vats of stew are cooked up, giant puppets parade through the street, and workshops take place on citizens' assemblies and dancing. A central thread of XR's strategy has always been 'arrestable action', such as blocking roads or causing damage to property: the intention is to flood the legal system with activists, all repeating the same message, as a way to drive wider change. But the movement incorporates many people who don't feel able to risk arrest, each bringing their own skills. Writers Rebel is just one of many community groups within the movement, united by their shared interests, experiences or identity, working in their own way to bring about change – there are groups for architects, grandparents, Buddhists, graphic designers, farmers, lawyers, musicians, walkers and many more. In turn, Extinction Rebellion is just one group within a much vaster movement around the globe.

That's good, because the challenges facing us are complex and manifold. The climate and ecological emergency is connected to social justice, to the heritage of colonialism, to the exploitations of capitalism and the crisis in democracy.

We can't tackle any of these issues in isolation; instead, what's required is a mosaic of responses as varied as the problems we're facing. This means that you, and your creativity, are most urgently needed.

* * *

The Niger Delta has never recovered from the ecological fallout of the oil extraction business. In one of the most polluted places on earth, Ogoniland, water sources and soil are still clogged thick, black with oil spills from ageing pipelines that have never been cleaned up. But the campaign Saro-Wiwa and the Ogoni Nine led succeeded, although they did not live to see it. Pressure from MOSOP caused Shell to stop oil production in Ogoniland in 1993; human rights organisations regard the aforementioned settlement in 2009 as a milestone in terms of corporations being held accountable for their environmental and social actions. Over the years since, there have been several landmark court cases brought against Shell to hold them responsible for their actions in the Niger Delta.

A few days before Saro-Wiwa was executed, he wrote a short story from his cell in which the narrator – presumably based on the author – is languishing in prison after being tortured. In the story, a ghost, dressed in a Nigerian Army uniform, appears in front of him. It is here, it explains, 'to finish' him.

The narrator appears unafraid. The ghost, curious, holds off shooting him for a moment and asks how he can be so undaunted in the face of certain death. 'I have what is greater than your weapon,' the narrator explains, and paraphrases

Blake – 'I will not cease my mental fight/ Nor shall my pen sleep in my hand/ Till they have built a new Ogoni/ In Niger delta's wealthy land'. With that, he draws out his pen, and the ghost perishes.

In Westminster, spectres stood beside us in the dark. Shoulder to shoulder, refusing to move. I imagined a long chronology of moments like this, of marches and occupations and picket lines and barricades: confrontations between two versions of the truth. Humanity rewrites its story at these fault lines. Sometimes the bad guys win, but more often than we are led to believe the victory goes to the underdog. Plot lines, after all, are better with a twist.

Later, there would be fake blood poured over the steps of number 55, 'LIES' sprayed in black on the white-painted pillars propping up that secretive place. The police who circled us all evening, listening to the speakers impassively, would spring into action, dragging several protesters away in handcuffs.

Now, though, we waited. Balanced on the edge of our future.

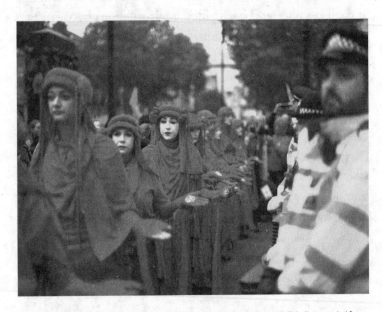

Extinction Rebellion's Red Rebels (photo by Victoria Jones/ PA Images/ Alamy
Stock Photo)

Chapter 2

THE HILL

The hill in question is small – an ascent of only 191 metres – rising above the River Avon one mile to the south of the city of Bath. Its flat top was once the site of an Iron Age fort; its sides are faintly lined with the memory of a medieval 'ridge and furrow' planting system. More recently, someone has carved a labyrinth, a five-metre-wide twist of ripples dug into the turf.

Little Solsbury. The name, local wisdom suggests, is derived from the Celtic goddess Sulis, who was worshipped at the hot springs nearby. From its mount, the gold buildings of the city spread beneath you. The green fields and woodland of the Mendip Hills stretch out along the horizon and, to the south-west, the enigmatic figure of the Westbury White Horse is a pale silhouette on the hillside.

History in layers, as thick as the strata of sedimentary rock beneath. The musician Peter Gabriel claims he once had a mystic vision here. Someone standing at the top might well hum the strange, moving song he wrote about it: *Climbing up on Solsbury Hill/ I could see the city light/ Wind was blowing, time stood still/ Eagle flew out of the night.* Or perhaps that music is only an exaltation of skylarks, moving upwards, their

song trailing in the sky as they depart their turf nests. *Grab your things/ I've come to take you home.*

I grew up in the shadow of Little Solsbury Hill, my youth playing out in that network of streets and crescents that seems so small when viewed from overhead. Bath was a quiet corner of the West Country where, in the late twentieth century, not an awful lot seemed to happen. But in 1994, when I was nine years old, Little Solsbury Hill was suddenly at the centre of the national news. The protest against the building of a new bypass destined to pass through the meadowlands surrounding it animated the entire community and captured the country's imagination.

Heroes arrived in our town by the trainload, dressed in chunky knitwear, hair in dreads. They set up camp, squatting in nearby houses earmarked for demolition and occupying treetops in their hammocks. I was fascinated by the forts they built high up in the canopy, ascending and descending on abseiling ropes. From the branches hung a sign: *Tree Pixies Resting. Do Not Disturb.*

The city was divided over the bypass. Around 25,000 vehicles a day thundered through Batheaston, the village the road would circumvent, and residents were exhausted by living with rattling windows and air clogged with fumes. But I was firmly on the side of the protesters. The vastly expensive bypass would cut through rough pasture and water meadows, a habitat of ancient hedgerows, hawks, badgers and foxes. Why would anyone want to destroy it?

At the start of the decade, the government had announced the 'biggest road-building programme since the Romans', with a £23 billion budget and 500 construction schemes planned across the country. 'A man who, beyond the age of twenty-six,

22

finds himself on a bus can count himself as a failure,' Prime Minister Margaret Thatcher is alleged to have said. Oblivious or indifferent to the irreversible damage wrought by burning fossil fuels, she wanted to enable universal car ownership and reduce Britain's reliance on public transport. In response, the activist group Earth First! launched a vast nationwide campaign of road-blocking. News stories about protesters at Batheaston, Newbury and Twyford Down were as much a defining feature of nineties Britain as yellow smileys and lip balm from The Body Shop; Swampy, a mild-mannered activist with a reputation for digging himself into makeshift tunnels on construction sites, stood alongside Take That and Mr Blobby as one of the major cultural icons of the day.

At Solsbury Hill, the children's author Bel Mooney undertook a fast in a Mongolian yurt. She wasn't the only resident who gave up a comfortable lifestyle to join the occupation. Some of the older kids at my school bunked off, going down to chain themselves to gates and mounting the roofs of occupied houses as police attempted to evict them – acts of genuine bravery by those getting their first taste of direct political action. In a grainy documentary, a woman climbs onto a yellow digger in the middle of the churned-up mud of what was once a meadow. Five men in hi-visibility clothing carry her off. 'I felt so sad but so powerless,' she told the documentary makers later. 'The powers-that-be had decided that my countryside was being destroyed, and my home, and there was absolutely nothing I could do to stop it, or even to fight it. I never thought I'd be the sort of person to break the law really. It's great!'

* * *

I didn't know it then, but the protests I saw unfolding in my sleepy corner of the West Country were directly inspired by a work of art. They had their provenance in a novel written two decades previously, 5,000 miles away in the American Southwest. In 1975, the author Edward Abbey published *The Monkey Wrench Gang* – his most enduring novel, and what was to become one of the most important texts of the radical environmental movement.

The Monkey Wrench Gang is a rip-roaring, outrageous caper following the adventures of George Washington Hayduke and friends as they launch a campaign of sabotage against the industrial forces ripping up their beloved American Southwest. Imbued with Abbey's deep knowledge and appreciation of the landscape, we follow his unlikely heroes through that vast landscape of red dust and rock, as they fell billboards, derail trains and incapacitate bulldozers. Their obsession is with destroying the Glen Canyon Dam. They don't manage it in these pages, but in a spectacular chapter they do blow up a bridge nearby, which 'opens up like a flower', fragments, and tumbles into the river, 200 metres below.

The dam exists in reality: a vast, concrete arc that spans the canyon, interrupting the inky waters of the Colorado River not far from where they cross the border between Utah and Arizona. Over 200 metres high, it holds one of the largest artificial reservoirs in the States, containing around 32 million cubic metres of water. Abbey was a furious witness to its construction, completed in 1966, and the consequent destruction of the canyon as it flooded. It became a recurring focus of his anger, art and activism.

Abbey's protagonists are the antithesis of the kale-munching, bamboo-wearing eco-activist archetype of today – they're

hard-drinking, meat-loving and gun-toting – attitudes that are a little hard for a lefty millennial like me to swallow. Although Abbey clearly intended to present flawed – and so very human – characters, Hayduke was surely in no small part modelled on his own outlook and experiences. His version of environmentalism was a very American one. In fighting for the wilderness, he was fighting for the right to be free and alone, an individual making his way unencumbered by the impositions of centralised power, which he saw the roads, factories and infrastructure ripping up his beloved landscape as representing. He was an anarchist, attuned to the poetry of the wild and the potential fun to be had in the struggle for it.

'Human society is a stew,' he once said. 'If you don't stir it up you get a lot of scum on top. Agitate.' Like Saro-Wiwa, he was an activist as much as an artist; I doubt he'd have given much time to dwelling on the distinction. He was understand-ably vague when asked about the extent to which the actions of his fictional gang reflected his own, but he was known to undertake 'night work', not dissimilar to the goings-on on the page. His friend, the artist John DePuy, claimed they chopped down some 200 billboards together, and once sent a Caterpillar tractor over the edge of a 500-foot cliff in Utah.

'*The Monkey Wrench Gang* is an incendiary device bound as a book,' activist and co-founder of the environmental group Earth First!, Dave Foreman, states in filmmaker ML Lincoln's documentary, *Wrenched*. 'What it says is the salva-tion of the planet is blowing up the property that's killing (it).' It portrays a literal, sleeves-rolled-up kind of activism, carried out on the front line where the destruction happens, born of a deep mistrust of authority to do the right thing or

heed public opinion. What Abbey seems to advocate in the novel is sabotage – distinct from terrorism in that the action he believed in stopped short of harm to life – but committed to wreaking havoc against the tools and property of those carrying out environmental destruction.

The term 'monkey-wrenching' slid off Abbey's pages and into common activist parlance, a shorthand for just such eco-activism. It's proof of how much his novel has shaped the environmental movement of the last fifty years. Over and over again, activists have spoken of *The Monkey Wrench Gang* as a cornerstone text, persuading them that a different kind of life, dedicated to the wilderness, is not only possible but a moral imperative. US environmentalist Tim DeChristopher said that, when he read the novel at eighteen, he was 'old enough to understand it, but not quite old enough to understand it wasn't a manual'. A few years later, he came to national prominence when, in 2008, President George W Bush put the oil drilling rights on parcels of public land up for sale. Attending the auction, DeChristopher started placing bids himself, pushing up the price and ultimately winning 22,000 acres of land for around $1.7 million, which he never intended to pay. Not quite monkey-wrenching, but in keeping with the bold, unapologetic activism of Abbey's protagonists. He ultimately served twenty-one months in prison as a consequence, but his actions forced delays in the auction sales being processed. When the Barack Obama administration took power, the majority were cancelled.

Most notably, the book directly inspired the forming of Earth First! '(We) were more influenced by Edward Abbey than anyone else,' Foreman says. 'He was a voice for us and that influence helped us take a more irreverent look at things;

26

it allowed us to think outside the box and take things in a new direction.' Founded in 1980, Earth First! was a new kind of environmental movement, borrowing the tools from Abbey's toolbox. The group operated under the slogan 'no compromise in defence of Mother Earth!', and their logo – a stone tomahawk crossed over a monkey wrench. Foreman published his guide to direct action titled *Ecodefense: A Field Guide to Monkeywrenching.*

In March 1981, Earth First! announced their arrival in the world with their first public action. At Glen Canyon Dam, they hung a 100-metre plastic 'crack' over the edge, watching the black fissure unfurl across the vast concrete face. A symbolic evocation of the activism of Abbey's heroes, it was also a statement of intent: Earth First! would be more radical than the environmental movements that had come before, stepping outside mainstream political processes that tended to push environmentalists towards a more moderate position, and undertaking acts of sabotage in order to protect the planet. Abbey looked on, dressed in a denim western shirt and Stetson hat, grey beard straggling over his red neckerchief. He explained in an interview in front of the dam, captured in the short 1982 film *The Cracking of Glen Canyon Damn* [sic]: 'We're morally justified to resort to whatever means necessary in order to defend our land from destruction.'

Earth First! went on to become one of the most significant climate movements of the late twentieth century, with groups in at least nineteen countries around the globe. Among their victories, they successfully prevented the destruction of a 6,000-acre area of wilderness in Cove-Mallard, Idaho, which had been sold for logging. At Warner Creek in Oregon, they blockaded the road for an entire year, preventing the

destruction of 9,000 acres of forest until the law caught up with them and banned the logging of the forest.

All power to the imagination. The reason *The Monkey Wrench Gang* and Abbey's other books had such a huge impact on the environmental movement is because they offered people a vision of a new kind of ecological protest. His protagonists were uncompromising and unapologetic, taking whatever steps they deemed necessary to save their beloved wilderness with scant regard for the law. In fiction, Abbey could portray the poetry and romanticism of the activist life in a way that rational political argument could not. Who wouldn't be seduced by Hayduke and his life unencumbered, carried by the river's flow, the only love of his life the vast, exquisite wilderness? Abbey called himself 'a part-time crusader, a half-hearted fanatic'. He believed that those fighting for nature had to allow themselves to be recharged by the pleasure of it, and he advised activists: 'It is not enough to fight for the land; it is even more important to enjoy it . . . So get out there and hunt and fish and mess around with your friends, ramble out yonder and explore the forests, climb the mountains, bag the peaks, run the rivers, breathe deep of that yet sweet and lucid air, sit quietly for a while and contemplate the precious stillness, the lovely, mysterious and awesome space.' Perhaps his novels had a similar role to play – reminding his readers that while activism can be one of the toughest things you'll ever get involved with, it is also a huge adventure.

Author Robert Macfarlane, who writes about our relationship with nature, has said of *The Monkey Wrench Gang*: 'Every now and then, the imaginary forms of literature feed back into the lived world with startling consequence. They

assume real-world agency in ways that exceed the cliché of "life imitating art".' Tracing the line from Abbey's fictional heroes to those transformational protests of the nineties is a vindicating reminder of the power of art. It seems to me as if the explosion on his pages rent a hole, not only in the artificial structures of the Glen Canyon, but in the border between reality and the imagination. Proving it flimsier than we think.

* * *

I suspect what those activists experienced when they picked up Abbey's book was a certain kind of excitement, a feeling I've had myself. It's a feeling of recognition – the experience of encountering the world portrayed just as you see it. Perhaps you've felt it too: a song that captures exactly the sensation of losing a love, or a poem that truly describes how it feels to stop at a quiet railway station on a slow summer afternoon. A great artist can put into words the truth that tarries at the tip of our tongue, creating forms that present the world back to us in ways that are startlingly original and yet connect with a reality we feel deeply.

Alternatively, art can portray lives and experiences we know nothing about, or ask us to pay attention to what we've previously overlooked. As I write this, the front pages of Britain's national newspapers are dominated by headlines about the Horizon Post Office scandal, a miscarriage of justice in which, between 1999 and 2015, over 900 people who owned and ran post offices were falsely accused and prose-cuted for fraud and theft, as a result of errors in the Post Office's accounting system. Nearly a decade later, and three

years after the public inquiry into the scandal began, it has taken a TV dramatisation of the events to bring them to such prominence in the public eye. *Mr Bates vs the Post Office,* written by Gwyneth Hughes, features a roll call of some of Britain's finest actors – Toby Jones, Monica Dolan, Julie Hesmondhalgh, Amit Shah and Will Mellor among them – and presents a hugely moving portrayal of what happens to ordinary lives when they come into conflict with the machinations of a system that has far outscaled the human – in this instance (and who knew?) the malign antagonist is the British postal service. And so we see how the accusations against Mellor's Lee Castleton cause his children to be bullied at school; Dolan's sunny, scone-baking Jo Hamilton is reduced to tears as she crouches on her shop floor, unable to make sense of the numbers in the papers that surround her. Ordinary people imprisoned, bankrupted, driven to self-harm and suicide.

The drama translates the monochrome news accounts of the case, as they appear in press articles and legal documents, into human form – something we can map onto our own lives, our relationships with the people we love. Notably, Hughes's background is as a journalist and documentary maker. When *The Guardian* asked her why she had turned to drama to portray the story, she replied: 'As a viewer, when you watch even the best documentary, you're looking at the screen and thinking, "Oh, that poor person, that's terrible." But when you watch a drama, you're looking at the screen, and thinking something different. You are thinking, "Oh, poor me! Poor me! That could be me!"'

The power of this TV drama has moved the scandal to a different place in the public psyche. Described by British Prime Minister Rishi Sunak as 'one of the greatest miscar-

riages of justice in British history', the government has announced the unprecedented step that it will overrule the judiciary, enacting legislation to provide blanket exoneration for all those convicted. Meanwhile, former Post Office CEO Paula Vennells has returned her CBE in response to a petition with more than a million signatures demanding just that. Beautifully, Hughes's drama has become a part of the very story it is telling. And, at the time of writing, that story is still unfolding. As *The Guardian*'s Tim Adams put it: 'The greatest political dramas have the power to do this. They present a reality that is so emotionally honest that it gives a moral framework not only to the events portrayed, but also to everything that comes after.'

Art, then, has power as a mirror, representing reality to us as a way of demanding we transform it. In discussions about the political efficacy of art, 'representation' – the attempt to portray a reflection of some element of reality in creative form – can sometimes get a bad rap, as I'll explore in the next chapter. But so many of the examples I've come across of art having a tangible impact on the political, legal and economic structures that govern our lives are exactly this – portrayals of reality as the artist sees them.

In fact, such art can reach places and people that other forms of political expression can't, connecting not only with those already interested in the issues, but also drawing in individuals who might not previously have considered themselves politically active. In a discussion panel a couple of years ago titled *The Aesthetics of Resistance*, I heard the French author Édouard Louis speak about latent collectives: networks connected across communities, countries, the globe, by a shared sense of injustice, who don't yet know they are

reaching for the same thing. Art, he believes, can enable these collectives to recognise themselves. 'The beauty of art is to change a collective that does not know it exists,' he said. 'The power of art is already here, in the way it changes so many individuals; and in the end creates a kind of silent, almost invisible collective moment but which *is* a collective.'

He spoke about Marilyn French's 1977 novel *The Women's Room,* the bleak *Bildungsroman* about a woman trapped in an awful life as a suburban American housewife, who continues to be battered by the patriarchy even when she's got divorced, gone to Harvard and discovered women's lib. The novel, which was a and instant popular hit, helped a lot of women to understand that feminism was relevant to their lives, reaching in particular those unlikely to connect with more direct polit- ical polemics. Louis experienced something similar himself, as a gay teenager, seeking to liberate himself from the tough, masculine, working-class culture he'd grown up with. He described how watching the films of Pedro Almodóvar and Gus Van Sant, both of whom present complex portraits of gay characters in their work, gave form to his dawning sense of self: 'It was a way of completely liberating myself, of changing myself,' he said. 'OK, after these movies there weren't people demonstrating on the street. But I realise that this personal revolution was a collective revolution.' Art may not be enough, but Louis's experiences show that it can help, a lot, and that there is something powerful in recognising your convictions or experiences reflected in the creative sphere.

That perspective sheds light on the enduring power of Billie Holiday's discomfiting and unnervingly beautiful rendition of 'Strange Fruit'. The song refuses easy categorisation: sitting somewhere between folk, jazz and blues, it has a penetrating

musical poetry entirely its own. It is a Top 40 hit about a lynching. Abel Meeropol, a Jewish schoolteacher, wrote the song in 1937, giving voice to the horror he felt when he saw a photograph of two Black men, J Thomas Shipp and Abram S Smith, hanged from a tree, surrounded by the 5,000-strong mob that had murdered them. A terrible, terrible image. Looking at it now, I can well understand how the strength of emotion it provoked in Meeropol led him to create a song that sounded unlike anything that had come before.

Two years later, Holiday recorded her version of 'Strange Fruit' and made it her own. A different kind of protest song, it offered no prescription for change or rallying cry. Instead, her art was simply to reflect the acts of society back, giving voice to the horror of the violence. Listening to it again, it strikes me that its power lies in its caustic cognitive dissonance. The sweet scent of magnolias underscored by the smell of burning flesh. Holiday's voice is compulsive with lunacy, her smooth, honey-heavy articulation breaking with the ugliness of her implicit question: how do you experience beauty, when man is capable of doing such things to man?

Holiday released the song a decade and a half before Brown vs Board of Education, the court case ruling that racial segregation in schools was illegal, which is often considered the start of the US civil rights movement. What was the line between that song and the movement that, through the sustained, committed bravery of many ordinary people, utterly transformed US society? *Time* reviewed it as 'a prime piece of musical propaganda for the NAACP (National Association of the Advancement of Colored People)', not intending a compliment. By the end of the millennium, the magazine had changed its tune, naming 'Strange Fruit' as 'the song of the

century'. Meanwhile, the co-founder of Atlantic Records, Ahmet Ertegun, called it 'a declaration of war . . . the beginning of the civil rights movement'.

Yet Holiday didn't sit down on a bus and refuse to move for a white passenger. The power of her song was of a different nature to the actions of the four students who refused to leave the 'whites only' lunch counter of a Greensboro diner. Instead, she gave voice to the oppression of Black people through her art, and that resounded with the clarity of a siren, helping those who would form the movement that transformed the nation to recognise themselves as activists. 'When she recorded it, it was more than revolutionary,' the drummer Max Roach told David Margolick, author of *Strange Fruit: Billie Holiday, Café Society, and an Early Cry for Civil Rights*. 'She made a statement that we all felt as Black folks. No one was speaking out. She became one of the fighters, this beautiful lady who could sing and make you feel things. She became a voice of Black people.'

* * *

The urgency of the times we live in might seem to demand that artists set aside their paintbrushes and writers give up their fictions for the more serious-minded business of journalism or law, science or politics. Even Tom Stoppard, the celebrated playwright and screenwriter, believes that 'if your aim is to change the world, journalism is a more immediate short-term weapon'. Or, more bluntly – 'ART WON'T SAVE THE WORLD. GO VOLUNTEER AT A SOUP KITCHEN YOU PRETENTIOUS FUCK' – as a flyer pasted up at Dublin Contemporary 2011, which has since become a meme

on social media, put it. (Whether it was intended as a critique of, or an advert for the art fair was unclear.)

The artworks I've looked at in this chapter, though, give the lie to the notion that art cannot be a powerful tool of change. Furthermore, it is clear that stating the facts only does not work as a political strategy. To return to the impact of the climate and ecological emergency, it doesn't take much to grasp one of the most essential factors in ensuring future human life on this planet – that we need to stop releasing new carbon into the atmosphere by burning fossil fuels. We have all the – widely publicised – scientific evidence we need; the consensus in peer-reviewed scientific literature that climate change caused by human activity is greater than 99 per cent. Why then do so many of us continue with 'business as usual'?

This is a failure not of facts, but of the imagination. A gap exists between our intellectual grasp of what we face, and its real meaning for ourselves, for the people, creatures and places we love. This gap is where we must make art. In their compelling book *Active Hope: How to Face the Mess We're in with Unexpected Resilience & Creative Power,* authors Joanna Macy and Chris Johnstone chart the urgent need for society to shift from just such a 'business as usual' position to recognising and embracing 'The Great Turning'. This, they explain, is 'the essential adventure of our time' as we 'transition from a doomed economy of industrial growth to a life-sustaining society committed to the recovery of our world'. It's a surprisingly optimistic vision. We exist at a pivotal moment in the history of the planet, they write, as an epochal transition towards a new – and better – way of living begins. It is already under way; it exists everywhere; it is gaining momentum. This

isn't to deny the significant grief so many of us feel in recognising the state we are living in – a state they call 'The Great Unravelling', as we experience deepening social and ecological collapse – but to realise there is a place we can go beyond grief, a light on the horizon of that grey state.

Macy and Johnstone argue that key to the Great Turning will be a profound and necessary shift in consciousness – without it, the structures established to sustain new ways of inhabiting the planet will not take root. It will be a deep shift in our understanding of our relationship to the earth, and of the human experience as part of nature, not separate to it. Art is at the heart of this shift in consciousness. The example they use is the first colour photograph of our planet taken from space by a person – the 'Earthrise' image, taken from more than 200,000 miles away in 1968. A remarkable shot by William Anders, one of the astronauts aboard Apollo 8, the first crewed spacecraft to orbit the moon. He took his camera as the craft rounded back from the dark side, and on its lens, an image of the earth appeared: a small, blue hemisphere, delicate and unutterably beautiful.

For those of us born too late to recall life before such photographs of the earth existed, it is hard to comprehend how significantly this image reshaped the public psyche about the particular value of life on this planet. That we got to see it at all is thanks to the campaigning of Stewart Brand, the American writer, futurologist and 1960s hippy icon, who led the campaign for NASA to release the first ever photograph of the whole earth taken from space, after becoming convinced during an LSD trip in 1966 that seeing such an image would transform how we understand ourselves. 'WHY HAVEN'T WE SEEN A PHOTO OF THE WHOLE EARTH YET?'

demanded the plywood sandwich board he wore around college campuses and the buttons he sold for 25 cents. The following year, NASA released a photo taken by satellite of the entire planet, which Brand published on the cover of his *Whole Earth Catalog*, a kind of countercultural bible for communal living that had a vast influence on American culture and is credited as an analogue precursor to the internet. But it was the *Earthrise* photograph, taken in 1968 and eventually adorning the covers of three later editions of the *Whole Earth Catalog*, that became synonymous with that project and lingers in the public psyche.

Because Brand was right about the power of seeing our planet like this. So great was the impact of this image that it has been cited as one of the most important photographs ever taken and, significantly, is seen as having played a pivotal role in the foundation of the contemporary ecological movement. In *Earthrise: How Man First Saw the Earth,* Robert Poole argues that the picture marked a defining moment in twentieth-century history, impacting religion, culture and science. 'It is possible to see that *Earthrise* marked the tipping point,' Poole writes, 'the moment when the sense of the space age flipped from what it meant for space to what it means for Earth.' Al Gore underlined the photo's importance in his book, *An Inconvenient Truth,* stating, 'Within two years of this picture being taken, the modern environmental movement was born.'

Notably, *Earthrise* wasn't the first photograph of the Earth taken from space – that had happened over two decades previously, and several images of varying quality were captured in the intervening years. But there is something about this image in particular – the first colour photograph of the Earth to be

37

taken from the moon by a human – that elevates it from more prosaic documentation to a work of art. Remarkably, an audio recording captures the moment Anders took the photo. 'Oh my God!' he says. 'Look at that picture over there! There's the Earth coming up. Wow, that's pretty.' Then he quickly swaps the film in his camera to colour, ensuring he can capture the view in all its glory.

Looking at it again now gives me a shiver of what the inhabitants of that bright globe must have felt when they first saw their home represented like that over half a century ago. The feeling is the opposite of cosmic irrelevance. At the same time as noting how fragile our planet looks, half shrouded in shadow and guarded only by its thin atmosphere, one has a sense, too, that this is a rare jewel: lovely in its peculiarity. Everyone who views this image must surely be united in their sense of what a remarkable thing it is to be alive, whether through the extraordinary chance of circumstances or at the hands of a higher power. 'We came all this way to explore the moon,' Anders famously said, 'and the most important thing that we discovered was the Earth.'

Macy and Johnstone believe the image has been a vital factor in a turn towards a 'deeper, collective identity' over the last fifty years, 'no longer just citizens of this country or that ... as many Indigenous positions have taught for millennia, we are all part of the Earth'. The point is that, for many of us, what shifts our ethics is not facts and figures but something more elusive – whatever it is that moves us when we see that trembling half-sphere against the unfathomable blackness of space and understand the gift of human life afresh. Reaching for that ineffable thing, attempting – if not

to capture it – at least to alight on it for a moment or two – is, I think, the business of art.

When *Earthrise* was printed in *Life* magazine, a simple poem by James Dickey accompanied it:

'And behold/ The blue planet steeped in its dream/ Of reality, its calculated vision shaking with the only love'.

* * *

The story of *The Monkey Wrench Gang* and its influence is a talisman for me; proof to hold on to whenever I need it that art really can transform the world, or at least define the landscape of a country. The British branch of Earth First! didn't win at Little Solsbury Hill. The protests lasted for eighteen months; in the end, the bypass was built. But they did achieve a more significant victory. Fighting the protests here, at Newbury, and other sites had proved too costly and complicated for the British government. In 1996, their national road building programme was entirely abandoned.

That road building scheme would have completely altered the psychogeography of the UK, changing how we visited loved ones, got to work, went on holiday, and perhaps casting the railways in the same way they're viewed in the US – as a poor second option for those who can't afford to drive. Instead, where they would have been, we have ancient hedgerows and the fields they have framed for centuries. Quiet testament to the forces that made it so. Such victories quickly slip from view, because everyday life is busy and we have other worries, other battles to fight. Telling their story is a guard against forgetting them.

Billie Holiday (photo by GRANGER – Historical Picture Archive/Alamy)

Chapter 3
THE POWER STATION

The street is full of sunflowers. Ten thousand of them, in fact. They crowd in front gardens. Sunflowers occupy the parking bays all along Lynmouth Road, tossing their heads in sprightly dance, as if misjudging the beat from the speakers set up in their midst. Sunflowers proceed along the street, carried in their pots by pupils from the local primary school. At a piano, children gather to sing a sunflower song. Painted faces, bright petals radiating across cheeks. And in the distance I can see my daughter, toddling in and out of the crowd, clutching a blossom made of yellow paper in her hand.

When visual artist Hilary Powell envisaged the street she lives in full of sunflowers, it was February, the days short and the skies grey. The image was surreal and somehow futuristic, a vision of the urban space reclaimed and repurposed, with nature reintegrating into the cityscape as it might in a sustainable, post-capitalist society. As she sketched the picture she had in her mind on paper, she thought of a book she had loved as a child. The traditional Chinese fairy tale tells of a young boy with a magic paintbrush. Everything he paints becomes real. 'He had the power to create these visions that

came to life,' she says. And so it was with her sunflowers. 'On the day, it actually looked like the picture.'

Conjuring a transformed reality into being, with paper and paint, storylines and cameras, is what she and her husband, filmmaker Dan Edelstyn, like to do. In 2019, having been inspired by the actions of Strike Debt, part of the Occupy Wall Street movement, they took over an old bank in the heart of Walthamstow, north-east London, where they engaged the community to 'print money' – beautifully designed banknotes with the faces of local heroes in place of the Queen. These miniature artworks were sold around the world, raising £40,000. Half went to local causes and the other half was used to buy up £1.2 million of high interest personal debt.[1] They stuffed the receipts for the debt into a gold-painted van and blew it up, right in front of the high rises of Canary Wharf, capturing the whole process in a witty, energising documentary-cum-spoof-heist-movie called *Bank Job.* The fragments of the van and the papers inside it ended up on display at the Fitzwilliam Museum, Cambridge – suspended in mid-air, caught in outward propulsion.

Now, they are attempting to transform their ordinary, terraced street in Walthamstow into a solar power station. Through Powell and Edelstyn's project *POWER*, they intend to put solar panels on the roof of every home in Lynmouth Road, decarbonising the street and providing energy savings and security for the residents. In November 2022, they launched *POWER* in typically zany fashion by moving their

[1] So called 'delinquent debt', that the borrower has defaulted on, is often available to buy far more cheaply than the face value of the debt, because the lenders have been unable to recover it and are seeking to offset some of their financial loss.

double bed onto their roof and sleeping outside through wind, rain and frost to raise £100,000 via sponsorship. Film footage shows how risky the operation was – three storeys up, they struggle to cling to a tarp as the elements batter them, a bedside standing lamp flailing dangerously as if it might tumble into the gardens below. They stuck at it for twenty-three nights – the time it took them to reach their target. As they did in *Bank Job*, they have once again raised funds by printing and selling their own 'art currency'. At Christmas, they released a single they had created with their local primary school, raising a further £50,000. 50 per cent of the proceeds have been donated to local grassroots organisations, including two food banks, a migrants' rights group and a local football team. The rest will be spent on solar panels.

In her book, *The Case for the Green New Deal*, economist Ann Pettifor makes the argument for far-reaching state invest-ment in the solutions to the climate and ecological emergency, including the transition to 100 per cent clean energy by 2030, as a means to transform society radically. A key phrase she uses is 'every building a power station'. When they read it, the image stuck with Powell and Edelstyn. They decided not to wait around for the government to take action. Instead, they set out to 'enact a grassroots Green New Deal . . . (to) take a leap of imagination and give ourselves the power of government to unleash an arts-led stimulus to address the big challenge of our time'.

Those words, 'arts-led', are significant. They consider *POWER* an artwork. The title captures the whole breadth of it: the bed on the roof and the sunflowers in the street, the solar panels and the song of the schoolchildren, the limited edition 'greenback' bank notes, the online network

of like-minded souls interested in community-led solutions to the climate crisis, and the documentary film Edelstyn is making as they go. Powell calls it a *Gesamtkunstwerk*, or 'total work of art', in which the artists synthesise many creative strands into a coherent whole.

Today's event celebrates how far they have already come – fifteen homes with solar panels on their roofs. There are speeches and a treasure hunt, a pot luck street feast, limbo dancing and music. *The sun's going to shine on everything you do.*

* * *

Implicit in the statement of the anonymous author who created that flyer in Dublin – 'ART WON'T SAVE THE WORLD. GO VOLUNTEER AT A SOUP KITCHEN YOU PRETENTIOUS FUCK' – is the idea that making art and volunteering in a soup kitchen are intrinsically opposed. They couldn't have had in mind the residents of Lynmouth Road sharing their street feast with all comers, or indeed the two food banks who are part of the project. Nor can they have thought of the 1960s anti-capitalist theatre collective The San Francisco Diggers, who once took to the streets with flyers reading: 'Free food. Good hot stew. Ripe tomatoes. Fresh fruit. Bring a bowl and spoon to the Panhandle at Ashbury Street. 4PM 4PM 4PM 4PM. Free food every day free food. It's free because it's yours.' Those among the 200 people regularly fed by The San Francisco Diggers were served their food with a side helping of theatricality: diners were asked to enter through a bright orange 'Frame of Reference' and were served prints of revolutionary poetry with their meals.

Eurocentric cultures, at least in recent history, haven't tended to think of art like this. Instead, its position has been aloof – its purpose to represent life rather than be a part of it, as it plays in the shadows that human experience casts. Surely this is one of the characteristics that makes many of those driven to make change a little queasy about claims for the political efficacy of art. I once discussed this with the artist-activist Jay Jordan – whose work I will return to later in this book. Their significant fury with representational art was summed up in their response to Olafur Eliasson's *Ice Watch,* which saw the artist transport eighty tonnes of ice to the streets of Paris during the United Nations Climate Summit in 2015, where they stood, melting. Eliasson intended those ice blocks running off into the sewers as a metaphor for government complacency. Instead, for Jordan, they stood for artistic inaction, a willingness to trade in symbols while the planet burns. 'Why make an installation about refugees being stuck at the border when you could co-design tools to cut through fences?' they ask in their book, *We Are 'Nature' Defending Itself* (co-written with their partner Isa Fremeaux).

'Why shoot a film about the dictatorship of finance when you could be inventing new ways of moneyless exchange? Why write a play inspired by neo-animism when you could be co-devising the dramaturgy of community rituals? Why make a performance reflecting on the silence after the songbirds go extinct when you could be co-creating ingenious ways of sabotaging the pesticide factories that annihilate them? Why make a dance piece about food riots when your skills could craft crowd choreographies to disrupt fascist rallies?'

I can't entirely agree with Jordan – as I explored in the last chapter, representational art has often played a pivotal role in changing how societies understand an issue they are facing and shaking them up to do something about it. Surely, we need to make change in many different ways, and the power of art as a political force is expansive and plural. To offer a single prescription for how it must work is to overlook the power of creativity to reinvent the ways we connect over and over again, astounding us with its ingenuity at the very moment we think we've pinned it down.

But it's an invigorating provocation, and in contemplating the political efficacy of art, it may well be necessary to expand our understanding of what art can mean and where and how it can operate. What would happen if you challenged yourself to put your creativity to immediate use as a means of making the change you want to bring about? What would happen if you dared to believe you didn't need to wait for the intervention of the traditional power structures but could 'give yourself the power of the government', too?

* * *

'I don't want art that points to a thing. I want art that is the thing,' Cuban artist and activist Tania Bruguera has said. One of the leading proponents for art that has a practical impact, her work includes *Immigrant Movement International* – 'a long-term art project in the form of an artist-initiated socio-political movement' – which began when she spent a year living with undocumented migrants in a tiny Queens apartment and established a local community space that offered free education, legal advice and health programmes.

Another work, *Cátedra Arte de Conducta* (Behavior Art School), provided free arts education to anyone who wanted it, promising an alternative to the narrow perspective of mainstream arts education in Cuba. Her work has led the government in her home country to consider her a significant political threat: she was once arrested for announcing she would be placing a mic on a pedestal in Havana's Revolution Square to allow ordinary citizens to express their views.

For Bruguera, art can be a soup kitchen or solar panels on a rooftop. It can be a toilet built for an off-grid community, the construction of an entirely new neighbourhood in the Netherlands, a project turning unused industrial sites into edible gardens. This is to say that art can be *real,* with practical applications in the places where we go about our lives, where we eat and shit, work and relax. All of these examples are captured by Bruguera in her archive of what she calls Arte Útil, or 'useful art'. To meet the criteria for inclusion, an artwork must function in 'real' situations, with beneficial outcomes for its users. Crucial for Bruguera, too, is that *Arte Útil* must 'challenge the field within which it operates (civic, legislative, pedagogical, scientific, economic, etc.).'

To highlight the artists who create works that have a real-world impact is to refute the notion that art cannot transform reality, because it eliminates any distinction between the two. It's notable how many of the examples of the kind of 'useful art' that interest Bruguera are grassroots interventions, working in neighbourhoods on a relatively small scale to create real change in the lives of local people.

One of my favourites of Bruguera's examples is Rick Lowe's *Project Row Houses*: a line of modest, white clapboard homes in an unremarkable street in Houston, Texas. Single-storey,

with three steps from the path to a small porch, some with a narrow bench, some with a sign hung from the rafter announcing the inhabitants: *Sissy and Denny Kempner; Emily Todd; Roslyn Bazzelle & Derrick Mitchell.* Small front gardens meet a tree-lined sidewalk and a quiet, wide road.

In 1990, Lowe was a young artist, not yet thirty, whose practice centred on creating billboard-size works that were used as backdrops for political rallies. A meeting with a student who visited his studio made him question the value of what he was doing. The student admired his work but told him that those living in the neighbourhood needed artists like him not only to point out problems but also to find solutions to them.

The question gave form to an unarticulated thought that had been troubling him. He wanted his work to go further, to move beyond the audience as spectator to creating art in which the audience was actually engaged. 'One sure way to engage people is to find something bigger than you are, beyond your capacity, and it forces you to build some kind of relationship to others to move the project forward', Lowe told academic Mark J Stern in an interview for the book *What We Made: Art and Social Cooperation.*

Project Row Houses was something bigger than Lowe. Inspired by that student, he started looking for a way to support low-income African American communities through his art. He went on a bus tour with a group called SHAPE (Self Help for African People through Education), taking in impoverished and run-down areas of the city that were earmarked for demolition, including the Third Ward, the centre of Houston's African-American community where Project Row is situated.

But rather than tearing them down, Lowe, who grew up in Alabama and moved to Houston in the 1980s, began to imagine a future for those derelict houses – warm, powerfully domestic – and he began talking to people about what that future might be. I love the notion of engaging people by creating a dream bigger than you could build on your own, and how it makes you connect in a way that develops from a genuine need. It's an antidote to what can seem like fairly imperialist approaches to engagement in the arts – communities becoming beneficiaries of charitable acts of art being done to them, enriching them in ways they never knew they needed, and they were getting on pretty well without.

First, a collective of seven artists (James Bettison, Bert Long Jr., Jesse Lott, Floyd Newsum, Bert Samples, George Smith and Lowe) formed, then they convinced the National Endowment of the Arts to back the project, before any agreement for the houses was in place. That was enough to convince the owner to grant them a lease on twenty-two of the houses; next, they went to talk to different groups within the community, from churches to museums, corporations to school kids. The first job was to make them habitable again: clearing away rubbish, fortifying the porches, painting and decorating. The local museum gave their employees days off to help; state representative Garnet Coleman, who came from a family that had been based in the Third Ward for more than a century, sponsored the refurbishment of one of the houses.

In the mid-nineties, the houses began to open. Alongside residency spaces where artists could spend up to five months, working on whatever inspired them, were free homes for single mothers and their children, allowing them up to two

years to complete their education and organise their lives. Three decades later, Project Row Houses is still thriving, having grown to encompass five city blocks and thirty-nine houses, centring on the interaction of art and artists with the local community. Now the project incorporates low-income housing blocks, counselling services, free tutoring for local schoolchildren, a community market and a playground.

Project Row Houses has spawned imitators within the art world. Art world darling Theaster Gates cites Lowe as the inspiration for his Rebuild Foundation, a hugely ambitious project that has seen the artist use his cultural cache to transform a run-down area of the South Side of Chicago – literally selling marble tiles from the abandoned local bank, carrying his signature, for $5,000 a pop to rich art investors, using the profits to reinvest in the area. And the model is imprinted on Turner Prize-winning *Granby Four Streets,* an artwork that saw collective Assemble work with residents of a sparsely populated area of derelict houses in Liverpool to bring empty houses back into use as affordable family homes, lovingly rejuvenated through local craft and employment.

There are more cynical projects too. In the wake of *Project Row Houses,* savvy property developers have latched on to the potential of the arts to drive up the desirability of poorer areas and, consequently, the readiness of middle classes to push up house prices by moving in – the process known as gentrification. American academic Richard Florida provided the blueprint for urban planners with his 2002 book, *The Rise of the Creative Class,* which identified the role that concentrations of artists, as well as queer communities, can play in attracting more investment to an area, and suggested

that attracting these communities should be at the core of a city's regeneration strategy.

If you've ever spent time in Dalston, London, or Williamsburg, New York, you've spent time in Florida's world. What he failed to recognise was that the regeneration processes he imagined wouldn't serve everyone equally – least of all the established poor and working-class communities of an area, who were likely to be displaced by the influx of more affluent new arrivals. Fifteen years later, he apologised, writing what amounted to a mea culpa – *The New Urban Crisis,* a book that identified the role the creative classes have played in helping the rich get richer, not solving the problems associated with the poor communities they've arrived in, simply displacing them to areas further from the city centre, with fewer readily available flat whites.

It's impossible to pretend that a work described by the *New York Times,* as *Project Row Houses* was, as 'the most impressive and visionary public art project in the country', is not going to change perceptions of an area previously dismissed by investors due to high crime rates and levels of unemployment. What is a conscientious artist to do about the risk their presence and work in a community might contribute to changes that do not benefit those already disadvantaged?

The solution might be for artists to refuse to play a role in areas and communities in flux. But for anyone who believes, as I do, that art and creativity are crucial to living well, that isn't satisfactory either. Lowe has thought deeply about these issues in relation to *Project Row Houses.* As he put it in the interview with Stern, 'There is some middle ground between things staying the same and a total community makeover. I'm interested in creating a social collaboration to extend that

period of transition to allow for all kinds of social dynamics in the process. . . . Every place has to move one way or another, whether it's through decay or some kind of positive growth experience. The key is just how we interact within that space of development.' In an area already earmarked for regeneration, he suggests artists can play a positive role in slowing the rate of change and complicating how it happens.

In 2003, Row House Community Development Corporation was founded, with the mission 'to promote low and moderate income rental housing for persons in the Northern Third Ward, while preserving the character and architecture of the area'. Lowe's proclamations about the role arts might play in complicating the process of regeneration here have a practical function – the success of the artistic project has allowed for a real-world intervention 'promoting equal opportunity to live in the Northern Third Ward'. *Project Row Houses* has allowed a long-term community of low-to-moderate income residents to remain in the area, in decent housing, with access to educational opportunities and other forms of support. Surely the benefit belongs to everyone in the area. Communities need the threads that tie them to their history – people who have grown up in a place, know its textures and carry its stories beneath their skin. By demonstrating this, Project Row makes an argument 'supporting a continued need for quality affordable housing in Third Ward in the foreseeable future'.

* * *

Such enterprises might prove their real-world efficacy. But are they really art? Susan Sontag once wrote: 'Art is a technique

for focusing attention,' and perhaps this is enough to justify placing the works of the *Arte Útil* archive in the sphere of what constitutes art; only that the artist asks us to cast our gaze this way. We act differently around art, look more closely, tune in to the missives of our senses. Bringing such a quality of attention to the good acts of the world could have a trans-formational power. Imagine we hailed a new tree planting scheme with all the excitement of a new Beyoncé album? Or the construction of cooperative housing with the energy that goes into the launch of a James Bond movie?

A ridiculous idea, I suppose. But artists have a trick up their sleeve, in the way they insist on what matters by placing a gold frame around it. Infuriating as it may have proved for many critics at the time, nothing stopped Marcel Duchamp displaying a porcelain urinal as a 'readymade sculpture' (*Fountain,* 1917), or Robert Rauschenberg's *This Is a Portrait of Iris Clert if I Say So* (1961) – a telegram simply bearing the words 'This is a portrait of Iris Clert if I say so' – from going down in art history. If such tongue-in-cheek works have secured their place in the canon, why shouldn't those with more obvious political purpose appropriate the lens of the art world to achieve their ends? It's a way of turning the rarefication and privileged platform of the art world back on itself – perhaps that is what Bruguera meant when she said '*Arte Útil* is about robbing the system'.

But to imply this is merely a kind of ruse pulled on the art world is to miss something. Bringing the intentionality of art-making to a real-world process suggests a particular way of going about things. The American painter and performance artist Allan Kaprow once decided, for two weeks, to pay attention to brushing his teeth as a work of art. He noted

the subtle movements of his elbow and fingers, the slight pressure of the brush on his gums. He discovered 'how much this act of brushing my teeth had become routinized, nonconscious behavior, compared with my first efforts to do it as a child. I began to suspect that 99 percent of my daily life was just as routinized and unnoticed; that my mind was always somewhere else; and that the thousand signals my body was sending me each minute were ignored.' The practice of artistic attention brings a new purposiveness to what he is doing, at the same time bringing to the surface the significance of his action. Now apply the same mindset to how we consume, interact with our communities and engage with nature. 'Ordinary life performed as art . . . can charge the everyday with metaphoric power,' he writes.

The way Edelstyn describes *POWER* makes me think of Kaprow: Edelstyn talks about plotting the project like plotting a film, using the same thought process. Initially, he and Powell wanted to turn the whole of Waltham Forest into a power station, putting solar panels on every building. But they worried about getting people to engage if the ambition seemed too outlandish. 'There has to be a degree of realism within the vision, a bit of – OK, they could just about do this,' he says. 'In any film, the challenge the characters take on must be within the realm of possibility. Even though it seems almost impossible, there has to be a grain of possibility.'

And of course that's exactly what they were doing: ultimately, *POWER* will be a film. But it is fascinating to me that their artistic sensibility has shaped the entire enterprise. We might say that their art is what Edelstyn and Powell think with. This project is an artwork because, I suspect, artists can't ever let go of how they've learnt to interact with

their material and subject matter. In *POWER*, what matters is not only that fifteen houses now have solar panels on their roofs that didn't before. It's the story that goes with it that counts – the fact that they did it with their neighbours, as well as the local football team, the primary school, two food banks and a refugee poetry group. It matters that Edelstyn and Powell are ordinary people, taking action in the street where they live, blundering their way through, getting some things wrong, but ultimately achieving far more than we might have supposed. The warmth and humour that Edelstyn and Powell bring to their project reminds me of something else: treating the business of shaping reality as a work of art is often a much more fun way to go about things.

* * *

A sunflower reminds us that the workings of nature are rarely random, but in fact follow a careful design. Look closely, and you'll see the seeds in its head are a tightly packed Fibonacci scale, repeating in two series of curves, winding in opposite directions. At the height of summer, each seed bears a flower, so a sunflower's centre comprises hundreds of tiny florets, a minute version of the plant's whole.

In her book *Emergent Strategy*, adrienne maree brown explores what we can learn from the patterns of nature, presenting a convincing approach to activism informed by the phenomenon of 'fractals'. Fractals are 'patterns of the universe that repeat at scale' – like ferns, where the same shape is repeated in the branches, the leaves, and even the veins of the leaves. In the context of her strategic approach, it means that a way of transforming the large scale is by

focusing on the small scale. It is, she writes, a way to 'grow a compelling future together through relatively simple inter-actions'. There is a deep intentionality in this, a modelling process akin to artistic practice.

Her thinking signals to artists that the particular quality of meaning-making they can bring to small acts of transfor-mation matters. It's easy to cast ourselves as too small to make a difference, and to imagine that what we can achieve at a grassroots level is irrelevant in the context of the vast scale of the planet's woes. To work to reopen a treasured local library, for example, in the face of the government onslaught against arts education, or to set up a football team with local refugees while considering the scale of displace-ment globally, could seem like a trivial gesture. But beyond the significant value these actions have on their own terms, what's particularly relevant here is how they can seed broader transformation. Imagine everyone who engages takes a cutting away with them, some value or idea to embed in their own life. To take the example of the library – perhaps someone who visits it is inspired by what they can do within their own community, and starts a project of their own. Maybe a schoolteacher uses it as an example to inspire her class about how to make change. Perhaps a local MP, seeing the enthusiasm for the project, decides to make public space a campaigning priority.

In this context, it is the role of artists to make clear the significance of such grassroots actions as metaphors for how we can all live. An artist would recognise that the story being told at the local library is not solely about ensuring a small community has access to great books. It's also about the meaning of communal space in communities with so little of it; it's about

the value we place on knowledge and creative expression; it's about what we pass down to the next generation; it's about how we want to live. Fertile ground for an artist: so how do you make those themes resound?

Already, *POWER* is branching, repeating. Some streets in Orkney, Newcastle and Swansea want to adopt the project and become power stations themselves. Powell and Edelstyn plan to transform schools by installing solar panels on their roofs; six are already on board. Ed Miliband, Shadow Secretary of State for Climate Change and Net Zero with Labour, who are – polls suggest at the time of writing – likely to take power in 2024, has been following what they are doing, and there is a real sense that it could influence policy. Ever attuned to potent symbols, next year they want to take on a petrol station and fill it with solar panels. All this is making the plot of their film difficult. Usually the credits roll once the hero has triumphed or failed definitively. But *POWER* could keep repeating forever.

'I came from a fine art background,' Powell says, 'and to say "art can change the world" – it would have been so embarrassing to consider that, the arrogance of that! But the power of art in creating these visions . . . you make others see that they, too, can make things happen. We want to be contagious.'

After the games, we gather around the trestle tables where the residents have laid out pots of food to share. Pakoras, quiche, jerk chicken, couscous, scones with jam and cream. Ice cones, banana smoothies and beer. I pile my plate with a mix of flavours. As we eat, we chat with the neighbours about poetry, migration, energy and love. The atmosphere captures the spirit of the project and, in some sense, the future it is angling towards – localised, optimistic, collaborative and creative.

57

My daughter weaves in and out of legs, fists full of home-made rhubarb cake. I watch her. She squeals as she runs up and down amid the yellow rows of flowers, meanders into open porches. She is too young to know, yet, that she ought to be afraid of running in roads, of strangers. This is the way of life I want for you, I think. The sun is going to shine on everything you do.

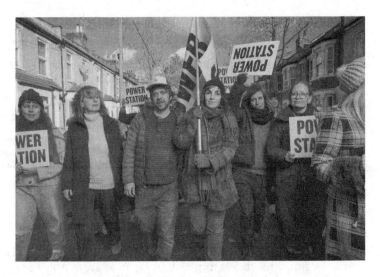

Dan Edelstyn and Hilary Powell (photo by Charlie Clift)

Chapter 4

THE VILLAGE

Kata, Bolivia, 1968. Early one November morning, a group assembled around a fire high on the Altiplano, in a remote hamlet far from the nearest road. They made for an unlikely gathering – alongside members of the local Indigenous Quechua community, dressed in brightly coloured shawls, knitted caps and bowler hats, stood a group of filmmakers from the city, with the long hair and beards of hip young revolutionaries.

The filmmakers, members of the Ukamau[1] Group, had arrived a few days previously, lugging their heavy equipment up the steep mountain passes to reach the village. Their young families came with them; they would be away from home for several months. In town, they had met the community leader Marcelino Yanahuaya, who had seen their previous work, *Ukamau*, and invited them to make a film in his community. He offered them an old outbuilding that pigs were usually kept in: swept clean and with cardboard laid on the floor to protect their equipment from dust, it provided suitable accommodation.

[1] *Ukamau* means 'this is how it is' in Bolivia's Indigenous Aymara language.

Director Jorge Sanjinés had an idea about the film he wanted to make in the community. A terrible rumour prompted it: he had heard that the Cuerpo del Progreso, modelled after the US Peace Corps, were forcibly sterilising Indigenous women without their consent. While researching a planned documentary on the subject, writer Oscar Soria had travelled to the area where the practices were allegedly taking place. But no one would speak on the record, so it was impossible to proceed with their project. Instead, the Ukamau team were here, attempting to make their first ever fictional film, based on the rumours.

From the beginning, things had not gone well. On the first morning, one of the party went out looking for extras to appear in the film, explaining what they were doing and offering to pay the locals generously. But they refused. 'Basically nobody understood,' Antonio Eguino, the cine-matographer, told me, 'because nobody saw a film before in their lives.' Sanjinés later identified the fundamental mistake they had made. Because Yanahuaya, as village leader, had invited them to make the film, they took it for granted that their plan would proceed with the community's support. But Quechua society doesn't work like that. Decisions are taken collectively; the leader has no sway in determining what the people will, or won't, do. One afternoon, a group of local teenagers started throwing rocks at the outbuilding the Ukamau Group were staying in. The irony of the situation mortified Sanjinés. The group had intended to make a film critiquing the unwanted imperialist presence of the US in the lives of Indigenous communities: 'Here,' he later said, 'we're realising what kind of gringos we are in our own country.'

The filmmakers packed up their belongings, ready to leave. They went to where the community was gathered and asked forgiveness for coming without their collective permission. Then, a last hope – what if they put their fate in the hands of the cocoa leaves? Cocoa leaves are sacred to many Quechua communities and are read as a means of gazing into the future. Who will I love? How many children will I have? Will the crops grow? Should we let this movie happen?

The community agreed. The Yatiri, a local healer with spiritual powers, undertook the ceremony. It lasted all night. In the end, he looked at the leaves three times, and then spoke to the community leader. 'Mother Cocoa says your hearts are clean,' Yanahuaya told them. They could stay.

But this moment underlined a tension relevant to all artists of resistance. The question is more than what story you are telling. It also matters how you tell it.

* * *

A film of sorrowful beauty, *Yawar Mallku (Blood of the Condor)* is full of harsh landscapes and shadows, vibrating with dissonant panpipes that sound like sobs. Shot in black and white, the story centres on Ignatius, the community leader (played by Yanahuaya), and his wife Paulina (played by Benedicta Mendoza, an Indigenous actor the group met through *Ukamau*). Early in the film, it becomes clear that the couple have lost three children and are struggling to conceive again. The Yatiri reads the cocoa leaves and reveals: 'Something is blocked inside her. It stops children.'

At the local hospital, a group of American 'Progress Corps' have turned up to administer medicine and gift hand-me-down sneakers to the local children – they look like hip 1960s gap year students, all hair and headscarves, spending their evenings dancing the twist. This louche bunch have a secret. From their brightly lit medical centre, they are sterilising the Indigenous women without their consent – 'only,' one of the Progress Corps protests when she is confronted, 'the women with too many children.'

Running in parallel is the story of Paulina's desperate quest to find the money for treatment to save Ignatius after US soldiers shoot him. Time in the film is a fractured thing, and only as it evolves do we understand that Ignatius was shot as he retaliated against Paulina's forced sterilisation. She finds herself in the city – a counterpoint to the big landscapes, soaring birds and drifting mists of home, here is a hostile environment of grinding factory machinery, seas of faces, leering puppets. 'People in the city have forgotten the Gods,' her brother-in-law tells her.

The film's politics are worn on its sleeve. At the same time as recognising the violence of the alleged sterilisation programme, we are asked to recognise the violence of the intervention of a foreign power in a culture that they do not understand or care for. A pamphlet, then, but a lovely one – rich in the textures of a Quechua culture that had never previously been portrayed on screen, the music and the dancing, 'the life-breath of a popular culture', Sanjinés called it. Beauty, for him, was a means, not an end – a way of arriving at truth. 'And this is what differentiates it from bourgeois art,' he wrote, 'where beauty is pursued even at the cost of lying.'

* * *

I watched the film alone, on my laptop. The Ukamau Group didn't intend it to be seen like this. Sanjinés insisted that the group's films should only be watched at public screenings, as a collective experience. 'The problems of distribution are the problems of realisation,' he wrote, understanding that the film's politics weren't restricted to the celluloid it was printed on. It was about who watched the film, how and where. The Ukamau Group was motivated by the politics of collectivism and solidarity, so watching their films alone made no sense. They understood how the fire generated by a film like this could become a force in a room full of people, directed immediately into discussion, ideas for action. *Blood of the Condor* reached its audiences through screenings at universities, trade unions and workers' groups.

The work of the Ukamau Group was unapologetically didactic. In his book *Theory and Practice of a Cinema with the People*, where he lays out the manifesto that guided the group's work, Sanjinés begins by describing Bolivia's history in the 1950s and 1960s, as if to make clear that understanding the work they had made would be impossible without grasping the political context. In 1952, the leftist Revolutionary Nationalist Movement (MNR) had set the Bolivian National Revolution in motion, overthrowing a military dictatorship in the country. With them swept in a wave of change – universal suffrage, the nationalisation of the mines, agrarian reform breaking up large tracts of privately owned land. The Aymara and Quechua Indigenous communities, who repre-

sented most of the population, were integrated into public life in a way they had never been before.

However, serious economic problems accompanied the changes, and the country became reliant on US state aid. Twelve years later, in 1964, a military junta led by General René Barrientos seized power. Barrientos, whose heritage was both Spanish and Quechua, was a complex figure; closely associated with the struggle of the Indigenous popular classes, he was also an anti-communist conservative. A stance he proved in 1967 when he clamped down on a guerrilla army led by Che Guevara – the Marxist revolutionary who had played such an important role in the Cuban revolution – in the south-east of the country. Guevara was, on Barrientos's order, executed. Guevara's death moved Sanjinés and his milieu of young intellectuals. 'We asked ourselves – an Argentine.came to die for the liberation of Bolivia. And what are we Bolivians doing?' This pivotal moment drove the group to create work that was more radical than their first film, *Ukamau.*

'Social cinema in Bolivia was born and forced in the atmosphere of struggle,' Sanjinés explained. 'The filmmakers saw history actually protagonised and directed by the people.' In those years, the movement of history must have seemed palpable. The time needed an art form to match it. The Ukamau Group were in the vanguard of the Third Cinema movement, which dominated Latin American filmmaking in the 1960s and 1970s. Across the continent, filmmakers were being swept up with the revolutionary zeal of the period, making works with deeply anti-capitalist politics at their heart, both in their content and methodology. Distinguishing themselves from 'first cinema' – what they saw as the escapist form

preferred by Hollywood – and 'second cinema' – the individualism of European, auteur-led film – Third Cinema artists celebrated collectivism. 'We wanted to make films that could move the conscience of people and government,' Eguino said. 'Because the leaders, as in other countries in the world, were so odious, so terribly harsh for minorities.'

* * *

Internationally, *Blood of the Condor* was a hit. The first Bolivian film to be released commercially in the US, it was feted by the critics, who loved its zeitgeist politics and deep sense of poetry. Selected for film festivals around the world, it won awards at the Venice Film Festival and Rotterdam's International Film Festival.

At home, the government attempted to dampen the film's reception. The Cinemateca was closed in La Paz after refusing to submit the film for censorship. Little surprise to Sanjinés that *Blood of the Condor* should be treated this way: 'Since culture is the human expression of ideology,' he later wrote, 'the destruction of culture as an agent of resistance is imperialism's favourite operation.' The following day, there was a protest in the streets, and the authorities capitulated to popular opinion – the film reopened.

But in the years that followed, the Ukamau Group frequently ran into conflict with the authorities over the undaunted gaze their films cast on the power structures in their country. Sanjinés explained that he received 'threats by phone, many times: that I was going to be killed, calling me a red bastard, that they were going to shut my mouth.' He spent seven years living in exile, along with most of the

Ukamau Group. Cameraman Felix Gomez was jailed in August 1971 for close to eighteen months.

'The new Latin American cinema did have a political impact,' Eguino tells me. 'In Bolivia, Chile and Argentina, it was very strong. People began thinking for themselves in a broader sense. That's why political filmmakers were arrested and executed . . . in Argentina, they killed them.'[2] He was arrested and detained for fifteen days himself, for having in his possession a copy of the Ukamau Group's later film, *The Courage of the People.*

When *Blood of the Condor* became popular, it prompted two inquiries into allegations that the Cuerpo del Progreso were responsible for sterilising Indigenous women without their knowledge or consent, including one from the National Congress. The inquiry concluded that the allegations were true. In 1971, in response to the findings, the Bolivian government – then led by the newly, and ultimately briefly, appointed socialist politician Juan José Torres González – kicked the US Peace Corps out of the country.

A victory.

* * *

That's the interpretation of events that earns *Blood of the Condor* a place in magazine articles titled 'Ten Films that Changed the World'. But it isn't the whole story.

[2] Here Eguino is referring to Raymundo Gleyzer, Pablo Szir and Enrique Juárez, left-wing Argentinian filmmakers who were among the thousands of 'disappeared' during the military dictatorship that ruled Argentina between 1976 and 1983: kidnapped and presumably murdered by a death squad.

When *Blood of the Condor* was complete, Sanjinés took a 16mm projector and a portable generator back to the village on the Altiplano where it was filmed, and around the local communities. It was the first time many of the people in those communities had seen a film, Eguino says, and they enjoyed certain aspects of the experience: recognising themselves, and the way they danced and played music, was a moment of pride.

But they found it hard to follow the film's narrative. Sanjinés ended up hiring a narrator to explain it before the film began. One of the aspects that made no sense to these communities was how the plot revolved around the narratives of just two characters. In making the film, the Ukamau Group had failed to grasp the lesson those local teenagers were trying to teach them when they chucked rocks at their door. They had captured the music of the Quechua, the way they danced and the costumes they wore. But their film didn't reflect how the community perceived themselves – not as a collection of individuals, but as a collective; their stories one story. The way the film identified two protagonists, whose narrative was more important than everyone else's, struck them as ridiculous. 'We had to develop a language capable of expressing a collective conception of things,' Sanjinés wrote, 'consistent with a collective culture.'

Blood of the Condor remains the Ukamau Group's most internationally acclaimed film. But on the Altiplano, they learned that international acclaim wasn't as important to them as being true to their ethics. The group had the humility, at last, to learn from what the Quechua community had to teach them.

* * *

The experience of the Ukamau Group opens up an important consideration in the role of art as a means of resistance. Many of the artworks I've discussed so far have driven change through their content, the stories they have represented and the messages they've communicated, as in the case of El General's *Rais Lebled* and *The Monkey Wrench Gang*, or they have made change directly, as *POWER* and *Project Row Houses* have. But art can also be a political force in terms of *how* it communicates, either using structures that reinforce the dominant worldview or that propose that we look at things differently. It can tell a new kind of story.

I remember well the fairy tales of my childhood, which always began *Once upon a time, in a land far away* – as if the story was already complete and separate from me. Of a few things I could be certain: a princess or impoverished yet beautiful young woman, rendered helpless by sleep or a spell gone wrong or a bite of a poisoned apple. A heroic prince or a knight, performing feats of remarkable bravery and wit to rescue her. That there would be threat, seemingly insurmountable odds – and yet, in the end, all would live happily ever after. I listened, at the edge of the day, tucked beneath my eiderdown, mind already muddling fact and story, tipping into sleep. I carried them with me into dreams: the magic castle. The enchanted rose. Eyes as big as plates.

Easy to forget them now, to write them off as childish stuff. But for many of us raised in Eurocentric cultures, such stories taught us how to see the world and understand our place within it. Aristotle pinned down the ingredients of a

great story first – in 330 BCE, he wrote that 'A whole [story] is what has a beginning and middle and end'. They must follow an arc, one neat chain of action, cause and effect – he had no time for flashbacks or digression.

This framework has governed notions of 'correct' storytelling in such cultures ever since. The Hollywood movies that I started watching before I was old enough to remember them went further. In 1949 the American writer and academic Joseph Campbell published *The Hero with a Thousand Faces*, asserting the notion of 'the monomyth' which, he held, underpinned all great stories, across all cultures – from the ancient Egyptian god Osiris to James Joyce's *Finnegan's Wake*. He summarised the monomyth thus: 'A hero ventures forth from the world of common day into a region of supernatural wonder: fabulous forces are there encountered and a decisive victory is won: the hero comes back from this mysterious adventure with the power to bestow boons on his fellow man.'

The astonishing impact of this book on popular culture led, in 2010, *Time* magazine to name it one of the 100 most important books published since 1923. Although not intended as a writing manual, the great Hollywood studios treated it as one, and for any of us raised on those movies, his blueprint is ubiquitous. I loved those celluloid tales, *Star Wars, The Godfather, The Matrix* and *The Lion King*. They taught us how to understand ourselves.

So it is that such narratives have come to seem as if they contain some essential truth – not that the stories were a paradigm placed upon the messy, muddled up experience of existence in an attempt to tame and make sense of it, but as if that is how things really are. It was to this that the Third Cinema filmmakers set themselves in opposition: a

worldview that places individuals as the heroes of our own lives, setting out on conquests at which we will triumph or otherwise. The story of heroism. No coincidence that Hollywood flourished as the United States did, bloated on the American dream – a mirror infatuated with the values this society upheld, and, in some sense, a blueprint. Consider the damage such a worldview – present in many Eurocentric cultures – is having on the globe. The Hollywood story arguably gives licence for the continuing exploitation of the natural world to feed self-actualisation; it permits the dehumanisation of other cultures, and other classes, in pursuit of personal benefit. In his book *How to Tell a Story to Save the World*, the author Toby Litt takes issue with Campbell and his ilk in unforgiving terms:

'I am not accusing the great screenwriting gurus . . . of destroying our ecosystem, [or] making us hugely vulnerable to pandemics,' he writes. 'I am accusing them of something much worse – I am accusing them of creating the people who are capable of destroying the ecosystem, because those people have a really strong motivation to do so, and because they are facing powerful antagonists . . . and because they are Heroes. I am accusing them of creating the people who, in the face of coronavirus, are selfish, irresponsible, exploitative and completely incapable of seeing why they should be otherwise, because they have seen, again and again, that only the Hero is guaranteed to survive – only the Hero counts.'

In his example, a protagonist, Paul, is driving home from a hard day at work and flicks a cigarette butt out of the

window. Perhaps the cigarette butt fizzes out in a gutter, or perhaps it starts a forest fire that burns a town – but 'once the cigarette butt is out of the moving car, it is out of Paul's story'.

If we see ourselves as the heroes of our own stories, our only responsibility is to our own plot lines. That cigarette butt is Superman destroying the Metropolis as he battles his enemy, the annihilation of the Death Star and all the men, women and children on board. It is jumping on a plane on a whim for a weekend in Malaga because you 'deserve a break'; it's buying a disposable sequinned dress made in a sweatshop because you want to look good at a party where you might run into your crush. A sequin can take a thousand years to decompose.

* * *

There are other ways of telling stories. To survive might mean seeking them out, listening to different ways of thinking through experience, different kinds of wisdom. The *Kwik-Kwak* of the Caribbean, which centres call and response between audience and teller, a process that unsettles the ownership of the story's narrative. The animism of ancient Celtic legends in which animals, plants, rocks, the wind and the water are charged with spirits. Native American tales, which may not have a beginning or end – a character's journey spanning a constellation of interlinking narratives understood only by those who are part of the community. 'Most people who hear American Indian stories translated from a native speaker will have no idea what the story is about,' writes storyteller Dan SaSuWeh Jones of the Ponca

Tribe. He refers, as well, to 'the winter count', which is common to many North American tribes: a pictorial record of the passing years, painted on cowhide, which must be read in a spiral.

For Aboriginal Australians, storytelling is cartography, a way of mapping the land and understanding its meaning. 'Song lines' or 'dreaming tracks' – as the Anglicised neologisms have them – mark paths across that vast land mass, some of them thousands of miles long. Traversing the country, elders and other trained members of the community sing the oral histories that have been passed down by their ancestors, recounting the origin myths that make up what is known as 'The Dreaming' in English – terms for it in various Aboriginal languages include 'Tjukurrpa' and 'Ngarrangkarni'. This mythological period was when the ancient gods created the land and the skies, and many of the features within it: there are stories connected to Uluru, the huge red rock at the centre of Australia; the curious, 1,000-km-long 'Morning Glory' cloud that rolls in over the north of the country each September. Each clan knows certain parts of this vast web of stories; some parts remain a secret, known only to a chosen few. The songs hold the shape of the land, and their purpose is practical as well as spiritual – they recall waymarkers and provide instruction on how to preserve ecology. In a sense, following the song lines is a way of giving the land its life, awakening the ancestors that inhabit it.

Time is understood differently here too. The 'Everywhen' is another neologism, coined to capture a temporal sensibility quite unlike the linear history familiar to Eurocentric cultures, where events pile up at greater and greater distance as they stretch back into the murky reaches of the past. Instead, this

is a sense of the continuous present: events that have happened are still happening; our ancestors, like our descendants, are with us in the now. Such thinking makes a mockery of Aristotle's neat formulation.

'Aboriginal people talk in an all-times way,' the author Alexis Wright, who is from the Waanyi nation, tells me. She considers the environment 'the world's oldest library – the land, seas, skies and atmosphere of our traditional home'. Wright came to writing fiction late – she was in her late forties when her first novel, *Plains of Promise,* was published in 1997; almost a decade passed before she published her second, *Carpentaria,* in 2006, which propelled her into the literary world's attention and won Australia's biggest literature prize, the Miles Franklin Award. Her life has been dedicated to the Aboriginal struggle for land rights, and it is significant, I think, that her move towards publishing fiction emerged from that fight, rather than the other way around. 'Writing gives me the independence to think,' she tells me, 'and ask myself questions about where we are going as people.'

She has great faith in the power of literature as we face a troubled horizon: 'It will be literature,' she believes, 'that is capable of offering more thoughtful scope, and far more imaginative possibilities, that will have the capability of transmitting knowledge to expand our understanding of how to think the realities of our future times.' The narratives in her novels are the result of growing up with an Aboriginal Australian oral storytelling tradition; often referred to by literary critics as 'experimental', betraying how faithful the international publishing community has long been to the monomyth (*Carpentaria,* it is worth noting, only found a

home with a small independent publisher after receiving many rejections). The author Tara June Winch, whose father is from the Wiradjuri nation, offers *Guardian* readers advice for how to read *Carpentaria* in her review of it: 'Tear down your calendars, disable your phone's clock, your complete understanding of before and now and after,' she writes. 'Dream and reality blend, and time bends, and everything occurred even if it never happened.' The prescription works. Initially, I struggled with the novel, too beholden to the narrative arcs I'd grown up with – it was only when I relaxed my attention and allowed it to become unmoored from the familiar spatio-temporal framework, that the magnificence of the story reared up in front of me. 'Awe' is the word, that combination of admiration coloured by fear, for it is indeed frightening to contemplate the margins of our lives dissolving, to recognise ourselves and our actions as existing in many times and places at once – at least for those of us not raised on stories like these. But it is a more accurate way of understanding ourselves too. We are at once the cigarette butt, and the person in the car driving away from it.

Listening to Wright, I think of how certain individuals from the Australian Aboriginal communities can move across land like a finger across paper, the landscape's natural features legible as sentences. This culture, it seems to me, has shored story against its ruins. In a very real sense, Wright observes how the ancestral knowledge shared within Aboriginal communities contains workable ways to survive and mitigate wildfires, such as the creation of wildlife corridors and 'cool burning'. 'The laws of the land don't change,' she tells me, 'and the stories tell us to respect that.' A vital integration of the practical, the spiritual and the creative. Here all along,

yet catastrophically ignored by the people with the means to destroy our common home.

I'm struck by how a culture that understands itself as coexisting with its ancestors and descendants must think differently about its responsibility to those generations. Wright described her recent novel, *The Swan Book,* as being written 'to the ancestors', as if they might rise, shake off the dust and take her story down from the shelves of that ancient library. One of the biggest barriers to Eurocentric cultures tackling the climate and ecological emergency is surely the inability of those of us who 'benefit' from such a system to contend with our historical privilege: how lucky we are to be alive right now. What would it mean to be in dialogue with our successors as if they were here, confronting us with the consequences of our bequeathment? Or to be accountable to our ancestors for what we've done with their legacy?

The news bulletins offer a clue that time is, indeed, out of joint. This week I saw images from Spain of people sitting on the roofs of their cars as they were swept by flash floods down the street; Tuesday was the hottest day on record, since the previous hottest day on record – Monday. But on Friday, my friend told me about a community in Wales she wants to join, where a group of people in eco-smallholdings are working on land-based self-reliance, living in tandem with nature in a way that might hold the key to our survival. The ignored future is already upon us. We are the next generation.

For artists, the question is – what paradigms do we need to enable us to make the imaginative leap into the society we want to inhabit? How can our creative inventions show

us the way? Key to creating an art of resistance is surely expanding the imaginative capacities of the audience, unpicking the ways we've been taught to think and to fight and to value, and inventing them afresh. This, ultimately, is the work of artists: the urgent work of shaping how we understand the meaning of our lives on this planet. 'We're entering the most challenging part of our times on earth,' Wright tells me. 'It's time to write the big epics of what's happening around us, and to do it in a way that people will read it.'

I admit that I struggle to grasp the full depth and meaning of the song lines, and some part of me mourns that I never will – too bound, I am sure, by the circumstances of my birth and upbringing in that Eurocentric culture. But the knowledge of it quickens something in me. That belief, again. That we make the world with the stories we tell about it. The stories we tell, and the way that we tell them.

* * *

The way we have learned to tell stories in Eurocentric cultures – from Aristotle to Hollywood – shapes the way many of us think about resistance, too. Victory is framed in terms of the monomyth: accounts of individual artists or small collectives taking on brave crusades, battling heroically and alone towards victories that represented satisfying endings. It's why we're drawn to figures like Joan of Arc and Che Guevara, whose determination and defiance of the odds set them so far apart from ordinary human experience. I admit I've been guilty of it here, too, seeking out narratives

with resolutions that neatly prove my point – that artistic acts of resistance really can have a material and demonstrable impact on the political, legal and economic structures that govern our lives.

I'm not suggesting we have to give up our heroes and the tales that have inspired us for so long. But they are also only part of the story, and, in most cases, a more realistic account of the workings of resistance would be polyphonic, woven from many voices – music for a choir, not a soloist.

I recently heard the activist Mikaela Loach speak about resistance, drawing on the image of the mycelium web: the vast network of fungi that exists beneath the earth, sometimes stretching over thousands of acres, linking trees by the roots, redistributing water and nutrients, and appearing above ground as mushrooms. She sees networks of resistance as being like mycelia, unseen but spreading widely underground. In her analogy, the mushroom that pops up above the surface is the victory, and you never quite know when – or how – it will appear. What is certain is that without that web – hidden from the human eye – no mushrooms, and no victories.

Here's a different way to think about the victories of resistance then. Not as the property of single actors or actions, but as belonging to groups of people whose lives and experiences are woven together. Earth First! took energy from Abbey and *The Monkey Wrench Gang*, but in Batheaston the protesters were also nourished by the local residents who turned up with pots of stew and bags of pasta, the school kids who bunked off to join them with placards where they chained themselves to JCBs. And the Ukamau Group's victory, as Sanjinés's introduction to his book indicated, was

just one visible manifestation of a vast sweep of social change happening across Latin America. 'There is no Hero with a Thousand Faces,' Litt writes, 'instead there are a Thousand Faces without a Hero – there are a Million Faces – there are Seven and a Half Billion Faces – without a Hero. And that is what will save us.'

To their credit, the artists themselves are often the first to give the lie to their own monomyths. Gran Fury did so in particularly bold terms. In 1988, hip Off-Broadway performance venue The Kitchen invited the group to take over the cover of their season brochure. They did so with a clear message: 'WITH 42,000 DEAD/ART IS NOT ENOUGH/ TAKE COLLECTIVE DIRECT ACTION TO END THE AIDS CRISIS'.

Art is not enough: the slogan caused much debate and anger among their peers, particularly more established artists, some of whom felt affronted, as if, Kalin says, 'it was wiping everything away, a dismissive gesture designed to say – all of your whole life of making art is not enough'. But Kalin argues it wasn't intended to be censorious. 'To me, it's "collective" that is the key word. If we *collectively* take direct action it means something different to when we do it individually . . . it is the affirmative thing of saying, "Don't be lonely in the studio, come out and join us."' And perhaps that's why an art collective could make that statement – it wasn't a proclamation against art, but rather a proclamation against the idea of art being 'enough' – enough in the sense that art could stand alone and deliver its own solutions.

The statement doesn't take away from the importance of Gran Fury's art; it simply reframes it as one strand of a

resistance belonging to many people. Their victories were part of a much bigger story: that of a network of brave gay, lesbian and queer folk, along with their allies, who refused to stay quiet in the face of homophobia that was leading to their deaths. Those who stitched the quilt. Those who offered a hand or a hug when so many backed away. Those who [Kalin] 'brought the ashes of the person they loved and dumped them on the doorstep of the fucking White House'.

* * *

After *Blood of the Condor,* the Ukamau Group began to do things differently. Their next film, *The Courage of the People* (*El Coraje del Pueblo*), recounted the terrible events of 24 June 1967, when miners and their families in San Juan were celebrating the Winter Solstice festival. Early in the morning, soldiers from the Bolivian military surrounded the group and opened fire, killing more than twenty people. President Barrientos ordered this act of staggering violence, because he believed a new guerrilla force was forming in the area.

Created with survivors and witnesses of the massacre, the Ukamau Group now saw their purpose not so much as artists bringing to life their own creative vision, but as a lens bringing into focus a film that already, in some sense, existed in this community. There are no heroes here. The film's protagonist is the collective, reflecting the polyphonic history of the massacre and the way the area's Indigenous communities understood stories about themselves. They shot the film in the locations where events actually occurred; the script was based on the memories of those who had been there, and

the performers – themselves survivors and witnesses – performed freely, improvising without direction. For all the content is brutal and unrelenting, the message, in the end, is one of the power of memory, to assert the truth.

Ultimately, creating art with, and of, the people had its own political potency. 'The enemy knows that to strip a people of its culture is to disarm it,' Sanjinés wrote, 'and that, oppositely, a people with a national identity, with its own conceptions and means of resolving reality, is a potentially dangerous enemy.'

The Winter Count (photo by Witold Skrypczak/Alamy)

PART II

Crimson paint-splattered crosses in a churchyard of newly dug graves. *Waiting for Godot* in a bombed-out theatre, its foyer full of rubble. A cartoon slipped in a soldier's pocket, musical notation on toilet paper, chalk murals on the school wall, Albinoni on the cello where the shelling happened. Acrobats in the displacement camp. The song in the gas chamber.

I have returned to these moments and images again and again while writing this book. They are taken from the stories of artists on the front line and under siege, enduring the very worst manifestations of war. Artists who – even under the gaze of the sniper's crosshairs – have persisted in creating, bringing considerable risks to themselves as they forcefully reject the attempt to dehumanise them. I am fascinated by these brave artists, by the extraordinary reserves of fortitude they have drawn upon in order to keep going. To understand their stories has seemed to me of critical importance in understanding the value of art as a means of political resistance. Even though, for someone who has led a comfortable life in a country that chooses to wage its wars in foreign lands, what it was really like must necessarily evade my grasp.

Researching these stories, the questions that have preoccupied me are: what motivated these artists to create, even with the odds so heavily stacked against them? What was so important about their art that it was worth risking their lives for? The answers are not simple. Previously, I have written about artists and artworks that have driven towards transformation, whether independently or as part of collectives. Many of their actions have resulted in victory. But the art of resistance takes

on a different significance in the context of war. These aren't stories of triumph, at least in the sense that the history books teach us to think about it. These artworks didn't change the battle's outcome. Their power is of a different order. In the following pages, I attempt to understand that power by telling some of these stories in depth. The accounts that follow are about the many ways the creative act of resistance makes meaning for a life under siege.

Chapter 5

THE ISLAND

Jersey, 1940

The planes came to Jersey on 28 June 1940.

I picture Claude Cahun in the garden of La Rocquaise, her home in St Brelade's Bay. Tanned in her swimsuit, her close-cropped hair beginning to grow out in curls. She might have been for a swim that day, stepping out of the back gate and down to the beach, footprints fading in the damp sand behind her. Or maybe she'd spent time with her partner, assembling one of their impromptu sculptures with flotsam gathered at the shoreline. She often posed for photographs then, leaning in a doorway or balancing on the wall, playfully dressed up in a wig or some other disguise.

At that moment, though – the early evening, still hours of sunlight to be wrung from the high summer day – she was on a towel on the lawn with a hose in her hand. A sparkle of water carving an arc over the plants in front of her.

'The illusion of holiday without end. A garden already in flower.'

A rumble in the sky. She looked up at the underbellies of the machines overhead, wings tipped with black crosses. The

bombers came so close that she could make out the faces of the pilots. A moment later they were gone. Then – smoke on the horizon. The sky trembled. Something shattered. Eleven people dead, she learnt later. It was the end of the illusion.

* * *

Facades, disguises, tricks of the eye. Cahun was a surrealist, and she created art that was full of them. In self-portraits or portraits taken by her collaborator, Marcel Moore, her face appears over and over – here she is, androgynous in white face paint, hearts for cheeks and lips, her pale body framing a mask that fixes the viewer with a blank stare. Here she is, Buddha, painted gold. Here, her head in quadruple, disembodied beneath a cloche jar. An arched eyebrow: 'or is it?'

Cahun, who was born Lucy Schwob in Nantes on 25 October 1894, has been described, in recent years, as 'the first female surrealist artist'. The moniker would no doubt have made her bristle. Not solely because the tendency to view 'female' as a professional categorisation of its own is so irritating – although it is – but because she didn't think of herself as female at all.[1] She started using her male alter ego, 'Claude Cahun', seriously in 1919, signing off her various literary and journalistic works with what she saw as her 'true name rather than a pseudonym'. She wrote of her gender:

[1] She may well have rejected the gendered pronouns I'm using, if using gender neutral pronouns had been common in her time as it is today. She did, however, use 'she/her' to describe herself during her lifetime, so I've chosen to follow that here.

'Shuffle the cards. Masculine? Feminine? It depends on the situation. Neuter is the only gender that always suits me.'

She returned to the theme again and again in her work. In one of her most celebrated self-portraits she appears with a dumbbell of the type favoured by circus weightlifters. Her short hair is coiffed into a masculine style, but her nipples are painted on her shirt with dark paint and her lashes are clownishly long. 'I AM IN TRAINING, DON'T KISS ME', read the words scrolled across her chest. In training for what, the viewer wonders – Cahun offers no easy answers.

She and Moore spent most of the 1920s and 1930s in Paris, wrapped up in the giddy Left Bank cultural scene. She complemented her photographic output with a number of experimental literary works, often reclaiming fairy tale and mythical heroines, retelling their stories with a feminist twist. She wrote articles for newspapers and literary journals. She loved the theatre, too, performing roles in numerous avant-garde productions. Photos of her performances would, in turn, be chopped up and appear later in her montages. She had as much fidelity to the confines of one artistic form as she did to the confines of gender, slipping elegantly between them from one day to the next as her self-expression demanded.

* * *

In March 1937, she and Moore left Paris behind and moved to Jersey, an idyllic British holiday island situated off the north coast of France. Cahun spoke of her 'physical and primordial need to live in the countryside'. In truth, though, it was the dark elements coalescing in mainland Europe that

drove them to flee the trembling city of light. Cahun was Jewish, and as she witnessed growing anti-Semitism in France, her thoughts turned to the serene spot where she'd been holidaying since childhood.

For the first few years, the illusion held. The pair fell in love with La Rocquaise, a farmhouse next to the church at the end of the golden crescent of St Brelade's Bay. Moore's mother had recently died, leaving an inheritance that enabled them to buy it. 'It seemed that the only thing left was to become familiar with the trees, the birds, the doors, the windows,' Cahun wrote of those endless days. 'Pulling from the clothing trunk the appropriate article, short or long, to dive into the sun and the sea.'

Who wouldn't envy that life, unbounded summer spreading out in that perfect place, living just as they pleased? The walls of the house filled up with artworks by the surrealists they admired: Max Ernst and Joan Miró. Their time was taken up with swimming, making art or taking their cat, Kid, for walks. Often Cahun spent the afternoons reading and writing, while Moore took charge of domestic arrangements.

They cut a curious silhouette on St Brelade's sands, these two. Dressed in trousers, hair dyed, unwilling Kid pulled behind them on a leash. They kept the true nature of their relationship secret. Cahun and Moore, whose families were friends in their childhood, had fallen in love while still in their teens. Their parents' marriage (Cahun's father to Moore's mother) in 1917 gave a legitimate veneer to a romantic partnership that was to last the rest of their lives. They lived together as stepsisters. Jersey local Bob Le Sueur, who was a teenager when the war broke out, told me he'd heard rumours that if you climbed on the hill behind their house, you could sometimes spot them sunbathing naked.

The war followed them to Jersey, in the end. As the Allied campaign teetered on the brink of collapse, in June 1940, the British government decided to demilitarise the island, evacuating boatloads of citizens. But when the last ships for the mainland disappeared over the horizon, Cahun and Moore remained.

No defence of the Channel Islands was mounted. As instructed by the Germans, the islanders signalled their surrender, hanging out ripped bed sheets and tea towels. Cahun and Moore laughed at the absurd sight of the white flag the rector erected amid the tombs in the churchyard that bordered their garden. As if even the dead had to demonstrate their lack of intent to rise, take up arms and go to war.

* * *

A single photograph from the occupation remains in Cahun's archive. Kid in the window, the beach beyond. On the sand are eleven figures in inky silhouette. German soldiers.

They cast a long shadow over the war years in St Brelade's Bay. Early on, they took up residence in the hotel a few moments' walk from La Rocquaise. Services were held for them in the church next door. As the months went by, they began to bury their dead here. Sometimes, after a funeral, the Germans found new wooden crosses planted in the freshly dug earth, emblazoned with white text: *Fur sie ist der krieg zu ende.* 'For Them, War is Over'. The crosses were splattered with crimson.

If the soldiers had looked closely at the unassuming, middle-aged spinsters who lived in the house next door, would they have spotted red paint stains beneath their fingernails, or scuffs on their knees from where, at night, they'd clambered over the cemetery wall? But they never

had any reason to look closely. Nor did they connect them with the banner that had appeared above the altar when they arrived, one Sunday, for worship: *Jesus is great but Hitler is greater; Jesus died for us but we must die for Hitler.*

Cahun and Moore had acquired a new disguise. Dressed in wellies and headscarves, they looked like ordinary Jersey farmers' wives, little different to the other inhabitants of the island. After years of shrugging off the confines of female gender norms, Cahun was alert to the irony of the fact that this normative attire was now her redoubt. This was role play of a new sort, rather different to the days when she'd dressed up for a night out with the surrealists in Paris, her eyes made up extravagantly, head shaved and painted pink or gold. Now the pockets of their Burberry macs jangled with coins decorated with the words *Nieder Mit Krieg/Down With War* as they headed for the local amusement park – they went on the rides and left the coins lying about for off-duty soldiers to find.

Their resistance had begun with a small act of subversion. In the early days of the occupation, Cahun kept turning a phrase over in her mind. *Lieber ein Ende mit schrecken als Schrecken ohne Ende/ Better an end with terror than a terror without end.* She read it in a magazine – apparently it had been popular among German citizens in the 1930s as they watched the Nazis grab power. She stripped it back until she was left with two words: 'Without End'.

Bleak as it was, the adage, she thought, contained a truth. She knew that the people who suffered on both sides were not those pushing chequers across maps in war rooms as if wrapped up in a game of tin soldiers. Instead, it was the working-class families whose teenage sons would never return

from the front line, whose homes were bombed and livelihoods destroyed. Nothing, for them, would ever be the same again. She believed in 'the perpetual distance from definitive victory'. A war stains history, reverberates across time. *Ohne Ende.*

Cahun and Moore graffiti-ed their slogan on nearby walls and buildings, scribbled it in purple crayon on empty cigarette packets the soldiers were likely to pick up, looking for tobacco. That was the first act. Over the years that followed, they mounted a quiet, concerted artistic resistance that nearly cost them their lives.

* * *

The activism that Cahun and Moore undertook on Jersey holds a particular relevance in this book, because it was part of their practice as surrealist artists. Cahun always spoke of their resistance not as something distinct from their art, but as the ultimate expression of it.

In the 1920s and 1930s, the Paris-based surrealists had maintained a fraught relationship with the French Communist Party (PCF), sharing the same political aims in principle, but at odds about how to achieve them. Cahun weighed in on this debate when, in 1932, she became a member of the Association des Écrivains et Artistes Revolutionnaires (Association of Revolutionary Writers and Artists – AEAR), a network of communist artists and writers united in the fight against fascism. There, she proposed the creation of a 'poetry section' of the movement. Many members were opposed: poetry seemed to be the most bourgeois of art forms. Marxists liked art that was more to the point – the preferred style was social realism.

Cahun, however, warned against the risks of art becoming purely propagandistic. She drew a line between consciously political writers, particularly journalists, and poets, who 'act in their own way on men's sensibilities. Their attacks are more cunning but their most indirect blows are sometimes mortal.' Later, she left AEAR and, in 1935, became a founding member of another group, Contre-Attaque (Counter-Attack), along with Georges Bataille and André Breton (surrealism's co-founder and 'high priest'). A political group defined by its opposition to patriotism and its championing of violent, popular uprising, it was also founded on surrealist principles. As Bataille wrote: 'We are now convinced that force results less from strategy than from collective exaltation and exaltation can only come from words that do not touch reason but rather the passions of the masses.' Short-lived, the group was dissolved in March 1936. A year later, Cahun and Moore left for Jersey.

Cahun and the surrealists, like so many artists throughout history, were thrashing out the matter of whether and how art can change the world for the better. But on Jersey, far removed from the internecine struggles of Breton and his milieu, Cahun no longer had the luxury of contemplating this as an intellectual exercise. History was upon them, then, so they had no choice but to bring their art to the fight – because their art was what they had to fight with.

'I struggled with all that I had,' Cahun later told a friend, 'beginning with surrealism.'

* * *

In a photo taken in 1947, The Soldier with No Name appears as a debonair chap, dressed in boots and a smart military

jacket unbuttoned to the waist, with an ironic smile and a cigarette perched between forefinger and middle finger. But the image is double exposed; he's fading and a background of military tombstones is overtaking him. A tiny skull casts its shadow at the edge of the frame. In another photo from the same period his uniform, now buttoned up, is indistinguishable from the dark bush behind him – he seems to be disappearing, but for a white mask devoid of expression, two hands clasping it in place, a gesture borrowed from Munch's *The Scream.*

Assuming an alter ego was a fine surrealist tradition. Just as Max Ernst had Loplop and Marcel Duchamp had Rrose Sélavy, Cahun had The Soldier with No Name. An emissary from the dead, the character Cahun took on to pursue her resistance activities was just the opposite of The Unknown Warrior buried at Westminster Abbey after the First World War, in tribute to those who had given their lives for their country. Cahun's soldier reviled patriotism; he was intent on stirring up trouble and mocking the authorities that had sunk so many soldiers into the ground.

Cahun and Moore conceived of The Soldier with No Name as the head of a fictional resistance movement on the island. Their target was the German soldiers, many of whom, they felt sure, they could inspire to desertion if they could convince them of the existence of an underground network that shared their views. Throughout the war years, their tactic was to let loose an unrelenting barrage of antagonism and ridicule on the occupying forces. Taking on this alter ego gave Cahun courage, helping her imagine the interior life of the soldiers they intended to convert. 'He was more qualified than I to know what must be done,' she later wrote.

Cahun and Moore knew that the German soldiers could not access news of the war's progress. They had kept an illicit radio – a crime punishable, from 1942, by death – and they decided to create their own news service for the German soldiers. She would listen to broadcasts from the BBC and create inventive flyers conveying the news – 'manifestos, slogans and short dialogues', which Moore would then translate into German. Cahun and Moore intended to undermine the information the soldiers received via Nazi propaganda. Other tracts contained poems and cartoons, collages spoofing German illustrated magazines, or the apparent confessions of dissenting soldiers. The documents were signed by *The Soldier with No Name*.

In town, they'd mingle with the crowds, sliding their tracts into pockets and shopping bags, or they would stash them in empty cigarette boxes, or drop them in the letter boxes of German officers. They loitered in newsagents and secreted their collages between the pages of German illustrated magazines before replacing them on the shelves. On service days at the church, they left them on the windscreens of German cars.

Most of the pamphlets have vanished now – only forty-five remain in the Jersey Archive. The tracts are full of terrible puns and cheap gags. One poem features a brave German soldier returning home to discover his wife is pregnant by another man's child: 'The Fatherland needs soldiers!'. On another occasion, Cahun and Moore created an illustrated magazine that seems to have been an extended spoof on the name of Jersey's Field Commandant, Colonel Knackfuss, which translates as 'tired feet'.

These playground cracks could have been made by any one of the German soldiers. What mattered was that they

were being made at all. The surrealists knew that humour can be a powerful tool in unlocking the subconscious. If the soldiers laughed, that laughter might have revealed – before their conscious brain had recognised it – that the authoritarian cause they were fighting for was ridiculous.

I'm particularly stirred by a pastiche of the final verse of the classic German poem *Die Lorelei* by Heinrich Heine, which tells the story of a mermaid who lures seamen to their deaths. In Cahun and Moore's interpretation, the verse is accompanied by a crude stick-figure soldier with a Nazi flag, who stands on the prow of a boat disappearing beneath a stormy sea.

I think at last the waves devour
The boatman and his boat;
And that, with his roaring power,
Adolf Hitler has done.

I do not know if Cahun wrote her poem before or after a tragic incident that occurred along the coast at La Rocque. Four German soldiers were seen standing on guard on a rock as the tides rose. Local people shouted a warning, but the soldiers would not give up their watch. All four drowned. When the tides retreated, their bodies were discovered, rifles still tightly grasped in their hands.

* * *

Under occupation, the island became a prison, five miles long and nine miles wide. Fuel shortages meant the only way to get about was by bike or on foot; clothes became ragged. There wasn't enough food to go around. With malnutrition came

exhaustion and disease – diphtheria, TB and whooping cough. Not only the coastal watchtowers and the volatile Channel confined the islanders. The regime thrived on paranoia; the knowledge that anyone you met might be a potential collaborator, ready to give you up to the authorities. Even minor crimes could result in a death sentence. Cahun had declined to register with the authorities as Jewish, but she and Moore knew Jewish people were being deported from the island.

Outside their window, prisoners of war and enslaved labourers from across Europe and North Africa were being put to work on the beach. They were clearly starving. Cahun and Moore smuggled small gifts to them – chocolate, a pair of socks – even though they had little themselves. They built a rapport with one prisoner in particular, who would occasionally sneak into their kitchen, where they would feed him what they could. Such offences were punishable by death. Then again, so was owning a camera, owning a radio, and certainly distributing magazines containing bad puns on the names of German colonels.

The soldiers were starving too. The islanders saw them begging for food; cats, dogs and rabbits started to go missing. One night, someone broke into La Rocquaise and stole all Cahun and Moore had to eat. For eight days after, they ate nothing, surviving on milk. Many such thefts were carried out by the prisoners under the direction of the German officers.

Cahun only cried once throughout those years. Out walking one day, she witnessed two Russian prisoners dying in the middle of the road as German soldiers passed by, ignoring them. They were so hungry, she learnt, that they had eaten grass that poisoned them. The other prisoners loaded their corpses into a wheelbarrow and carted them off. Later, in prison, she wrote, 'The understanding of history doesn't

prepare you for the emotional reality of history. It doesn't even prepare those with imagination.'

In late 1941, La Rocquaise was requisitioned by the German authorities. Four soldiers and their officer moved into the west of the house, keeping their horses in the outhouse, while Cahun and Moore remained in the east of the building. This might have ended their activities, but Cahun and Moore kept at it. Their very audacity was a cover: the authorities couldn't conceive that what they'd been duped into believing was an extensive resistance movement was essentially an extravagant performance art project executed by two spinsters, right under their noses. Louise Downey, registrar at the Jersey Cultural Archives, estimates that Cahun and Moore distributed around 3,000 distinct pamphlets and tracts over the four years of the occupation.

Once, The Soldier with No Name issued an invitation to a meeting in the caves at Plemont Bay. Cahun and Moore had borrowed the typography and phrasing of a genuine Nazi gathering; only a few words were changed, and a signature was added from The Soldier with No Name. The meeting, of course, was never intended to go ahead, but Cahun imagined the havoc that might be caused by the authorities seeking the source of the missive and placing the remote, dangerous caves under surveillance.

We will never know if anyone turned up. But I like to imagine them gathering in the quiet dark of the caves, the adrenaline of dissent thudding in their hearts.

* * *

The woman from the stationery shop, they suspected, gave them up to the authorities. The paper they used for their

tracts was very thin – perfect for rolling up and secreting in the pockets of unobservant passers-by, but also, it transpires, quite unusual. It wouldn't have taken much to connect the seditious literature appearing all over the island with the two sisters purchasing the onion skin sheets in bulk.

One evening in July 1944, just as they were finishing dinner, the Gestapo arrived at La Rocquaise and arrested Cahun and Moore. The pair were unfazed: the only surprise was that arrest hadn't come sooner. The Gestapo had been searching for them for two years, interviewing everyone on the island who could speak German – Moore had never registered as a German speaker – but was unable to countenance the idea that the resistance movement they were chasing wasn't a sophisticated network of tens or hundreds, but two middle-aged ladies living in the pretty house at the end of the bay. For a long time, they had assumed that the dissent came from their own ranks, so accurate was The Soldier with No Name's impersonation of a German soldier.

Moore smuggled twenty barbiturate tablets out of the house. In the car on the way to prison, they managed to swallow them. The suicide attempt was, perversely, to save their lives. As they lay in a coma at the prison in St Helier, too unwell to be moved, the last ship of detainees departed from Jersey for France, from where they were taken onwards to the concentration camps.

The pair recovered, but several months passed before they were brought to trial in November 1944. Found guilty of producing propaganda that undermined the morale of the German forces, they were sentenced to death. They were also sentenced to six years in prison for possessing a radio. It was characteristic of Cahun that she responded to the

sentence with a grim sense of irony: 'Are we to do the six years before we are shot?'

Invited to sign a plea of mercy, they refused. 'It would have been their idea of the ultimate act of defiance,' Downey told me. They were sent back to prison to await their execution.

Cahun and Moore secretly kept notes throughout their incarceration which, after the war, Cahun used to write a long narrative of that time, held now at the Jersey Archive (in fragmentary form, as numerous pages have gone missing). She recounted the months in prison in characteristically vivid detail, conveying an 'atmosphere of schoolboy cheerfulness in our prison, in spite of the rigours of the cold, the hunger and the threats'. Against the backdrop of executions and near starvation, Cahun offers pinpricks of light: singing 'For He's a Jolly Good Fellow' to those released from prison. The yellow ribbon she ties around her wrist to wave out of a raised window to friends in the neighbouring 'civilian' prison who cannot see her face, so they would recognise it was her.

Cahun and Moore formed friendships in prison with both German deserters and their prison guard, Otto, who seems, in Cahun's telling, ill-suited to his role. Although young, he takes an almost paternalistic interest in Cahun's wellbeing, fretting when she is ill and refuses food. These encounters must have bolstered the pair's refusal to make enemies, automatically, of those whom circumstance had placed on the opposite side in the conflict. 'I am unable to trust morals,' Cahun wrote in her diary. 'I can only trust people. I know what the wind makes of people but, in order to live well in the wind, you have to resist the collapse of people. I can only trust that – bad or good – this man, this woman, resists with

me ... I want humanity, in all its perspective, to determine values, proportions and just actions.'

One of the German soldiers imprisoned with them reported that he had seen Cahun and Moore's tracts and taken heart. 'After all the political plans he most candidly expected us to make for the liberation of Jersey, [he gave] his assurance that he and his group would carry them out,' Cahun wrote. 'He had already told us that there was no more than one percent of the soldiers on the island who were willing to fight and that there was a conspiration, he took part in, to get hold of the officers and disarm them.' Cahun and Moore's pamphlets had given this soldier the courage to desert, even on that isolated island, with nowhere to run. The officer in charge of their trial was right when he told them, as Cahun recorded, that: 'We had used spiritual arms instead of firearms, something which, according to him, was more serious because with firearms one could measure the amount of damage done whereas with spiritual arms one could never know how far the damage had spread.'

On 9 May 1945, the island was liberated. Cahun and Moore's execution day never arrived. They were free.

* * *

And I saw new heavens and a new earth, reads the gravestone where Cahun and Moore are buried alongside one another, in the churchyard of St Brelade's. A line from the Book of Revelation, it makes for a fitting epitaph. What united these two, even in the darkest moments of their lives, was their belief that a better existence was possible. They never lost sight of that vision.

Cahun's health had significantly deteriorated during the war. She died in 1954. Moore outlived her until 1972, suffering from arthritis, when she took an overdose and ended her life. The final years of their lives had passed quietly; while they had thoughts of returning to Paris and their surrealist milieu, they never came to pass.

A doctor who had known the two commented that 'except for a few close friends, [they] passed unknown and unrecognised for [their] brave attempt to defy the great German Reich.' It was only in the early 1990s that the story of their resistance activities emerged into the public psyche, after French critic François Leperlier, undertaking research into the obscure surrealist artist on Jersey, placed an advert in a local newspaper and was contacted by a member of the community who had purchased boxes belonging to the pair in a house clearance after Moore's death in 1972. Inside, he found hundreds of photos and writings from the war years. History, by then, had finally begun to catch up with the way these women lived half a century previously: Cahun was embraced in the context of queer studies.

It's hard to comprehend now, in an era of performative activism, what it was like to spend the war years in the anechoic chamber of the occupation. Risking their lives to issue those secret messages, hoping that they would land with someone. But while they nurtured their wish that they would persuade some of the soldiers who encountered their tracts to desert the German army (as they did), their resistance was also about maintaining their integrity – their sense of self. From Cahun's experiences of anti-Semitism and the queer relationship she and Moore had committed to in their teenage years and sustained ever since, these two had always been outsiders, at odds with the status quo. How easy it would be to feel down-

trodden by that, in a society intent on silencing people just like you – instead, they made it material, the substance of their creative expression. As historian Jeffrey H Jackson notes in *Paper Bullets,* his account of Moore and Cahun's resistance, 'fighting the German occupation of Jersey was the culmination of lifelong patterns of resistance, which had always borne a political edge in the cause of freedom as they carved out their own rebellious way of living in the world together.'

The idea that they would now, in the context of the occupation, adopt a position of meek acquiescence was intolerable. For Cahun, their resistance was essential to their survival, despite the enormous physical danger it placed them in. She realised how contradictory this outlook was; as she wrote to a friend after the war: 'The only thing that made me happy was my papers, my madman's project. I cannot convey to you what this project was to me . . . a torment, certainly! But at least I was taking action; it was an open door, a hope, at the same time it was an obsession.'

Claude Cahun (photo by Claude Cahun/Alamy)

Chapter 6

THE SIEGE

Sarajevo, 1993

'TO THE ARTISTS OF THE WORLD: You bastards! We challenge you to make a real piece of art. Come to Sarajevo and make your masterpiece here in the center of the world, in the most significant city on this planet. Move your fucking asses and make something real. Raise your voice against fascism, save some human lives, feed the soul of the people in pain, tell the world that aesthetics is nothing but a lie if the art cannot face the terror of the so-called civilization at the end of the twentieth century. You bastards! Don't be stupid! Stop making excuses! Don't let the art sink in shitty conformism. You dear lovers, our only allies, you lonely riders! Come to Sarajevo. We can make it!' – *The Sarajevo Artistic Survival Group*[1]

In April 1992, Sarajevo had become a prison. The war had begun as Yugoslavia splintered with the demise of the USSR

[1] Fax sent to Susan Sontag by Haris Pašović, held in her archive at UCLA.

from 1989; when Bosnia and Herzegovina's population voted for independence in February 1992, Serbian nationalist forces (the Chetniks) retaliated, attempting to seize land within the republic in the name of the Bosnian Serb population. The fighting reached Sarajevo on 5 April. The Chetniks encircled the city, cutting off supply lines and setting up snipers in the surrounding mountains, from where they shot at the people in the streets far below with pinpoint accuracy. There were few places of safety for Sarajevo's citizens, who had almost no way to get in or out of the besieged strip. At the height of the siege, an estimated 3,000 shells fell on Sarajevo each day. It was to be the longest siege in modern history.

Susan Sontag first visited a year later, in April 1993. A public intellectual, critic, author and director, she was, like Cahun and Moore, preoccupied with questions about the role of art, and her own ethical responsibilities. Her intellectual reflections on these matters collided with reality in the besieged city of Sarajevo. During her trip, she was introduced to Haris Pašović, a dynamic theatre practitioner and then director of the MESS International Theatre Festival, who, at thirty-one, had established a reputation as one of Yugoslavia's foremost cultural figures. When the war broke out he was living away from Sarajevo; desperate to get back to his mother and sister, he tried for more than a fortnight to get on a UN flight or find another route into the city.

Eventually he succeeded. The runway at Sarajevo International Airport was one of the most volatile points of the battle. It was closed to civilian air traffic and under constant bombardment, but one of the few ways to escape the siege was a desperate sprint across the tarmac to the free Bosnian territory beyond.

Thousands of people attempted it; many were killed. But Pašović ran in the opposite direction. He threw himself against the tide and risked his life to get back in.

Pašović invited Sontag to return to the city, to direct a play in the festival. She initially suggested Samuel Beckett's *Happy Days*. Pašović replied: 'But Susan, we are waiting.'

* * *

Waiting for Godot, Beckett's most famous play, could have been written about the besieged city. In *Waiting for Godot*, two dispossessed characters, Vladimir and Estragon, meet by a tree on an unnamed road, waiting for the arrival of an enigmatic figure called Godot. Who Godot is, and why they are waiting for him, is unclear – seemingly even to the characters themselves. All that is certain is that they are waiting.

Pozzo arrives as they loiter, with his slave Lucky on a leash. After passing the time, Pozzo makes Lucky 'entertain' Vladimir and Estragon by delivering a fast-paced, long and perplexing philosophical speech about divine apathy. Then, towards the end of the first act, the Boy arrives and informs Vladimir and Estragon that Godot will not be coming today. The following day, they meet again, and the action happens all over – only everything has got a little worse.

'It did seem to illustrate a lot of the things that people are feeling now in Sarajevo,' Sontag later reflected. 'The play is about weak, vulnerable, abandoned people trying to keep their spirits up while they wait for some greater power to help them out.' Estragon and Vladimir could have been any of them, grown accustomed as they had by then to eking out a paltry subsistence on whatever odd vegetables and humanitarian

handouts they could lay their hands on, and spending their nights being assaulted by faceless aggressors. The Boy, who arrives to tell them that Godot 'won't come this evening, but surely tomorrow', might just as well as have been the French President François Mitterrand, who had visited in June 1992, bearing reassurances that led the citizens to hope for an imminent military intervention that never materialised.

Sontag returned to Sarajevo to direct the play in July 1993, taking up residence at the Holiday Inn, a vast yellow Lego-block construction erected on the edge of the town centre for the Sarajevo Winter Olympics in 1984. Like the international journalists who used the hotel as their base, she stayed in the rooms at the back: those at the front were too dangerous, exposed to shelling from nearby Mount Trebević. The BBC journalist Allan Little was a fellow resident at the hotel, and once visited a Serb gun position on the front line. 'Can you hit the Holiday Inn from here?' he asked one of the machine-gunners. 'Hit it? Pick a window,' the man replied.

Her walk to rehearsals each morning took her along 'Sniper Alley', the exposed stretch of road from the airport to the town centre, where the walls of burnt-out buildings bore bloodstains and hand-painted signs carried an ominous imperative: *Pazi – Snajper!* ('Watch out – Sniper!'). The Bosnian forces had lined some of the exposed parts of the street with shipping containers to provide cover from the Chetnik crosshairs. At other points, the UN would come by in armoured vehicles, travelling slowly, and you could walk in the scant shelter of their shadow.

She met her cast each morning at the Sarajevo Youth Theatre, picking her way through the rubble that filled the

foyer to make her way to the small studio where they gathered. They numbered nine altogether, an ethnically mixed cast reflecting the city's make-up – Bosniak, Serb and Croat. Some of Sarajevo's finest actors were in the room. The thespian grande dame Ines Fančović, a regal figure with bright white hair and kohl-rimmed eyes, was famous to TV viewers across Bosnia for her appearance as Mara in *Memoirs of the Milić Family*. Alongside her were Velibor Topić, who has since had roles in Hollywood blockbusters such as *Snatch* and *Kingsman: The Secret Service*, and Izudin Bajrović, now the artistic director of the Sarajevo National Theatre.

Each day, Sontag presented them with bread rolls that she had smuggled out of the Holiday Inn's restaurant, a little stale, but still edible. They took them gratefully. After many months of living under siege conditions, they had all grown thinner. Sontag was highly aware of exactly what she was asking of her actors. The streets were the most dangerous place to be in Sarajevo: every time they left their house in the morning to attend rehearsals, they would be hazarding their lives. Some faced a walk of more than two hours to reach the theatre, and the same on the way home. In just a month, they would be asking their audiences to risk their lives too.

Yet, despite the risks, a considerable number of cultural events took place during the siege. The people of Sarajevo may have been desperately short of most of their material necessities, but they could catch a string quartet performing Mozart or watch a screening of an arthouse film. ARS AEVI, a museum of contemporary art, was established in July 1992 – world-renowned artists and gallery directors including

Marina Abramović, Nan Goldin and Anish Kapoor contributed work to the collection as an expression of solidarity.

On 27 May 1992, twenty-two people had been killed by a shell while queuing for bread in Vaso Miskin Street. In the days following the shelling, the strains of Tomaso Albinoni's *Adagio in G Minor* could be heard there, soaring above the sound of gunshots and rocket fire. The cellist Vedran Smailović, clad in his dinner jacket and bow tie, played for twenty-two days straight at the spot where they died. Later he would take his cello to the wreckage of Vijećnica, and to the graveyards where those killed in the conflict had been buried – exposed positions where he risked his own life to play. In the besieged city, the notes emanating from Smailović's strings came to signify something bigger than themselves.

As for theatre, *Waiting for Godot* was just one of many productions that received a premiere during the siege. The Sarajevo National Theatre, Chamber Theatre 55 and the Sarajevo Youth Theatre, where *Waiting for Godot* was performed, all continued to operate, and a brand-new venue – the Sarajevo War Theatre – opened its doors in May 1992. According to Nihad Kreševljaković, current director of the Sarajevo War Theatre, it was 'probably a unique institution in Europe, the first place where, in war conditions, someone founded a theatre'. What was it that made starting a new theatre seem so urgent? 'When the government announced they were funding the Sarajevo War Theatre, they wrote that they were funding it because of its importance for the defence of the city,' he said. 'I found that very inspirational. It's a reminder that the role of artists is to defend the concept of civilisation. We are probably the last line.'

To defend the concept of civilisation – that would no doubt have spoken to Sontag. There's a photograph of her taken by her partner, the celebrated photographer Annie Leibovitz, who had accompanied her to Sarajevo. It shows Sontag amid the rubble of Vijećnica, the City Hall and National Library, which was bombed in August 1992. She crouches on a rock, shoulders forward, one wrist grasped in her other hand, a guarded posture. Her face is framed by her black hair, with its trademark flash of white. An oversized shirt is thrown on over a polo neck – clothing for getting work done.

Two million books and countless precious artefacts were destroyed when Vijećnica burnt down. Leibovitz's photograph embodied an idea that was crucial to Sontag's understanding of the conflict – that here in Sarajevo, not solely lives, but also ideas and culture, were under attack. Culture was also playing a vital role in the city's resistance, and this fascinated her. 'Culture, serious culture, is an expression of human dignity,' she wrote, 'which is what people in Sarajevo feel they have lost, even when they know themselves to be brave, or stoical, or angry.'

Many of the cast viewed their involvement in the play as a necessary survival strategy despite the challenging circumstances. No one was getting paid to be in Sontag's rehearsal room. Nonetheless, it was vital to them that they persisted, to maintain some semblance of normality. Of course, they all had to attend to the arduous, energy-sapping business of fetching water each day, trying to find a little firewood, enough to eat. But as Fančović told a reporter from the UK trade newspaper *The Stage* at the time: 'If I didn't work almost every day I would find it very difficult to live through this

war. The shelling and the death of many friends so far has shaken me, but acting helps me forget.'

* * *

After a few days working on the script, Sontag's actors moved out of the studio and into the theatre. The rehearsal process wasn't easy. In the gloom, disorientated by hunger, the cast struggled to master the famous hat-swapping routine – dropped bowler hats rolling off into dark corners of the wings. As soon as there was a break in proceedings, the actors would immediately lie down on the stage, attempting to conserve what little energy they had. Progress was further slowed by the fact that few in the cast spoke English, and Sontag spoke no Bosnian, so all of her notes had to be communicated via an interpreter. In contrast to the tendency for directors to downplay the emotion in Beckett's drama, Sontag encouraged performances 'full of anguish, of immense sadness, and towards the end, violence'. For Lucky's notoriously incomprehensible speech, she directed Admir Glamočak to deliver it as if it made perfect sense. 'Which it does,' she wrote, 'especially in Sarajevo.'

She had a relaxed attitude in the matter of fidelity to Beckett's text and stage directions. Early on she had decided on a staging that would feature three pairs of Vladimirs and Estragons: a pragmatic choice apparently rooted in the fact that there were many good actors in Sarajevo keen to be involved, and too few roles for them to play. It was not the only liberty she took. The casting, for instance, was gender-blind, reflecting her belief that the characters are intended as allegorical figures: 'If Everyman (like the pronoun "he")

really does stand for everybody – as women are always being told – then Everyman doesn't have to be played by a man.' The purview of Beckett's notoriously litigious estate, it seems, didn't reach into war-torn Bosnia.

A few days before the premiere, the show was still far from ready. Several of the cast were still not 'off book', and Sontag despaired whenever one of them had to interrupt a run-through, detouring to a candle to blink down at their script. The technicians struggled to lay their hands on the crucial props for the play – Lucky's suitcase and picnic basket, Pozzo's whip and rope. As for Estragon's carrot, vegetables like that were far too scarce to use up in a rehearsal. That would have to wait until opening night.

They hadn't even begun work on the second act. The first act, performed in the melodramatic style that Sontag demanded, was running at more than ninety minutes, meaning the full production would be over three hours long: a test of endurance even for Sarajevo's urbane theatre-going community. Sontag decided to stage only the first part. Although the repetition of action is an essential vehicle for the existentialist message of Beckett's play, she had a convincing rationale: she wanted to propose to her audience, subliminally, that for them, unlike Beckett's hapless protagonists, there might be some hope that the second act would be different. It seemed apt to be staging *Waiting for Godot*, Act I.

During the war years, every theatre performance in the city was full, Kreševljaković told me. How to explain such hunger for theatre amid all this destruction? For Kreševljaković, the audience's willingness to risk their lives to be there, to be present, is the most important proof there could be for the

value of arts and culture. 'When you come to this you don't come because of the red carpet or because of the cocktail, because there is no red carpet. There is no electricity, yet you come – you risk your life. Most of the people who were killed were killed in the streets, so any of those people who decided to take that risk, to go from their home to some theatre performance, they are our proof.'

Sontag had a rather more mundane perspective. No electricity meant no telly. What else was there to do? The tickets for the ten performances of *Waiting for Godot* were in demand, and many had to be turned away at the door. In the audience, alongside the civilians, was a group of Bosnian soldiers. Correspondents from the world's leading broadcasters and newspapers took their places too. She knew that many of them regarded her motivations for being in Sarajevo with suspicion. Her long-standing critic, the *Wall Street Journal*'s Hilton Kramer, was on her back, accusing her of being a 'tourist'; the *Independent*'s Gordon Coales had already parodied her efforts in his column, proposing an 'Ars Longa War Arts Service', ready to dispatch artists to war zones around the world. He wrote: 'A performance of one of the classics of twentieth-century drama (selected by experts to be relevant to your war), staged in the heart of the war zone, would be an extraordinary event and a unique contribution to both military and civilian morale.' The artistic quality of the work, he implied, was moot.

But Sontag's sensitivity to the suffering of an oppressed people wasn't solely intellectual. Born Jewish in the US in 1933, as a child she had been hit in the head by classmates and called names, bullied for her ethnicity. When she was

twelve, her mother remarried (her father having died of tuberculosis when she was five), and she and her sister were delighted to be able to change their surnames from Rosenblatt to the less Jewish-sounding Sontag.

Around the same age she grasped, for the first time, the true significance of the Holocaust. Browsing in a bookshop, she picked up a publication containing photographs of Nazi concentration camps. She thought she was going to faint. 'I knew that the Nazis had killed a lot of Jews. I knew that I was Jewish. But I didn't know it meant what I saw.' The experience stayed with her throughout her life. Later, when a television interviewer asked her if it mattered that she was Jewish, she replied: 'It matters in the sense that I would always stand up and be counted, any time that it mattered for other people.'

A country road. A tree. Evening. The stage was set. A rickety platform, 8ft deep and 4ft high, ran across the width of the stage, and UN-issue plastic sheeting, intended to cover bombed-out windows, acted as a makeshift gauze. Behind it, stage left, the silhouette of a solitary tree in flickering candle-light. It was one of the few remaining trees in Sarajevo; throughout the winter, the citizens had scavenged any piece of firewood they could. In the nearby Veliki Park, barely a branch remained.

At 1 p.m. the cast stepped on to the stage. Silence descended on the audience. From somewhere outside the theatre came the rumble of a UN personnel carrier, a crack of sniper fire.

'Nothing to be done,' Estragon said.

*　*　*

The only footage I've been able to find of the production is a few grainy clips, captured by the filmmaker Pjer Žalica as part of a documentary called *Godot Sarajevo*. It shows a group of actors with real precision in their craft, a command of physicality and voice that contradicts the brutalised state of their bodies. The staging is haunting and beautiful: lacking electricity, the cast moves around in small pools of light from the twelve candles allocated for the performance.

In truth, the production is most remarkable not for its artistic merits, but for the fact it existed at all. But what does it mean to write that? Is it possible to divorce the value of an artwork from its real-world context? In her critical writing, Sontag had long wrestled with the moral responsibility of artists. Early in her career, she had celebrated form over function, in her famous essays 'Against Interpretation' and 'On Style'. Yet this position was not at odds with her admiration for artists willing to risk their lives to put their ideals into practice. The ethical standards of the artist infused their work, she believed, regardless of whether the art was explicitly political. In conversation with Tony Kushner in 1995, she distinguished between her work as an artist and her life 'as a citizen, as a soul'. The artwork may stand alone, but of its creator we should demand a moral position. 'I believe in righteous action; I believe that one should do good.' She held that the writer's place was on the front line and was cynical about pacifist positions that may so easily be a guise for complacency.

Sontag made a similar argument in her essay *Camus' Notebooks*. Here, she recognised *both* a writer's literary output and their moral actions in the world. Discussing Albert Camus, the existentialist writer who was active in the French

117

Resistance, she says: 'When an immensely gifted writer, whose talents certainly fall short of genius, arises who boldly assumes the responsibilities of sanity, he should be acclaimed beyond his purely literary merits.' She compares him to George Orwell, who fought in the Spanish Civil War, and James Baldwin, who played a prominent role in the American Civil Rights movement – writers who 'essay to combine the role of the artist with civic conscience'. She explains, 'What accounts for the extraordinary appeal of [Camus'] work is beauty of another order, moral beauty, a quality unsought by most twentieth-century writers.'

From the beginning, Sontag knew that theatre was the only form fit for what she wished to express in Sarajevo. The constrained, closely observed circle of the stage, the fragility of the drama that played out upon it: it might well have been a synecdoche of the besieged city in which it stood, where personal narratives were amplified and global politics played out at a human scale.

More than that, though, Sontag wanted to create something 'that would exist only in Sarajevo, that would be made and consumed there'. In this sense, the production was a material expression of solidarity, true to the shared etymology of that word with 'solid', meaning 'firm' and 'undivided'. Theatre, after all, is the form of presence, of what it means to be a body in a particular place at a particular time. Her production had been made, and could only ever be experienced, by people who knew what it meant to risk their lives to be there.

More than 11,500 people were killed in the siege, and 50,000 were injured. In this context, how could Sontag's actions have been anything other than trivial, even self-indulgent? As the

author Fran Lebowitz put it: 'Writers don't save lives. Writers would like to save lives, because it's more heroic . . . Military action. That's what it takes to stop genocide, by the way. Not productions of *Waiting for Godot*.'

The journalist Kevin Myers was less circumspect in an article in the *Daily Telegraph* – titled 'I Wish I Had Kicked Susan Sontag' and written to mark her death: 'It was mesmerizingly precious and hideously self-indulgent. . . . My real mistake was not radioing her coordinates to the Serb artillery, reporting that they marked the location of Bosnian heavy armour.'

But the Sarajevans I interviewed who had witnessed it praised its importance. As the journalist Gordana Knežević put it: 'This was the most meaningful thing she could have done. It was necessary to stay sane, and to preserve a sense of normality. And to do that you have to preserve culture. You have to keep theatre alive.' Kreševljaković cast Sontag's actions as a rebuttal to moral equivocation: 'How many intellectuals do we have today who are ready to sacrifice themselves for some cause? We have made everything relative. But if everything is relative you'll never make the trip. You have to go to fight for someone because you believe he is right.'

Bajrović was more ambivalent. 'I'm not sure that it was very important,' he said. 'I think it was more important that I was a soldier, because I had to fight, to defend the city and the people inside. But in that moment it was a question of life. Yes. To be alive means work. In that moment I thought that it was very important for people. We only had full theatres. Always, always, always. It was some illusion of normal life, I think. Because of that it was important.'

Fran Lebowitz was probably right when she said that writers don't save lives, and nor do productions of mid-twentieth-century absurdist theatre. But, as Sontag put it, 'It is important to remember that in programs of political resistance the relation of cause and effect is convoluted and often indirect. All struggle has a global resonance. If not here, then there. If not now, then soon. Elsewhere as well as here.'

* * *

Sontag's stance takes issue with a common misapprehension about the nature of political resistance: that its purpose is utilitarian, offering a guarantee – or at least favourable odds – of the tangible and direct impact it will have. Lebowitz can only contemplate the meaning of Sontag's actions in terms of a head count; how many are alive who wouldn't have been otherwise? Yet the longer I have spent meeting and thinking about the people who have dedicated themselves to resistance, the more I understand that, as much as they wish for their political hopes to be reality, many are driven to resist regardless of the potential efficacy of their gesture.

Why, then, resist? The reasons are many: resistance can be a means to build resilience and create networks with others who share your outlook and will support you. It can be a way to reaffirm your identity, particularly in the face of forces that seek to undermine it. The experience of sharing in resistance with those who see you and understand you can be euphoric, an ember of joy in the ashes. What motivated Sontag principally was her ethical commitment to solidarity; to standing with the people of Sarajevo, metaphorically and literally.

In recent weeks I have joined the protests calling for an immediate ceasefire in Israel's siege of Gaza; hundreds of

thousands of us marched, defying the Home Secretary's attempts to stop us. What do those of us in the streets hope for? Firstly, that our leaders look out of the window and are shaken to change their position. But our reasons for joining the protests are more complex than that. Regardless of the intransigence of politicians who ignore the 76 per cent of the British public who believe there should be an immediate ceasefire,[2] it still matters that I am here. With my presence, I show the Palestinians that we stand with them. They are not forgotten. I speak to my friend, the multidisciplinary artist Riham Isaac, in Palestine, and she tells me that seeing the protests – the drone shots of people filling the streets of central London, the sit-in at Waterloo Station, red and green smoke bombs over Eros in Piccadilly Circus, and elsewhere – in Paris and Bucharest and Sydney and Washington and Santiago – gives her strength. Solidarity is the word. Lately, I've been reminded of the story of A. J. Muste, a prolific American pacifist who, according to legend, during the years of the war in Vietnam, stood outside the White House with a candle, every single night. For years. When a journalist asked him, 'Do you really think you are going to change the policies of this country by standing out here alone with a candle?' he answered: 'Oh, I don't do this to change the country. I do this so the country won't change me.'

To recognise the significance of resistance beyond its capacity to change a country's policies is to refuse to allow the value of the action to be defined on your opponents' terms. It's a philosophy that suggests the rewards in resistance are close at hand and, paradoxically, that outlook builds the

[2] YouGov poll, October 2023.

resilience of a resistance movement and makes it more likely to succeed in its larger goals. Such expansive thinking about the purpose of resistance has a particular significance for artists, whose work does not always have the blunt directness of a protest march, but moves in its own ways, bringing aspects to resistance that other tools cannot.

In Sarajevo, Sontag told the *Washington Post:* 'People told me they thought I was crazy to come here ... But they didn't understand that I couldn't not come here. Once I understood what was happening, it was the obvious moral choice. It was the only choice.' Her position is one of virtue ethics: it means you do what is right regardless of the possible outcome. Howard Caygill, the British philosopher and one of the foremost experts on the matter, wrote that resistance 'responds to an implacable demand for justice with actions characterized by fortitude or the ability to sustain courage over a long period of time without any certainty of outcome'. That makes it sound like a heavy burden, but I see a kind of liberation in the virtue ethics of resistance, because it strips away the anxiety of gambling constantly on the outcome of factors beyond our control. Instead its demand, only, is that we do the next right thing.

* * *

Riham has been thinking about what the point of her art is, now. She is a multidisciplinary artist. To date, in the West Bank where she lives, over 358 Palestinians[3] have been killed by Israeli settlers and the military since the brutal Hamas

[3] UNOCHA data on 29 Feb 2024.

terrorist attack of 7 October 2023, in which around 1,200 Israelis lost their lives and 253 hostages were taken.[4]

Riham has addressed Israel's occupation of Palestine in her work before. One of my favourite performances of hers is a 2014 piece called *A Stone on Road*, inspired by the first Intifada from 1987–1993, a resistance movement against Israel's military occupation of Palestine. Riham was six years old when the first Intifada happened, living in Beit Sahour, a town to the east of Bethlehem, and she remembers it vividly. Beit Sahour was a key centre for the resistance movement, pioneering methods of non-violent direct action, burning ID cards and boycotting Israeli goods. When the town organised a tax strike, the Israeli government placed it under blockade for forty-two days, stopping food deliveries and cutting telephone wires.

Stones became symbolic of this grassroots rebellion, particularly the image of Palestinian civilians throwing stones at the Israeli tanks. 'People would also put large stones in the street, for the bulldozers and tanks not to come in,' Riham says. So she made a simple, durational performance piece for the Qalandiya International Biennale, pushing a huge rock along the road in Ramallah, documented on video. In the film, her costume is inspired by a photograph she found during her research of a woman who stopped to join in the stone throwing on her way back from church. She is dressed in her Sunday best: an elegant black skirt and sweater, with a yellow scarf and matching yellow heels – a reminder that the first intifada was the work of everyone within the community.

[4] The West Bank, unlike Hamas-controlled Gaza, is controlled partly by the Palestinian Authority and partly by Israel.

The rock must weigh half a tonne; Riham, whose slender frame looks even more delicate in her heels and ladylike scarf, braces her whole body against it, sometimes almost horizontal to the road before it begins to move. People gather around, amused, perplexed. Some seem to doubt her ability to move it; others try to help. One man somersaults clean over the top of it.

'I wanted to ask, where is this revolution?', she says. 'What is the form of it now? What are we pushing, now? Do we have the strength?' The video captures an onlooker's voice: 'This is not the right way to remind people about the intifada. This is a symbol. These interventions should happen in the case that the occupation has ended. But occupation still exists. This work should be real.' For Riham, his criticism inadvertently grasped precisely why she had made the piece: 'I wanted it to say – this stone needs to go further. I don't want it to be an art piece, I want it to be an actual provocation. Where is the revolution these days? This action was done in 1987; where are we today?'

Often, however, the performances she makes aren't overtly political at all. A few years ago, I worked as producer on a performance of hers called *Another Lover's Discourse*: a warm, witty solo theatre show about romantic love that invited audiences 'to think differently about love; to shake off stereotypes, free yourself from old traditions and think about what you actually want'. We presented it at London's Rich Mix in March 2020; just a week later, as the Covid pandemic came into full force, the theatres closed down, and the borders of the West Bank closed. Riham ended up stuck in the UK for months, wondering if she would ever make it back to her family. So that evening has a strange quality in my memory. The last night of an era that we'll never return to. We played to a packed

house; no one wanted to hug, I remember, but afterwards, we danced to music by the Iraqi-Swedish group Tarabband. It was the last time we danced together in a long time. The politics of that show rested in a young woman from Palestine talking about romantic love, defying the insistent narrative in the British media of Palestinians as either victims or terrorists.

Just before we speak, she has come back from a meeting with other artists: 'We were asking, what is art under war? Can we produce art now? Many people felt the same way.' She doesn't have any easy answers, nor does she think that there is a single answer. 'Each artist will find their own way. You are not expected to be heroes or to free Palestine with your art,' she says. Ultimately, after the events of recent months, she feels that it will no longer be possible for her to make work that doesn't address them. 'The amount of blood, the amount of horror that we live through – it's getting worse and worse and worse. But then the idea of freedom comes back. Justice. And this is a cause I need to call for.' But for now, making art is about a 'release'. 'We are human beings and we need to take care of ourselves,' she says.

At the time of writing, more than 30,000 people in Gaza[5] have been killed by Israel in the current conflict; over a third of them children. More than 70 per cent of homes have been destroyed.[6] I cannot imagine anything more terrible than the scenes I witness behind the glass of my phone screen, framed

[5] Figures taken from the Gaza Health Ministry – 29 February 2024. As acknowledged by senior US officials, these numbers are likely to be a considerable underestimate given the number of bodies trapped under rubble, and therefore not included in the official count.

[6] Figures taken from the Government Media office in Gaza – 31 December 2023.

in neat squares. A boy who has lost every member of his family being comforted by his neighbour. A young girl covered in dust at a bomb crater, crying, 'Where is my mama?'. A man pulling his child's body from the rubble. South Africa has taken Israel to the International Court of Justice, charging it with genocide.[7]

Yet even here, artists persist. Visual artist Menna Hamouda is creating murals with charcoal and chalk on the walls of the school where she is sheltering with her family – portrayals of the inner child she feels she lost when her home was destroyed. The celebrated writer Refaat Alareer shared his last poem, *If I Must Die,* on Twitter just over a month before he was killed by an Israeli airstrike on 6 December 2023. The poem depicts a kite flying over Gaza and imagines Alareer's orphaned son looking up at it after his death, thinking it to be an angel.

Meanwhile, the Free Gaza Circus Centre proclaims its intention to 'weave threads of hope, love and joy through the quilt of war'. Its acrobats delight children with astonishing somersaults and juggling displays amid the white tents of the displacement camps. In red noses they perform clowning routines on the sand – silly skits and clapping games that make the children giggle.

Watching online, I realise how many photos and videos I have seen of the children of Gaza in recent months. Yet this is the first time I have seen them smiling. I imagine their laughter escaping, soaring kite high.

* * *

[7] An interim ruling by the ICJ in January 2024 states that 'at least some' of South Africa's claims that Palestinian rights need protection under the genocide convention were 'plausible', ordering Israel to take measures to prevent genocide.

Thinking now about the artists of Gaza, as well as the culture that flourished under the bombs of Sarajevo and the creative resistance of Cahun and Moore, I feel humbled by the naivety of one of the questions I began this journey with: why, even under the most oppressive circumstances, do people create art against the odds? The answer, of course, is – why would they not? To sing, tell stories, dance – these are all essential aspects of a full human identity, which is not lost under the hail of shellfire, however much those pulling the trigger might seek to deny it. Pašović captured the sentiment of many in Sarajevo's creative community best. During the siege, he founded the Sarajevo Film Festival, now the largest film festival in south-east Europe. A journalist asked him at a press conference: 'Why the film festival during the siege?', Pašović answered patiently: 'Why the siege during the film festival?'

Of course. The absurdity is the violence, not the art. Here is the *particular* potency of creative expression as resistance – it is the ultimate defiance of the enemy, an insistence on your vivacity, your intent to go on living, in all your bright dimensions. The point is what the creative act indicates about the spirit's persistent freedom. For me, the most compelling evidence of the power of art as resistance is the urge of these people in the most brutalised situations to create. In this context, art can become a battleground – a site where the sense of self comes under attack, but also a place where it can fight back. For people robbed of all other agency, art can be a remarkably forceful expression of resistance.

Nowhere was this more apparent than in the Nazi concentration camps of the Second World War.

Susan Sontag with the cast of *Waiting for Godot* (photo by Paul Lowe)

Chapter 7

THE CONCENTRATION CAMP

Auschwitz, 1942

Filip Müller had just turned twenty when he was deported from Czechoslovakia in April 1942. A young man who loved the violin and had done well in school, he believed the soldier from the Hlinka Guard who reassured him he would have a good life if he took the train to the north. The number 29236 was tattooed on his arm when he arrived.

Within the first weeks, he had witnessed prisoners beaten to death in front of him. One Sunday afternoon, lying on a bunk weak with thirst and malnourishment, his fellow prisoner proposed a plan: together, they would sneak out of the barracks to where the evening's tea ration would be waiting. Caught by the guards rubbing the hot liquid into his dry lips, Müller received a clout around the head that knocked him out. When he came around, he was sure he would be killed. He had only been at Auschwitz-Birkenau a few weeks, but he had already witnessed his fellow prisoners put to death – cruelly, arbitrarily – for not being quick or young or useful, or simply for having a look that the guards didn't like.

But then he heard music. Somewhere close, a real orchestra was performing Schubert. 'I briefly put aside my sombre thoughts of dying,' the young music lover later wrote. 'I argued that in a place where Schubert's *Serenade* was sung to the accompaniment of an orchestra, there must surely be room for a little humanity.'

* * *

Auschwitz resonated with music. Choirs and string quartets and a brass band and a symphony orchestra. It is hard to reconcile the staggering brutality of existence in the concentration camp with the fact it was underscored by this vast musical repertoire: classical music, easy listening, jazz, dance music and pop. In this place where the smoke pouring from the chimneys of the crematorium was so thick the birds stopped singing. We might agree with the academic Juliane Brauer who described the melodies carried in that fetid air as 'the most striking symbol of the inherent lunacy of the camp'.

Yet in another sense it was inevitable. Around 1.3 million people were sent to Auschwitz, many of them from European cities at the heart of the roaring cultural explosion of the interwar years. So of course many gifted musicians were transported to the camps, among them individuals such as conductor and composer Karel Ančerl who survived and went on to be artistic director of the Czech Philharmonic, and violinist Alma Rosé, niece of Gustav Mahler and a remarkable musician in her own right. When Anita Lasker-Wallfisch arrived at the camp, the Women's Orchestra was without a cellist – Lasker-Wallfisch could play, and so she

was allowed to live. 'I can safely say that the cello saved my life,' she later wrote.

The formal bands and orchestras were possible because the SS Guards allowed them to be. They largely encouraged the groups, sourcing instruments and sheet music as a reward for hard work, even setting up rehearsal rooms. But it would be a mistake to perceive these gestures as a rare glimmer of generosity towards the prisoners. Music was allowed because of the part it played in the grim mechanics of camp life.

Early in the morning, the orchestra assembled at the camp gates. One of their chief tasks: to play cheerful marching songs and popular foxtrots as the prisoners assembled for the working day. The beat kept the prisoners in order and on time as they set off in neatly aligned rows of five, enabling an easy count. 'When this music plays,' Primo Levi wrote, 'we know that our comrades, out in the fog, are marching like automatons; their souls are dead and the music drives them, like the wind drives dead leaves, and takes the place of their wills. There is no longer will: every beat of the drum becomes a step, a reflected concentration of exhausted muscles.'

The terrible ambition of the Holocaust – that 'total burning' – was not purely to destroy the bodies of the Jewish people, but to crush their spirit too. At the entrance gate, new arrivals had their belongings taken from them, their hair shorn from their head. But something more critical remained: selfhood, culture, a sense of belonging. The music the prisoners heard as they struggled under the blows of the guards, wondering if they would survive the day, was the same repertoire that had once accompanied happy family gatherings, concerts and dances. The orchestra ensured that

not even those recollections were safe from the violence of the camp. Unmooring the prisoners' memories thus was a way of loosening their grasp on their identities. Those automatons Levi described were experiencing not only severe starvation but also a degree of abjection so profound they were 'mute and absolutely alone . . . without memory and without grief'.

At night, the orchestra would greet the prisoners as they returned. Beaten up, gaunt, often bloodied and barely able to stand, they hauled themselves back from the day's travails. Many times they carried the dead with them. As they laid out the bodies, the orchestra continued to play. The same tunes, over and over. 'They lie engraven on our minds and will be the last thing in the prison camp that we shall forget: they are the voice of the camp, the perceptible expression of its geometrical madness, of the resolution of others to annihilate us first as men in order to kill us more slowly afterwards.'

* * *

Prisoners arrived at Auschwitz in trains from all over Europe. As they disembarked, they were 'sorted' – those deemed able to work sent into the camps, the others channelled towards the gas chambers. Occasionally in Auschwitz-Birkenau, the orchestra was called to play at the ramps where these 'selections' were made. They would strike up a folk tune, playing their part in the SS conspiracy to deceive people that they were not to be killed.

No doubt the sound of the orchestra reassured them. Polish musician Halina Opielka, a member of the orchestra from

the women's camp who played at the 'selections', described what she saw: 'Many of them listened eagerly . . . Some even greeted the sounds with movements of their own bodies. The sight of the women's orchestra . . . gave them courage and hope that this place where they had just arrived could not be too terrible if they were being "greeted" by an orchestra.'

Müller wasn't killed at the barracks. Instead, he was put to work as a 'sonderkommando', joining the slave labour forced to assist with the operation of the gas chambers. They stood waiting as the new arrivals gathered in the courtyard outside. He heard the guards reassure them that they were only here to work in support of the war effort, and that they must undress for a shower to be disinfected. But after they had been sorted – with those deemed able to work having been taken to the camp – the doors to the gas chamber opened. Around 600 people entered, then the doors were bolted shut. Guards went to openings in the roof, poured in blue crystals of Zyklon-B, and covered them. Screaming, wailing, prayers, and then – a few minutes later – silence. With methods such as these, the Nazis murdered at least 1.1 million people at Auschwitz.

* * *

Rudolf Höss, the longest serving commandant of Auschwitz, lived in a villa close to the crematorium. On Sunday afternoons, concerts would be held in the square by his home, the prisoners carrying the piano to the spot from the music room. Many of the senior members of the SS loved music. The three-hour concerts consisted of a programme containing classical music and opera, punctuated with foxtrots so the soldiers could get up and dance. 'Sometimes when we played

on this elevation in front of the Höss villa, in this breezy concert hall, the smoke from the crematorium terribly irritated my colleagues,' Adam Kopyciński, conductor of the men's orchestra, later reflected. 'From time to time, such a cloud of smoke would come over that it was literally hard to see the notes.'

Over the intervening years, philosophers have struggled to reconcile this love of music and high culture with the crimes committed at Auschwitz. How can Josef Mengele – the notorious doctor known as 'The Angel of Death' who carried out cruel medical experiments – have whistled the arias of Mozart while he selected who would die in the gas chambers, as survivors have attested he did? How can we reconcile the fact that he – and many others in the SS elite – relaxed after 'the selections' by listening to compositions by Robert Schumann and Franz Schubert, then returned the next day, renewed in their task of sending innocent people to a horrendous death?

The critic George Steiner famously expressed an argument that has haunted art in the wake of the Holocaust. 'We know,' he wrote 'that obvious qualities of literate response, of aesthetic feeling, can coexist with barbaric, politically sadistic behaviour in the same individual. Men such as Hans Frank, who administered the "final solution" in Eastern Europe, were avid connoisseurs and, in some instances, performers of Bach and Mozart. We know of personnel in the bureaucracy of the torturers and of the ovens who cultivated a knowledge of Goethe, a love of Rilke. The facile evasion; "such men did not understand the poems they read or the music they knew and seemed to play so well," will not do. There simply is no evidence that they were more obtuse than

anyone else to the humane genius, to the enacted moral energies of great literature and of art.'

The troubling fact, as he has it, is not that these crimes were carried out *in spite* of the guards' pleasure in the edifying experience of listening to good music. Rather it is that the music enabled them: part, as it was, of their image of themselves as belonging to a decent, cultured Aryan race, their actions apiece with the continued refinement of European culture represented by the art they loved. 'Political bestiality did take on certain of the conventions, idiom, and external values of high culture,' Steiner wrote. 'Mined by ennui and the aesthetics of violence, a fair proportion of the intelligentsia and of the institutions of European civilization – letters, the academy, the performing arts – met inhumanity with varying degrees of welcome. Nothing in the next-door world of Dachau impinged on the great winter cycle of Beethoven chamber music played in Munich.'

The fact of this music in the concentration camp, how it became part of the architecture of power and upheld the most heinous excesses of moral failure in human history, chastens me. It is the harshest evidence that there is no inherent good in art; that it can be bent just as readily to ill as to good, and that we must guard against the belief that the practice of art in a culture is inherently a moral one. Theodor W. Adorno famously considered that 'to write poetry after Auschwitz is barbaric'. His point was not that the Holocaust has made art impossible – he later wrote that 'perennial suffering has as much right to expression as the tortured have to scream.' Rather what he rejected was the notion of art as an expression of enlightened humanity: he believed instead that the possibilities of art have been radically altered; that any art created

now must be wrought from the wreckage of the Holocaust, chaotic and failing.

* * *

But if it is true that music could be used to eradicate a sense of self so vital to survival, it is also true that music could be a means of resistance. Besides the official concerts sanctioned by the SS, the prisoners held unofficial concerts in the blocks at night, marking a birthday or a celebration when, for example, a prisoner was due to be released.

How strange to think of that sound swelling in the dark over that forsaken place. 'The Peat Bog Soldiers' was a favourite part of the repertoire. A protest song composed in the pre-war years by political prisoners of the Third Reich, held in prison camps in Börgermoor concentration camp in Germany, it had spread across the continent and is now one of the best-known protest songs in Europe. 'For us there is no complaining,' they would have sung. 'Winter will in time be past/ One day we shall rise rejoicing/ Homeland, dear, you're mine at last.'

So much original music was composed in the concentration camps, they have almost become a genre of their own. Musicologist Francesco Lotoro has built up a collection of over 8,000 scores, composed in these most extraordinary circum-stances. In his collection he has a song written with a piece of charcoal given as medication for dysentery, scribbled on toilet paper. Other compositions were collected in handmade song-books, beautifully decorated and exchanged as gifts in the camps.

Survivor testimonies from Auschwitz speak of music either as a form of torture, as Levi obviously experienced

it, or as a source of sustenance. German cultural scientist Guido Fackler reflects on the importance of musicians setting 'an example of solidarity and humane behaviour in their dehumanized surroundings. This meant, of course, that there was less emphasis on aesthetic criteria: through fostering a sense of community, music served instead as a form of cultural resistance, as practical assistance in the struggle to survive.'

In his epic document of life in Auschwitz, *People in Auschwitz*, Hermann Langbein records the unique role music played for many of the prisoners in enabling them to endure. He shares an anecdote from Jerzy Brandhuber, who describes entering the empty music room to see a Hungarian virtuoso sitting at the piano. 'He wears a shabby suit, the white and blue kind, and he plays and plays. . . . He plays Mozart, Beethoven, Schubert, Bach. And then he suddenly intones Chopin's 'Funeral March'. When he stops, he sits motionless with his hands on the keys. . . . That was the only moment at which I forgot the camp around me.' Another prisoner Langbein spoke to, Thomas Geve, was thirteen years old when he heard the concerts at Auschwitz: 'On more than one occasion I stood in that rehearsal hall and felt more clearly than ever before or afterward the power of music, which proclaimed there was a human world beyond Auschwitz, which was able to put individual features on the faces of the listeners, which managed to dissolve the inert, grey mass that constantly surrounded us, which helped to keep inmates from drowning in the everyday life of the extermination camp.'

What the scraps held by Lotoro, clutched from the wreckage of twentieth-century history, attest to is a great

unknowable absence: everything that went up in flames that we can never grasp. It is not that the death of someone whom history might have regarded as a great artist is any more tragic than the lives of ordinary people. Rather that the lost music seems to me to stand for the losses that can never be quantified. The stories and the dancing and the moments of quiet love. The joy. All that joy.

* * *

The prisoners transported from Theresienstadt ghetto in Czechoslovakia arrived at Auschwitz-Birkenau in September 1943. From their arrival, they were treated a little differently from the other prisoners. They were not subject to the usual 'selection' process on arrival: all of the prisoners were taken into the camp. Unlike other prisoners they were allowed to keep some clothes and luggage; their heads were not shaved. In their barracks they painted Disney cartoons on the walls for the children; formed a choir and gave performances – *Snow White*, an adaptation of *Robinson Crusoe*.

Modest comforts that did little to assuage the total brutality of life in Auschwitz. Over the months that followed, many died from starvation, hypothermia and disease. But uncommonly, for six months there were no selections for the gas chambers. Why they were treated differently remains unclear, but it seems likely that it was related to an attempt by the Nazis to conceal the reality of what was unfolding at Auschwitz. The following year, the Nazis took the International Red Cross to visit the Theresienstadt ghetto, which had been improved for the occasion. Perhaps the Nazis intended to bring them on a visit here too.

The reprieve was brief. On 8 March 1944, Müller witnessed large trucks pull up in the courtyard of the crematorium, filled with the Theresienstadt prisoners. Around 600 people dismounted from the trucks. Müller watched how the SS beat them with clubs. Crying, they began saying goodbye to one another. Then their sorrow turned to anger, which they directed at the SS leaders, expressing their fury at how they had been lied to. The SS were unmoved. Attempting to rush the doors, they were greeted with gunfire and beatings. Voss stepped up and instructed them to get undressed quickly and move into the next room: 'Your hour has come. There is nothing in the world which can reverse your fate ... do you want to make your children's last moments needlessly distressing?'

In shock, some began to undress. Others did not. With truncheon blows and dogs they were crowded towards the gas chamber. Their situation was hopeless; death was inevitable.

Then someone in the crowd began to sing. A single voice – 'Where is my home, where is my home?/ Over leas are waters streaming/ on the hills blue forests dreaming' – the Czechoslovakian national anthem. Someone joined in, and then another – 'the sound swelled into a mighty choir'. Then they struck up with the Hebrew song, which subsequently became Israel's national anthem: 'Hatikvah'; 'The Hope'.

'And all this time the SS men never stopped their brutal beatings,' Müller later testified. 'It was as if they regarded the singing as a last kind of protest which they were determined to stifle if they could.'

* * *

Müller survived. He bears witness to what he experienced in Auschwitz in *Shoah,* a nine-and-a-half-hour documentary

by Claude Lanzmann composed of testimonies from those who lived through the Holocaust, as well as in *Eyewitness Auschwitz: Three Years in the Gas Chambers,* his astonishing memoir about his time as a sonderkommando. He explains that when he heard the song he decided to end his life. 'After all that I had gone through I felt that to go on clinging to my hopeless existence was totally senseless.' In the confusion after the singing, he entered the gas chamber with the crowd and hid behind one of the pillars, waiting for the doors to be locked.

But a young woman, seeing what he had done, approached him. 'We understand that you have chosen to die with us of your own free will,' she said. 'And we have come to tell you that we think your decision pointless: for it helps no one ... *We* must die, but you still have a chance to save your life. You have to return to the camp and tell everybody about the last hours ... perhaps you'll survive this terrible tragedy and then you must tell everybody what happened to you.' Before they pushed him out of the door, she handed him a gold necklace and asked him to bear it to her boyfriend who worked in the bakery. 'Remember me to him. Say, "Love from Yana."'

* * *

Our hope is not yet lost, they sang – the words of 'Hatikvah'. Resistance is tangled up with the question of hope. 'The belief', as Rebecca Solnit defines it, 'that another world is possible.' Yet I cannot think of a situation more hope-*less* than that of the people of the Theresienstadt family camp as they waited to enter the gas chamber. Even when they realised that the gesture was utterly futile, when nothing could change, their fate inescapable: they sang.

I started this part of the book by saying that these aren't stories of victory, at least not as the history books describe them. The extermination of those individuals that day was certainly a terrible moment of defeat. But genocide is an attempt at the total destruction of a people, angled not solely towards the physical body, but also their spirit, present in their shared identity and culture.

When they sang, what the people in the gas chamber communicated to the guards – and, most importantly, to one another – was that their spirit was not destroyed. And in this, even at its heinous apotheosis, the Nazi project failed in achieving that goal.

Music at Auschwitz-Birchenau (credit: The Archive State Museum Auschwitz-Birchenau in Oświęcim)

PART III

Joy is the first thing that brings us to art in childhood, that time when we're all amateurs. I see it in my daughter, now two years old, delighting in sculpting odd shapes from playdough or splodging blue paint on paper; making up stories with a narrative arc, already – 'Tiger! Raaahhh! Scary! Run away!' – and giggling when I respond with a scream. And it is an important element in why artists persist late at night and through hard-up days, in spite of disappointing reviews or poor audiences. What we chase is the glimmering moment when the words align just so, or the sculpture starts to show itself in the marble block – a feeling that reminds us of the two-year-old we once were, who never really went away.

Joy is the thread through this final section of the book, whether that be about dancing in the street or telling jokes; creating art for its own sake, for the sheer love of it; or using art as a way of creating utopia. In serious times, seeking out joy in art might seem frivolous, a distraction from the gravity of world events. But the clowns of the Gaza Free Circus and Cahun and Moore's cartoons indicate that it is not so – rather, experiencing joy in art can be a way of holding off the darkness. It is a way of fighting for your place on this earth with your fierce, fierce love for it, and its light defines the edges of human experience more clearly. Which is to say, experiencing joy in art can be an act of resistance.

Chapter 8

THE PARTY

Among the affluent, white stucco homes of West London, the atmosphere is one of reclamation. The streets vibrate with music and motion. Flags at waistbands of denim cut-offs flutter in the colours of Jamaica, Trinidad and Tobago, Barbados. Soca blasts. The carnival floats come by, platforms piled high with amps. Feather headdresses and stick-on jewels. In a crush of bodies you lose your friends and lose your breath. The taste of warm beer on your tongue, and the smell of warm toilets. Boarded-up windows in the seven-figure town houses. The heat of late summer doused in rain. Tie-dyed T-shirts and whistles on strings. It is August bank holiday weekend, and in Notting Hill, 1.5 million people from across the globe are here to let their hair down.

The carnival marches onward with an irresistible force. You cannot turn and make your way back against it, only allow yourself to be swept up in it, carried with the current. Movement is in everything: from the steel pans and the dancing mas bands, to costumes formed of twists and flowing surfaces; gossamer wings to be held aloft and sinuous skirts that live with the body in motion. This forward trajectory

carries a message. Nothing here is complete, it says. Anything is possible.

I first went to carnival in my early twenties. Back then, I was only vaguely aware of its history, and my sense of the political significance of what I was participating in was far outweighed by my interest in showering myself in glitter, getting trashed on cans of Red Stripe, dancing myself into oblivion at one of the sound systems then staying up until dawn at some house party I'd blagged my way into. I cringe now at that middle-class white girl with her polystyrene box of jerk chicken, dancing badly to Soca music she couldn't name. I skimmed over the surface of the festival, ready to enjoy the bright colours and insistent rhythms without concerning myself with what it might mean.

For writer Yasmin Joseph, whose play *J'Ouvert* is set at the Notting Hill Carnival, it has been part of her life from the beginning. She recalls helping her mum dye T-shirts for her stall, every surface of their home covered in ink. As a member of the youth club on the Harrow Road, Joseph took part in the children's procession, lying on top of a speaker to rest when it got too much, the bass pulsing through her. 'What's really interesting in my experience of carnival is how celebrated I felt,' she says. 'At 7 a.m. my sister and I would be dressed up in feathers, with my mum lying on the ground to get pictures.' Later – a rite of passage – she was allowed to go to the carnival for the first time with her friends and no adult supervision; her mum and godfather would look out for her on the route, making sure she was having a good day and was all right.

Growing up so close to the carnival route, she saw how the August bank holiday weekend was only the most visible

part of a celebration woven throughout the year; a communal expression of industry and resourcefulness, through which those participating – in the preparation of costumes, the dance routine practices, the drum rehearsals – lay claim to their heritage. Carnival is a place, she says, for British Caribbeans 'to carve out space for ourselves in a country that otherwise seeks to erase our contributions . . . it exists to be shared, regardless of the disparity between rich and poor on any other day in Notting Hill, on this day it democratises the space'.

As an outsider it's easy only to see the bright colours and the smiles, to listen – as I did – to the music without hearing the thud of dissent beneath it. This is the version of carnival that the brands buy into; 'The Lilt Notting Hill Carnival' or 'The Western Union Notting Hill Carnival', a vibrant multi-cultural celebration in a global city where all racial tensions are resolved. This is the carnival that the newspapers peddle on Monday morning – images on front pages of police officers beaming, surrounded by dancing women in tiny bright costumes. *Hundreds of thousands of revellers adorned in glitter and feathers strut their stuff in sequinned Caribbean costumes for the world's biggest street festival.*

But there are spectres at this celebration. In this corner of West London, histories abut and bruise each other. Windrush. The Notting Hill Riots. Grenfell. There are other types of stories the newspapers tell about what happens when Black communities come together to party: *Notting Hill millionaires build barricades around their mansions to protect them from carnival revellers as police search the area and prepare their acid attack kits.* Cast in their shadow, the carnival is not so much a party as a protest, an act of defiance – here

where the bounds between art and reality, spectator and performer, fall away. The request is not to be seen or heard. No, not a request; this is an assertion.

* * *

'Notting Hill as a place has held a special significance for the West Indians who regarded it as, in the words of one leader, the nearest thing they had to a liberated territory,' wrote anthropologist Abner Cohen of the area, 'implicit reference to battles they had fought there against white racists in 1958 and against the police in 1970 and 1976.'

That summer of 1958, in late August, Notting Hill was clenched by riots. The simmering backdrop was growing racism stoked by the presence, locally, of the White Defence League, as well as British fascist Oswald Mosley's Union Movement, who held meetings as he prepared to run for MP in the 1959 election (he lost, resoundingly). Notionally prompted by an argument between a white Swedish woman and her Jamaican husband outside Latimer Road tube station, a white mob rampaged through the streets in their thousands with sticks and butchers' knives, shouting racist slogans and – over the next five days – breaking into West Indian homes and attacking any Black people they encountered. A week earlier, in Nottingham, Black people had been attacked by a white crowd who had objected to seeing a West Indian man having a drink with a white, blonde woman in a pub.

Claudia Jones had arrived in London a few years before those riots, in 1955. Born in Trinidad in 1915, she was part of the Windrush generation that began to arrive in Britain from the West Indies in 1948, part of a government enterprise

to fill post-war labour shortages. But her route to England's drizzly shores had been rather more scenic than those who boarded that first passenger liner at Kingston, Jamaica. Before the move, she had spent several decades in the US, where her family emigrated when she was eight. Here, as an adult, she'd become deeply involved in feminist politics and Black activism, and in 1955 was charged with 'un-American activities' for her involvement with the Communist Party; following a prison sentence, she was deported. She found refuge in the UK, where she immediately joined the Communist Party of Great Britain, and, in March 1958, founded the country's first newspaper for Black readers, the *West Indian Gazette*.

Jones recognised the riots as typical of Britain's fraught race relations. Her response was to throw a party. She called for an event to 'wash the taste of Notting Hill and Nottingham from our mouths'. On a dry, grey January day in 1959, at St Pancras Town Hall, she held London's first Caribbean festival. Photos from the day are joyous – a crowded hall packed with people, the men in suits, women twisting in the circle of their wide skirts, everyone beaming. They are images that give me a sense of expansiveness: open arms, open faces – how big that energy must have been, pressing up against the dull skies of Camden.

From the very beginning, Jones understood the political potency the celebrations carried. 'A people's art is the genesis of their freedom' was the slogan she gave the day. In the introduction to the brochure that accompanied the event, she wrote: 'If then, our Caribbean Carnival has evoked a wholehearted response from the peoples from the Islands of the Caribbean in the new West Indies Federation, this is itself testament to the role of the arts in bringing people

together for common aims, and to its fusing of the cultural, spiritual, as well as political and economic interests of West Indians in the UK and at home.'

That first carnival recalled the festivities Jones would surely have experienced in her youth. The Canboulay is a vastly popular aspect of Trinidadian culture, and, like the carnival in Notting Hill, its origins were deeply political. French colonisers brought carnival to Trinidad in 1783; enslaved people, not welcome at the celebrations, held their own version, incorporating African rituals and folklore, and satirising their masters. When slavery was abolished in the 1830s, the emancipation celebrations took the form of carnival – the name 'Canboulay' emerged from the term 'cannes brulées' or 'burnt canes', describing the flaming sugar canes the freed slaves held above their heads as they walked the streets, celebrating their liberation. The carnival featured stick fights and drumming; 'chantwells' – musical leaders from rival bands with fantastic names like the Don't-Care-A-Damns, the True-Blues, the Black Balls and the Dahlias – would provoke their opposition with insulting songs, and Black revellers would paint their faces white, parodying their former masters.

While it is common for historians to trace the origins of carnival to medieval Europe, in *Behind the Masquerade: The Story of Notting Hill Carnival*, a lovely, lyrical book capturing a day at the carnival in the 1980s, Kwesi Owusu and Jacob Ross seek to reclaim the 'overwhelming Africanness of Carnival'. They highlight how formerly enslaved people infused carnival with their own traditions, rituals and folklore, creating something far more their own than that of their oppressors, and they draw out the thread that ties carnival

back to Ancient Egypt, and the Sham Ennessim, first cele-
brated over 4,500 years ago, and still marked today. With a
name that roughly means 'Smelling the Zephyrs', the breeze
that carries in the fairer days of summer, the event marks the
cusp of the seasons and the arrival of spring. A day for taking
in the air – for picnicking on the foods that symbolise fertility,
brightly coloured eggs and dried fish, for music, games and
walks by the Nile.

* * *

While it may not represent its origins, the medieval heritage
of carnival in Europe is relevant in a discussion of its polit-
ical significance. The word comes from the Latin – *carne*
meaning meat and *levare* meaning farewell. Falling on the
days before Lent, carnival was a celebration driven by the
need to use up the stores of meat before the enforced absti-
nence of the final weeks of winter, and I love those resonances
with the 'carnal' in the name, which makes me think of flesh
and the body. Carnival is a time to attend to the animal self,
the name suggests, to eat and fuck and fart.

Imagine the streets of medieval Britain: a parade of people
in grotesque animal masks, getting drunk, singing and paro-
dying local dignitaries and clergy. There were reports of
cross-dressing and sexual mischief. Often a local 'fool' or
'glutton' would be crowned King for the day; a symbolic
inversion that inevitably parodied the foolish, indulgent
behaviour of the local gentry. In this the carnival seeded a
dangerous thought – that the societal structures that might
appear inevitable, preordained, were less static than they
seemed. Perhaps most remarkable is that the religious

authorities sanctioned carnival practices for at least a certain period in European history. At the Feast of Fools held in late December, a boy bishop would be elected and, on occasion, the clergy reportedly played dice and cards, read the liturgy dressed in women's clothing, and indulged in eating large blood sausages whose phallic symbolism wouldn't have escaped onlookers.

It was carnivals like this that Russian philosopher Mikhail Bakhtin was thinking about when he wrote *Rabelais and His World*. This text has become the cornerstone of an entire field of intellectual contemplation – Carnival Studies – a lens through which a subsection of academics interprets social structures. What Bakhtin saw in the medieval carnival was a kind of messy, populist utopia, a topsy-turvy place of 'second life', where the usual social hierarchies were upended and alternative orders experimented with. Carnival wasn't just a street festival but an entire attitude, present in bawdy songs and scatological humour, in the excessive and profane, in folk transgression and irreverence towards the ruling elite. 'With its joy of change and its jolly relativity,' he wrote, carnival 'counteracts the gloomy, one-sided official serious-ness which is born of fear, is dogmatic and inimical to evolution and change, and seeks to absolutise the given condi-tions of existence and the social order.'

Bakhtin was aware of the contradictions at the heart of carnival. Carnival mocks the status quo and, in so doing, tests its resilience. That which is vulnerable might be unsteadied, but that able to withstand may be reinforced. Scholar Chris Humphrey has called this the 'subversion or containment question', and it is a conflict that troubles anyone who seeks to think deeply about the political impact of

carnival – and indeed, a wider field of 'political art'. Do carnivals present a genuine threat to authority? Or are they a safety valve – a setting where subversive desires can be exercised and exorcised, before everyone returns to the status quo, relieved? 'Showing off your bottom in public,' Humphrey wrote, 'while admittedly fun, doesn't tend to free people from the shackles of whichever economic system binds them.'

Yet historical incident stands as evidence that the subversions of carnival really can overspill the bounds of the party into the cold light of reality. In Dijon, France, in February 1630, the annual Mardi Gras carnival celebrations tipped into riots in which drunken revellers – protesting reforms that would increase the power of the monarchy, as well as proposed tax increases on wine – ransacked the homes of the local elite. Continuing in the bacchanalian spirit of the carnival, they built bonfires with the luxurious possessions they had amassed – tapestries, jewellery, linen, furniture, books – and danced around them, drinking bottles of wine from the cellars of the gentry. While some punishments were inflicted on the town as a consequence, historian Mack P. Holt reports that 'in one sense, the (rioters), despite the punishments inflicted on them, actually won. The feared and hated (new political measures) were never installed in Burgundy, and the (tax) on wine entering the city was not raised.'

An even more ferocious instance occurred half a century previously, at the Mardi Gras carnival in Romans in 1580, where another revolt against taxes and the undue privilege of nobility, took place. French historian Emmanuel Le Roy Ladurie, in his careful reconstruction of the events *Carnival in Romans*, observes that 'Carnival dealt with social sins or ills, on which the community unfortunately could reach no

155

consensus. In other words, the elimination of social ills implied class struggle, with greedy nobles on one side and rebellious peasants on the other. Each group entered violently into Carnival, confronting the other with theatrical and ritual gestures leading up to the final massacre.'

The revolt was led by local craftspeople – predominantly drawn from the town's textile industry – who had met and begun organising at the previous year's carnival. The celebrations of February 1580 were weighted with political significance. Dancers in working-class areas of the towns wore shrouds and bore sickles – traditionally symbolising the end of the wheat growing cycle, they took on a sinister double meaning in the context of the mounting dissent. Mock coronations of a 'sheep king' and a 'rooster king' in working-class areas met with a retaliatory election of a 'partridge king' by the nobility; each faction viewing one another's celebration as a provocation prepared themselves for anticipated conflict.

Events came to a head when the 'partridge king' announced an inversion of the price of food and drink in the town – those items that were normally cheapest, such as hay, animal feed and salted eel, would become expensive, while expensive delicacies such as sugar-coated strawberries, turkey stuffed with cinnamon and pink wine would be available for next to nothing. The inversion seemed to mock the poor, implying that those who wanted to be the equals of the nobility were – in the words of Ladurie – 'like rotten herring substituted for strawberries'. The changes were strictly enforced among the food sellers and innkeepers of the town. A widespread threatening cry was heard among the popular classes in response: 'Flesh of Christians, four deniers the pound!'

On a night of revelry, as festivities drew to a close, the massacres began. Accounts vary as to who was responsible for starting the violence – whether the upper classes, led by 'the partridge king', sought to forestall the uprising they saw in the offing, or were themselves attacked – but what Ladurie describes as a civil war broke out among the town's 7,000 inhabitants. Dressed in masks, blackface, as animals and in other fancy dress, bloody fighting broke out in streets lit by children who paraded with torches. In the end, the popular uprising was quashed by the better-organised and armed 'partridge' faction – around thirty people were killed.

Canboulay has had real-world consequences in Trinidad, too. In February 1881, the English Chief of Police, Captain Arthur Baker, decided to clamp down on the carnival, sending his officers into the streets of Trinidad's capital, Port of Spain, to put an end to the revelries. But those who had gathered to celebrate were determined and – refusing to bring an end to the carnival – met the police with stones and broken bottles, fighting for three hours. Four officers were killed, and a further thirty-eight were injured. The following day, the Governor, Sir Sanford Freeling, attempting to prevent a serious riot, confined the police to the barracks and allowed the rest of the carnival to pass off peacefully.

There was widespread outrage on the island about the suppression of the carnival. The press captured the resentment of what was seen as 'high-handed attempts by an alien executive power to put down the festival … which belonged to the people'. Such was the embarrassment caused to the English government that in early 1882, Freeling decided to give official authorisation to an event that clearly couldn't be suppressed.

While the apparent English tolerance of Canboulay was short-lived, with further attempts to suppress it in 1884, the determination of the Trinidadian people to celebrate carnival continued, synonymous as it had become with the expression of resistance to English rule. When independence was declared in 1962, carnival was declared the country's national art. Now, the carnival each year commences at dawn with *J'Ouvert* ('daybreak'), a re-enactment of the riots – performers in white masks, gloves and eighteenth-century soldiers' garb, marching in line to mock those who once enslaved their people.

* * *

Indeed, the notion of political subversion is so closely woven into carnival that elements of the carnival have become increasingly, and consciously, a part of protest movements. 'Tactical carnival' sees serious political demands amplified with extravagant costumes; placards carrying satirical puns; people joining in with disco routines and steel pan bands driving the march forward. Perhaps an army of 'rebel clowns' will arrive – the Clandestine Rebel Clown Army, a motley bunch dressed variously in camouflage gear, fluorescent wigs and stripy tights, armed with feather dusters, faces daubed with oversized grins and red noses. Undertaking chaotic drill marches and with titles such as 'Major Fuck Up' and 'General Confusion', they parody authority figures in a manner not so different, really, from the medieval revellers who dressed up as the local priests or dignitaries.

What purpose can red noses, bad puns and dancing play in ensuring a protest is more effective? L. M. Bogad argues in his essay, 'Carnivals Against Capital: Radical Clowning

and the Global Justice Movement', that tactical carnival has several goals: '1) to create a joyous, participatory and semi-anonymous safe place for power inversions – anti-celebrity and collective are key; 2) put a friendly face on the protest that subverts typical images of protest movements; 3) suggest better alternatives to corporate globalisation; 4) experiment with new and unexpected ways of interacting with corporations, agents of the stage and passers-by; 5) create a celebratory culture of active defiance that helps people to feel empowered.' To put it more simply, let me borrow one of my favourite quotes on art and resistance, attributed to the author and documentary maker Toni Cade Bambara, who was deeply involved with activism on social justice issues. As she put it: 'The role of the artist is to make the revolution irresistible.'

The actions of the Orange Alternative, a resistance movement that emerged in 1981 in Communist Poland, certainly fall into this category. Led by 'Major' Waldemar Fydrych, a former History of Art student from Wrocław, the Orange Alternative was a serious political activist movement – led by dwarves. Fydrych pursued a programme of what he called 'socialist surrealism', staging dozens of actions and happenings. People would dress up as dwarves and gather in public, singing nursery rhymes and handing out flowers or toilet roll. On one occasion they dressed up in red and took to the streets carrying banners for 'red borscht', on another – at Christmas – they dressed up as Santa Claus, handing out sweets and gifts in the street.

The Orange Alternative insisted that their movement was not ideological. A typical pamphlet read: 'Down with happenings and with politicising! Long live carefree fun outdoors

in the afternoons! Viva Coca-Cola, fast cars and fashion. Let us be colourful, carefree and apolitical.' They encouraged people to turn up to the action dressed as:

'The psychiatric hospital
Untapped reserves
A chain of milk bars
Last year's rape harvest
Social consciousness
Graphomania
Early post-Impressionism
The Tenth Commandment
Birth of a new tradition or
Far-reaching conclusions.'

The movement spread to cities across the country, with people turning out in their tens of thousands to be part of it. Apparently nonsensical, the Orange Alternative's actions were in fact a brilliant critique of the absurdity of everyday life in Poland. 'Socialist surrealism meant that the reality people lived in was one of sophisticated, absurd metaphysics,' he wrote. 'One day there was toilet paper, and the next the shops were empty. It was the same with sanitary pads, meat, sugar and many other products.'

By refusing to assume a public position of critiquing the state, the movement could not be easily assimilated into a narrative of opposition by those in power. They were a classic example of what is called, in protest circles, 'a dilemma action': an action that places the opponent in a lose-lose situation in terms of making a response. In the case of the Polish authorities, the bind they faced was this: they couldn't let these thinly veiled displays of ridicule of the state continue. But if they decided to arrest people dressed up as dwarves

for handing out flowers and singing nursery rhymes, they'd also look really, really silly. How strong could a state that felt threatened by a bunch of dwarves possibly be?

In the end, they decided to arrest them. Footage of dwarves in orange pointy hats being dragged away by police beamed to television sets around the world. At the Christmas march, they inadvertently handcuffed department store Santa Clauses finishing their festive shifts along with the protestors. Occasionally, the Orange Alternative would declare their love for the police and attempt to assist them with their duties; maintaining their enthusiasm for the state when faced with prosecution, the police found it impossible to charge them and had to let them go. In 1988, Fydrych was arrested after handing out free sanitary pads in the street to mark International Women's Day and sentenced to two months in prison.

The following year, along with countries throughout Eastern Europe, communism in Poland ended, and the first free elections in half a century were held. While the rather more po-faced trade union Solidarity, which led the opposition to the Polish government, has taken a more prominent position in the history books, the Orange Alternative's witty, original line in creative subversion is taken seriously by political theorists such as Julius Gavroche, who recognises the importance of what the Orange Alternative did as a model for alternative strategies of political resistance. Artist-activist duo The Yes Men cite the Orange Alternative as an inspiration: 'Major Waldemar Fydrych . . . carries the torch in a pantheon of unreliable characters that autocracy has worked hard to forget. Loki, Prometheus, the Raven, Eshu, Winnebago, Coyote. Hundreds more. Fydrych takes

a contemporary place in an old profession: changing the course of history with humour.'

* * *

Embracing the carnivalesque means recognising how powerful it can be to laugh and to dance, to understand your oppression and yet to delight in the act of living. The carnivalesque is present in the impression you do of your boss when they leave the room; in school kids slipping a whoopee cushion on their teacher's chair when their back is turned. It can be forming a witches' coven or dressing in drag or singing on the Tube or having sex on a Tuesday afternoon when you ought to be in the office. It is football in no man's land and a strawberry plant nurtured in the cracks of a prison wall. What I'm describing is a defiant expression of spirit, of freedom, belonging most of all to those consistently robbed of their laughter.

In Soviet Russia, telling jokes could be a capital offence; the Soviet historian Roy Medvedev believed around 200,000 people were imprisoned for such a crime. A popular witticism from the time captures the reality with a heavy sense of irony. Two judges bump into each other outside of a courtroom. One of them is weeping with laughter. The other says, 'Hello, comrade. What are you laughing about?' The first replies, 'I just heard the funniest joke ever! But I can't tell you – I've just sentenced a man to ten years in the Gulag for it.'

Despite the risks, the Soviet Union was full of jokes, as Jonathan Waterlow has documented in his book *It's Only a Joke, Comrade*. These were not a concerted resistance to Stalinism, but just a part of daily life – a way of getting by and connecting. 'Humour helped them to cope and to stave off

despair – at least temporarily,' Waterlow explains, 'and sharing it with others drew them closer together to help ward off the chill of harsh realities'.

Such jokes represented a compact between teller and recipient, that both were on the same side. 'Every joke is a tiny revolution,' George famously believed. He defined humour as 'dignity sitting on a tin-tack'. With each eruption of laughter, the status quo is unsettled for a moment. In more liberal societies, humour is an important means of establishing moral boundaries and testing where the limits of good taste lie. Our sense of humour often reveals more about us than the face we consciously present to the world. We have little control over what makes us laugh, as anyone who has been seized by the irrational urge to chuckle at a funeral will testify. So sharing a joke is a way of letting your guard down, of showing your true self to another. As G. K. Chesterton pointed out, funny is not the opposite of serious.

It would be easy to dismiss such a slender, intangible gesture of resistance; a cupped hand at an ear, soon forgotten. But sociologist James C. Scott believes that we make too much of organised political struggle: the movements that have led to obvious victory or spectacular failures that animate the pages of our history books with neat binary narratives we find easy to digest. He contests the typical definition of resistance as 'group opposition, either formal or informal, against some element of the status quo that is dominating, oppressive or exclusionary'. Instead, he identifies a category of resistance that is anonymous and barely seen. He writes of 'everyday forms of resistance . . . foot-dragging, evasion, false compliance, pilfering, feigned ignorance, slander and sabotage'. I would add to the list jokes told in a whisper,

whistling, anonymous graffiti on bathroom walls, caricatures sketched on scraps of paper, limericks made up on the spot. Acts of creative resistance that are unwitnessed, scattered through life like specks of dust.

'Everyday forms of resistance make no headlines,' Scott writes. 'There is rarely any dramatic confrontation, any moment that is particularly newsworthy.' Such 'petty' acts of resistance are often anonymous; the state itself rarely has incentive to draw attention to such insubordination. This means it can be easy to overlook the real significance of such slight acts. But, despite their anonymity, 'vital territory is being won and lost here too'. Everyday practices of resistance both cultivate a capacity for resistance, in preparation for the moment of confrontation, and accrete, forming something bigger than themselves. 'Just as millions of anthozoan polyps create, willy-nilly, a coral reef,' he writes, 'so do thousands upon thousands of individual acts of insubordination and evasion create a political or economic barrier reef of their own.'

* * *

While carnivals and the carnivalesque can be a valuable tactic of resistance, to ask whether or not they *intrinsically* create political disruption or reinforce the status quo is, Bakhtin thought, to miss the point. Because what he saw as most valuable was a certain ambivalence. Academic Caryl Emerson has written: 'What is heroic in that attitude is its tolerance of uncertainty. . . . Carnival exists primarily to assure us of alternatives.'

The carnival, then, offers no guarantees or promises; it is a state instead of potential. A place of embodied hope, felt heavy in the press of flesh and the weight of the rhythms.

What we do with that is up to us. In this, carnival is true to the meaning of resistance. In Caygill's study *On Resistance: A Philosophy of Defiance*, he distinguishes resistance as a state with two possible outcomes: resolution or revolution. But at the moment of resistance, the future is uncertain. Which is the best thing it can be.

Claudia Jones did not live to see her party take over the streets of Notting Hill. She died in 1964, aged just 49, from a heart attack. She was buried in Highgate Cemetery, where her grave is next to the memorial of her hero, Karl Marx.

'It hurts me that she never got to see the fullest version of carnival,' Joseph says. 'That foresight in the wake of uprisings, and racist attacks, and unrest within local communities – to use celebration and joy as a response to that just blows my mind.'

By 1966, the carnival had come to Notting Hill, as local resident Rhaune Laslett, a half-Native American, half-Russian social worker, teamed up with colleagues from the London Free School, a community adult education project, to stage a multi-ethnic street festival, celebrating the huge diversity of the area and embracing the richness of so many different cultures coexisting. Whether the carnival truly began here or in St Pancras in 1959 is a contested part of the story, which perhaps only confirms the messiness of carnivals, how they refuse ownership and neat perimeters.

But when the procession took to the streets in 1966, it was led by steelpan musician Russell Henderson and his band, who had played at the St Pancras Town Hall. In the years that followed, the carnival took on the distinctly Caribbean flavour it is known for today. From such humble origins, Notting Hill Carnival has become the second biggest

carnival in the world after Brazil's Rio Carnival, a vast land-mark that, each year, shapes the contours of life in this city.

Joseph has seen the carnival change, even during her life-time. There's a scene in her play when her protagonists, Jade and Nadine, go to buy lunch from a street food van they've been frequenting for years, only to find the prices have shot up and the fare on offer now includes vegan salads and organic lychee juice. 'It's a "Time Out Carnival Top Pick"!' their tone-deaf friend Nisha – who comes from an Indian heritage – reassures them. Jade and Nadine are not impressed. 'No one wants to be dancing for hours and be hungry and be met by £15 chicken!' Joseph says, laughing. 'I've felt that rage before!'

There is a connection, she thinks, between the £15 chicken and the more significant problems facing the area. Her play is set in August 2017, two months after the Grenfell disaster. In the middle of the night, Grenfell Tower, a twenty-four-storey block of flats a few moments from the carnival route, caught fire. In the hours that followed, seventy-two people lost their lives, making it the deadliest residential fire in the UK since the Second World War. Highly flammable cladding had been installed on the building just a few months previously, intended to improve its appearance and increase insulation. Despite numerous instances of residents' serious safety concerns being ignored, and evidence dating from years before it was used at Grenfell that the cladding was unsafe, at the time of writing no one has been convicted for their part in causing the disaster.

'Casual instances of gentrification speak to a wider erasure that allowed the flammable cladding to be put on Grenfell, because it was considered unsightly to the wealthier neigh-bours,' Joseph says. 'It starts off trivial, but inevitably it's

violent.' Her play isn't explicitly about Grenfell – 'it's not right to package and complete something that's still unfolding,' she explains – but is about her characters finding ways of pushing back against those various forms of violence.

Now, each year at 3 p.m. the carnival stops for 72 seconds, commemorating the victims of the Grenfell disaster. That silence is there, at the heart of it. Then the carnival goes on.

* * *

The weight of all that politics probably isn't in most people's minds when they pour into the streets around Notting Hill Gate, Latimer Road and Westbourne Park on the last Sunday in August. What they're thinking of is friendship, family, laughter, music, dancing, perhaps the possibility of romance, or sex; perhaps getting a little drunk or high. They're thinking about the pleasure of the human experience, of what happens when people get together in the same place and move their bodies.

Pretending, though, that there isn't a political potency in that is to misunderstand the carnival. Especially when many of those people are Black and experiencing joy. In recent years, particularly in the wake of the Black Lives Matter protests, there has been an increasing emphasis on Black joy as a form of political resistance. The notion underpins Kay Rufai's *S.M.I.L.E-ing Boys Project,* a photographic series that shows Black South London schoolboys grinning at the camera, designed to 'address the mental health needs of black boys and challenge the negative portrayal of this demographic in the media'. Against brightly coloured backdrops, their joy seems to explode through the lens. Looking at these images, you can't help but smile too.

It's also the driving force behind writer Kleaver Cruz's *The Black Joy Project,* a movement she began when she decided to flood Instagram with images of Black people smiling, dancing, singing, and which has gone on to host talks, curate playlists and compile oral histories of Black joy. 'Black joy is an act of resistance' is her guiding motto. A smile, after all, is more than just a smile. It is a bridge, recognising something shared. A smile is a first acknowledgement of allyship.

It's true that the images of exuberance and laughter that emerge from the Notting Hill Carnival – particularly of police officers dancing with carnival goers – are at risk of being co-opted into a false narrative of social harmony. But to view the carnival only through this lens is to miss the point, I think, because it is to understand the carnival from the spectator's perspective. Carnival, though, isn't a spectator sport. Unlike other art forms, you cannot experience carnival as an audience member. There is only one way: to step off the kerb, into the street, into the throb and swell of it.

When I ask Joseph why she wanted to write about Notting Hill Carnival, she cites a poem: *The Law Concerning Mermaids* by Jamaican writer Kei Miller. The poem is inspired by an obscure – and apparently genuine – regulation from the years of the British Empire, which stated that if mermaids were discovered, *they would no longer belong to themselves.* Miller is writing about forces that seek to subjugate by curtailing delight; that cannot stand *mermaids who understood that they simply were, and did not need permission to exist or to be beautiful.*

Joseph recognises those mermaids in the streets of West London on August bank holiday weekend. 'At the core of the oppression, being able to imagine and spiritually exist beyond the confines of reality is a major key to freedom and

resistance,' she says. 'Carnival represents – at a time when the city was literally caving in on Black people, they found a way to push back, and to exist without the need for permission or validation. Just to exist happily for each other. Joy is at the spine of any kind of enduring politics.'

I think this is what Claudia Jones had in mind when she spoke of the need to 'wash the taste of Notting Hill and Nottingham from our mouths'. That lives cannot be led entirely under the heel of oppression. That even in hard circumstances, joy takes hold. Such is the force of humanity.

Carnival-goers (photo by Marco Mega/Alamy)

Chapter 9

THE TRIAL

In 1989, Czechoslovakia fell, and poet and playwright Václav Havel became the first democratically elected president of what was to become the new Czech Republic, ending forty-one years of single party rule by the Communist Party. He credited his victory to a rock 'n' roll band.

Who were The Plastic People of the Universe? In black-and-white photographs from the early years, they appear dressed in blue-and-white togas, their hair long, hokey home-made UFOs and cardboard cut-out stars decorating the stage. They played a mash-up of prog rock, free jazz and psyche-delia. Four of them to start, then five, an evolving line-up that shifted numerous times over their existence – the list of past and current members of the band on Wikipedia runs to thirty-eight – anchored by Milan Hlavsa, who played the bass and founded the group when he was seventeen. Behind the scenes, Ivan Jirous acted as their manager/artistic director – his nickname, Magor ('Madman'), indicates the larger-than-life character he was.

They formed in 1968, soon after the Prague Spring had ushered in a new, and ultimately brief, period of cultural

liberalism in the country. They wanted to play music inspired by their prog rock heroes – The Velvet Underground, Frank Zappa, Captain Beefheart, The Fugs; they took their name from a song on The Mothers of Invention's album *Absolutely Free*. They were part of a cool, avant-garde scene in the city, where experimental theatre, art and literature were all thriving. By 1970, though, the ruling Communist Party had started to become suspicious, once again, of this liberal, creative milieu. The Plastics lost their licence to play and were forced underground. But they continued to perform, identifying loopholes that allowed them to appear at weddings, school discos, private parties and even – thanks to the ingenuity of Jirous – at 'perfectly legal' art lectures about Andy Warhol's relationship with The Velvet Underground: the Plastics offering two-hour long 'live examples'.

Over the years their popularity grew. Fans would make their way to secret gigs in rural villages far from the city, trekking across fields to remote barns and farmhouses. Like their heroes they dressed in capes and grew their hair long. The long hair was important: a defiant symbol of affiliation with the underground. It was a dangerous fashion choice: beyond the arguments it could cause in families and difficulties with employers, it became a clear signifier for the police – *Mánička* – a term for a long-haired young person – became their shorthand for members of the counterculture. Despite their attempts to keep the details of their gigs under wraps, the police frequently broke them up and directed audiences to leave, most notably at České Budějovice in 1974, where fans were pursued by police and dogs to the local railway station and beaten with truncheons.

In spring 1976, a few weeks after an underground festival they had organised, the police came for the Plastics. They

arrested all of them, along with various friends and associates; more than 100 fans were questioned. By September they were in court, charged with 'organised disturbance of the peace'. The case became a cause célèbre, and the foyer filled up not only with the band's loyal fans but with prominent writers and journalists, philosophers and political dissidents. The band's saxophonist and clarinettist Vratislav Brabenec was sentenced to eight months in prison. Jirous got eighteen months; in total between 1973 and 1989 he spent over nine years in prison for his underground artistic activities.

Perhaps the authorities understood better than the artists themselves the potency of their surreal, irreverent music in a society with so little latitude for free expression. But perversely, by repressing them, they gave the Plastics a political significance they had not themselves intended. 'We just loved rock 'n' roll and wanted to be famous,' Hlavsa said. To be famous, and to grow their hair long, and to wear lace gowns and paint their faces with make-up and play music. It was hardly tanks rolling across Čelakovský Gardens towards the Federal Assembly. Not a political movement. Rather a way of life. The playwright Tom Stoppard, whose play *Rock 'n' Roll* is inspired by the band's story, wrote: 'The band was not interested in bringing down Communism, only finding a free space for itself inside the Communist society. But of course there was no such space, and . . . in the logic of Communism, what the band wasn't interested in and what the band wanted could not in the end be separated.'

* * *

Havel had met Jirous in early 1976. It would be fair to describe the meeting as transformational. Havel listened to the 'disturbing magic' of the band's music, and understood something new about the nature of the resistance to the totalitarianism of the Communist Party. He saw the Plastics and their followers as 'living within truth', as he later explained in *The Power of the Powerless*, his highly influential 1978 essay about life and dissent under communism. He understood that the confrontation with totalitarianism did not firstly, or most significantly, 'take place on the level of real, institutionalised, quantifiable power ... but on a different level altogether: the level of human consciousness and conscience, the existential level'. With those, in short, who were 'living within the truth', by refusing the manipulation of the communist regime and finding ways to maintain their human dignity. 'The sphere in which they were living in truth was not even that of political thought,' Havel wrote. He recognised particularly 'poets, painters, musicians', and an attack on those attending a rock concert was, for him, 'an attack on the very notion of living within the truth, on the real aims of life'.

When the trial of the band took place, Havel was there. Motivated by the events, he and a group of dissidents wrote Charter 77, a document announcing the arrival of a 'loose, informal, association of people' committed to the fight for human and civil rights, who would come to be known as the Chartists. The government swiftly outlawed the dissemination of the document. But the group became increasingly involved in oppositional politics as, through the 1980s, the USSR began to flounder. In late 1989, following a series of protests, the Communist Party of Czechoslovakia ceded

power, and a new, non-communist government led by Havel took over. Six months later, a democratic election confirmed his leadership. The events of 1989 were called the Velvet Revolution. A reference, most probably, to the smooth, non-violent transition of power. But some have drawn a link to the Plastics and The Velvet Underground, the New York band that inspired them.

What sometimes gets lost in the story of the Plastics is the music itself. But the *kind* of music they played is vital. Their most popular album, *Egon Bondy's Happy Hearts Club Banned,* recorded in 1974/75, is experimental and lo-fi: necessarily so as it was, of course, recorded underground and distributed surreptitiously by fans on poor quality, duplicated tapes. Likewise its improvisational quality results from how little time they had to practise together – jams meander through folk, rock, jazz, loose threads tied by a slow, insistent funkiness. A kind of camp darkness pervades the whole thing; it's eerie in the manner of a Hammer Horror score, and gives the impression of the silly, theatrical humour the group must have leant on to endure their circumstances. Lyrics come mostly from the work of surrealist Czech poet Egon Bondy; the Plastics sing of drugs and magic and constipation and stars and ageing, oozing a characteristic grubby glamour. They are anything but earnest, and that offers a clue to their appeal – how liberating it must have felt under the heavy boot of Sovietism to listen to their music and join them in being ridiculous, extravagant, just for the sake of it. You'd mark yourself as part of a gang by liking their music – the kind of stuff that, in more liberal societies, would have parents rolling their eyes and banging on bedroom doors. Outré and weird, the appeal is the way disparate sounds jar against one

another, creating an audioscape designed more to jolt than to seduce.

Can I imagine, when I listen to it, that it was threatening? What was unacceptable to the authorities about the Plastics' music was their refusal to conform to the sanctioned expressive forms of the communist regime – what Jirous called 'the first culture'. Instead, their sound was part of a 'second culture', one that – as he wrote – was not 'dependent on . . . the hierarchy of values laid down by the establishment'. Just like growing their hair long, it was a simple matter of being true to themselves, in the face of a system that sought to deny such individuality. And that changed the fate of a nation.

* * *

Jirous's observation underlines an unlikely kinship between these bearded psychedelic rock stars and the carnival goers dancing in the streets of Notting Hill on an August bank holiday weekend. Both are committed to self-expression in defiance of the prevailing forces that would limit it, and both are potent forces of resistance, in spite of bearing no explicit political message. They remind me that creativity can have an enormous power on its own terms, as a way of insisting on the value of the experience of those who participate. I don't wish to imply that all forms of creative expression are necessarily political. Instead, art becomes political because of who creates it, where and how, and, critically, what they are defying by doing so.

For those of us interested in art as resistance, it would be easy to assume that the artworks that concern us are the ones

with obvious political intent. In the book so far, I've considered many of these, from the posters and slogans of Gran Fury and the literal portrayal of contemporary reality in the work of the Ukamau Group, to the solar panels of *POWER* and Cahun and Moore's pamphlets. It would be an oversight, though, to omit artworks that – like the music of The Plastic People of the Universe – are less explicit about their intended impact. This is connected to a central question that has caused debate among artists and critics for centuries. Is it the purpose of art, they ask, to instruct us, to improve us, to make our societies work better? Or rather should the value of art be judged on its own terms, as a pure exercise of developing brilliant and original aesthetics and form? Typically critics come down in one camp or another, and hold their position vehemently. Given the nature of this book, you might well expect me to hold with the playwright I follow on X who recently wrote, emphatically: 'Taking space on a cultural stage and not trying to influence the world for social progress is a crime.' But I think that position is too simplistic. Yes, let's have art that tries to influence the world for social progress. And also art that moves in mysterious ways, that does not offer answers. There is room for both, and ultimately, for me, I think there is a kind of magic in art that such a simplistic position denies because it fails to recognise that a maker cannot always know the influence their work will have. The alchemy of how the encounter with the audience will complete it.

Of course, this perspective is shaped by the fact that many of the experiences of art that have moved me personally have resisted the demand to reveal their usefulness. I have always been drawn to the fringes and the avant-garde of the art 'scenes'

that interest me, and I know that my accounts of experiences there have, at times, left my friends who aren't quite so involved with the weirdos perplexed. Some of my most memorable nights out are perhaps ripe for pastiche, yet I have loved every second. A concert that consisted entirely of the sound of scrap metal being moved across the floor. The performance artist with hooks in his cheeks who bled, slowly, onto his white powdered skin. The time when I stripped naked and let a man I didn't know bathe me; afterwards he wrapped me in a clean white towel and fed me chocolate.

I have never entirely been able to make sense of moments like that: the art that is muddy, muddling, defiant, slippery, uncertain, sidelong, enigmatic, fragmented, digressive: not by mistake but by intent. So much of the art I love deliberately defies the terms in which we are used now to speaking of value, refusing to give a straightforward answer about what the return on our investment might be. It leaves me instead with the taste of chocolate in my mouth, a ringing in my ears and the sense of a world slightly rearranged. I hunger for it, although the gifts it offers are so hard to take in the hand – and I feel sure that my interest in these kinds of creative practices has ultimately shaped my politics, because they have cultivated in me a willingness to engage with new perspectives that informs my everyday interactions for the better too.

It seems to me that arguments about the efficacy of art often miss out the way the experience of art really moves people: sometimes by offering a direct engagement with specific issues, it is true, but sometimes simply by creating a sphere for thinking, seeing and being *differently,* just as the Plastics did. How easy it is to overlook the potency of that, in the demand any of us with a social and political

consciousness must feel to find the quickest solutions to the multiple crises we witness unfolding every day; how tempting to dismiss artistic gestures that do not make bold claims for the change they will make.

During the US civil rights movement of the 1960s, a groundbreaking new subgenre of music flourished. Free jazz mostly lacks formal structure and is often improvised, creating avant-garde melodies and noise: its defining characteristic is that there are no rules. Simply listening to the iconic album that gave the movement its name – Ornette Coleman Double Quartet's *Free Jazz* – it would be impossible to garner any political position from its fast-paced, compelling cacophony. Yet the very freedom of the form was connected to the freedom that the activists in the street were calling for. Free jazz is a rebellion against the structures and limitations imposed by the musical traditions that came before it, and for academic Evan Ruderman, the free jazz ensembles that made this music became a kind of microcosm of the society envisaged by Martin Luther King, where 'each member . . . gains individuality through their entrance into the community instead of sacrificing part of themselves for the greater good of the nation'. It was as if the music was a place to rehearse the wider liberation of which the movement dreamt.

But for many the music was, and continues to be, ugly and intolerable. Its early critics include jazz legends Miles Davis and Thelonious Monk, who said when he heard Coleman playing: 'There's nothing beautiful in what he's playing. He's just playing loud and slurring the notes. Anybody can do that.'

* * *

The term 'art for art's sake' is often invoked in the abstract in debates about art's purpose. It conveys a sense of art divorced from political reality, preoccupied with form and aesthetics at the expense of a meaningful message. It isn't intended as a compliment. Often the rage the idea invokes comes from a very reasonable anger at the disparity in privilege that allows certain individuals in society – frequently highly educated white men – to engage in esoteric experimentation, while others are forced to fight for their very existence.

'Art for art's sake is just another piece of deodorised dog shit,' the Nigerian novelist Chinua Achebe put it bluntly to a gathering of academics at Harvard University in 1972. Achebe was the author of *Things Fall Apart*, a novel published in 1958 that is now widely considered one of the most important literary works of the twentieth century. Set in the late nineteenth century, it recounts the life of a fictitious Nigerian Igbo tribe, and the impact of the arrival of white missionaries in their village. This was the first major novel by an African author to achieve international literary acclaim, opening the way for African writers to tell their own stories in their own words, in resistance to the racist portrayals of Africa by European authors that had previously prevailed.

Achebe had little truck with writers who weren't engaged with the politics of their times, particularly his contemporary white writers who tended to assume the 'universality' of their writing, eliding the extent to which it was the product of a colonising culture. 'Words like *use, purpose, value*,' he said, 'are beneath the divine concerns of this Art.' This outlook opposed his own: that 'art is, and was always, in the service of man.'

He forged his own work in the crucible of a country struggling for its freedom, coloured with the specifics of the intersecting Igbo traditions he'd grown up with and the Eurocentric literature he'd studied at university. In the context of a continent still fighting for its freedom from the European colonialism that had so long oppressed it, writers from Africa must, he insisted, be bound up with 'the inescapable grammar of values to straighten out, the confused vocabulary of uncertain fledgling polities'.

Of course it is enraging to live in a world where an abstract expressionist painting can sell for more than $100 million, when over 400 million Africans live in extreme poverty – how could it not be? And how much worse to know that the culture breathing hot air into this absurd overinflation of a painting's value is the very same responsible for stamping out so many Indigenous and grassroots cultures around the world.

I can't argue with this. And yet I'm still drawn to defend artists against the insistence that art must always be able to prove its use, purpose and value. Measurable utility, after all, is the demand of a capitalist society – we must demonstrate a solid return on investment, the value of every artwork weighed, somehow, against how many hospital beds or teachers it could have paid for. So perversely, it's the obtuseness to such demands that can sometimes make the most experimental artworks a pocket of resistance. While the usefulness of such an artwork might not be immediately quantifiable, we shouldn't write off the idea that it has political implications. Ultimately, artists cannot exist outside the economic, social and political realities of the present – and if they tell us their work is apolitical, they are most likely

pulling the wool over our eyes. This fact is perhaps best represented by the 4'33" silence[1]: as John Cage knew, it is full of noises.

Indeed, the very origins of the term 'art for art's sake' reveal the extent to which the notion of art divorced from politics is a myth. It was the credo of the Aesthetic Movement that sprung up in Britain in the latter half of the nineteenth century, a rejection of Victorian-era moralism and the prevalent perception of the role of art as a means of reinforcing the morality of the state and the Church. It was a reaction, too, to the ugliness of the Industrial Age. Those who were part of the movement – Oscar Wilde, Aubrey Beardsley, Samuel Taylor Coleridge, Edgar Allan Poe and others – believed that the purpose of art was to expand our experience of the world, to inhabit every moment as fully as possible. As the critic Walter Pater insisted in the essay where he coined the term, 'art for art's sake' proffers the 'fruit of a quickened, multiple consciousness', giving 'the highest quality to your moments as they pass'. Which is to say it was invested in art as a means of resisting the mindless moralism and dehumanising mechanisation of the day, creating a pocket of pure presence and experience. It was, in this way, political, and it became a redoubt for those whose sexualities were marginalised by the morality of the time. As Dustin Friedman, author of *Before Queer Theory: Victorian Aestheticism and the Self*, writes, 'Aestheticism is

[1] John Cage's experimental composition, *4'33"*, composed in 1952, consists of a score that instructs performers not to play their instruments for the entirety of its three movements. The silence – and the environmental sounds contained by the silence – are the artwork.

one of queer theory's unacknowledged ancestors.' The movement came to an abrupt end when Oscar Wilde was put on trial for 'indecency' and sentenced to two years in prison.

* * *

Further to his assertion that resistance is a state that exists before one of two possible outcomes – resolution or revolution – Caygill points out that a certain quality of ambiguity characterises it: in the moment of resistance, it's impossible to know yet what the outcome will be. A willingness to sit with this uncertainty strengthens the position of resistance because it keeps the possibility of radically different alternatives to the status quo alive. For Caygill, resistance in society is found where people are experimenting with different ways to be with one another, testing out alternative ways of life – places of the conditional and tentative. He believes art, in particular, can open a position for this. 'It is in the very indeterminacy of poetry or art,' Caygill writes, 'that the dependence on the past and openness to the future of affirmative resistance can be experienced.'

A quality of artistic 'indeterminacy' is one of the defining characteristics of the oeuvre of Samuel Beckett, and it is relevant, I think, that *Waiting for Godot*, which had such a huge impact in Sarajevo, is the opposite of art driving towards political change: a play in which (famously) nothing happens, twice. Attempts to read specific political meaning in his plays were always dismissed by Beckett – his attitude to such interpretation of his work can best be summarised by the final sentence of his novel *Watt*: 'no symbols where none intended'. He insisted that *Waiting for Godot* be mounted to the letter of his stage directions, allowing no possible room

183

for directorial or design decisions that might anchor it in a specific historical moment.

There was a reason why Beckett was so resistant to engaging directly with contemporary politics in his work. *Waiting for Godot* was written in the wake of the Second World War. Beckett had spent the early war years in occupied Paris, where he witnessed how his Jewish friends were treated by the German soldiers and was appalled. He joined the French Resistance soon after the arrest and deportation of his close friend, the writer Paul Léon, who was ultimately killed in Auschwitz. As part of the Resistance, Beckett translated messages about Nazi activities, which were then smuggled out of the occupied city to the Allied powers. Later, when Paris became too dangerous, he and his partner went on the run, ending up in Roussillon, a rural town in the South of France, where they lived in poverty, hunger and with the constant risk of arrest. They survived the war, but those years left their mark upon him.

How could a writer find the right form to make sense of the industrial-scale violence of those years, or the language to articulate what the European continent had lived through – the 'unspeakable' crimes of the Holocaust? Beckett's mentor, James Joyce, believed the purpose of literature was to tame the world by increasing one's understanding of it through creativity. He did not live through the war; he died in Zurich in 1941. If he had survived to see the images of the concentration camps emerging, to witness the industrial-scale murder wrought across his continent, perhaps he too would have felt sense disintegrating. Indeed, the scale of the crime was so great that a new word had to be invented for it – genocide. How could one have faith in language, when the acts of man could so obviously burst it apart at the seams?

Yet despite his unwillingness to draw overt political connections, Beckett's strange, elliptical play has – perhaps more than any other – come to be synonymous with situations of oppression and resistance, not only in Sarajevo, but worldwide. A few years after its premiere in 1957, the San Francisco Actor's Workshop took a production into San Quentin Prison, performing to a crowd of over 1,000 inmates. The show was a hit: '*Godot* was pretty special,' former San Quentin inmate and jazz vocalist Ed Reed reported. 'Everybody loved it.' The response contrasted with the reactions of mainstream audiences in the States – in Miami, there had been walkouts, and the *New York Times* called the play 'a mystery wrapped in an enigma'. But the resonance of *Waiting for Godot* in a prison setting was not unique. It has been performed in prisons in Sweden and Germany, and it was placed on the list of banned titles at the Guantanamo Bay detainee library – a recognition, perhaps, of the play's sympathy with the disenfranchised and powerless.

In 1963, Beckett joined the cultural boycott of apartheid South Africa, signing an open letter refusing performances of his plays 'in any theatre where discrimination is made among audiences on grounds of colour'. By the mid-1970s, however, in light of theatre's significant role in shifting attitudes about the apartheid, Beckett began to allow some productions to take place. In 1976, *Waiting for Godot* was one of the first productions at the newly opened Market Theatre in Johannesburg, a theatre dedicated to anti-racism: director Benjy Francis staged an all-black production. The obliqueness of Beckett's work allowed it to evade the censors. But 'it provided a powerful metaphor of our struggle,' Francis has said.

Two years after Hurricane Katrina, Vladimir and Estragon's long wait was observed in the desolate wasteland of the lower

Ninth Ward of New Orleans. That production was mounted by the artist Paul Chan, who had heard of the plight of the poor population who suffered worst in the disaster and received the least assistance, and recalled Vladimir's words: 'in an instant all will vanish and we'll be alone once more, in the midst of nothingness.' He mounted five free outdoor performances around the city, with storm-gutted houses acting as stage sets, and the smell of the Mississippi wafting through the air.

Language failing, breaking down, meaning nothing. Structures failing, breaking down, meaning nothing. It is no coincidence that this play has resonated so strongly in contexts where authority cannot be trusted. In prisons, in disaster zones, in unjust nations. Imagine them: two figures in ill-fitting suits and oversized bowler hats, waiting. Wherever people's destiny is out of their hands, wherever authority is removed and unaccountable. Where souls endure on the unfounded hope that someday things may be better. Wherever souls cannot go on. They go on.

The director, Herbert Blau, who directed *Waiting for Godot* at San Quentin Prison, commented of the play that 'One must listen for whatever they may find . . . for each there will be some meaning, some reaction, and dressed in what we hope is good theatre.' He hit on something important about why *Waiting for Godot* has had such a profound impact on the most unlikely audiences. What Beckett's characters don't say is as important as what they do. Beckett's art is in the spaces within the play, the pauses where the audience may make their own meaning.

* * *

What I'm asking you here is to let go of any assumptions you might have about what the art of political resistance must look and feel like. To allow latitude for the possibility it may not be immediately legible as such. As an artist, it is to permit yourself to begin without knowing where you will end up or how your work will influence your audience. To embrace the potential of uncertainty.

The poet John Keats called this attitude to the artistic process 'negative capability' – 'when a man is capable of being in uncertainties, mysteries, doubts, without any irritable reaching after fact and reason'. He rejected 'poetry that has a palpable design on us' and believed that, ultimately, a willingness to remain in this state could lead the poet to a quality that may evade them otherwise, achieving beauty in their work of a higher order, with the potential to 'enter into one's soul'.

This impulse is at odds with the activist spirit which, confronted with the urgency of the crises we face, often feels compelled to direct, decisive action. But I wonder sometimes if this approach plays into the hands of a system that knows only the quantifiable and has no room for other kinds of value. Instead of art inevitably chasing activism's methods, it can open it up, make space for the workings of chance and the imagination, discovering ways of understanding and communicating experience that have previously been unavailable.

None of this takes away from the uncomfortable truth that Achebe identified: that the kind of creative freedom I'm describing is often experienced only by those in positions of privilege. 'Not yet,' he said, on the matter of 'art for art's sake' in Africa, and I think that 'yet' is important. It implies that Achebe *can* imagine a future where 'art for art's sake' is

a reasonable form of expression: one presumably in which genuine equality has been achieved. This casts the notion of creative expression on its own terms, available to everyone, as a hallmark of a good society. It certainly requires an imaginative leap – we have to envisage circumstances where everyone has the leisure time to make art and the political and economic freedom to pursue it. Circumstances in which arts education is accessible to all, yet the esotericism cultivated in educational institutions is not privileged over broader permission to be creative and experimental.

It seems like quite a leap from the society you probably live in now. A kind of utopia. In France, I found a community that is trying to achieve exactly that.

Ornette Coleman (photo by GRANGER – Historical Picture Archive/Alamy)

Chapter 10

UTOPIA

We climb to the top of the lighthouse, the narrow gangway slippery with rain under our feet, slats rotting in the steep stairs. A flimsy length of industrial plastic piping surrounds the ladder to the highest level – 'it's so you can't see how high up you are,' artist and activist Jay Jordan explains. 'Up for it?' I say yes, and ascend upwards, stomach giddy with adrenaline.

From the top, we look out at a hotchpotch of small green fields, stretches of woodland and hedgerows thick with trees and thorny scrub. This lighthouse stands far from the sea, and the landscape surrounding us is bocage and wetland: a scene unchanged for centuries, characteristic of a peasant farm culture here in Brittany, France, that has long since ceased to exist in the UK. Beneath us is the communal living space of Jay's collective *La Rolandière* – an old limestone farmhouse with ivy tangling up its front. Last night we stayed up late, drinking tea in the kitchen, and I admired the building's restoration – windows made by the local blacksmith, hay tile walls for insulation, a new staircase with timber from adjacent woodland ('that's been put in today,' Jay said). Later, I went out through the overgrown garden past the vegetable

patch to the caravan I was staying in, falling asleep to candle-light and the percussion of weather on the roof.

Autumn is on its way in, tipping the trees with bronze and scarlet. 'Where's the edge of the ZAD?' I ask Jay, and they point to the horizon – just beyond that forest stand. Even up here I find it hard to grasp the scale of the ZAD de Notre-Dame-des-Landes: a 4,000-acre rural area close to Nantes that, in the 1960s, the French government earmarked for development as an airport. Local farmers and residents fought the plan for years, many refusing eviction and becoming squatters in their own homes. In 2009, activists gathered here for a Camp for Climate Action, described by Jay as 'somewhere between protest camp, popular university and music festival'. On the first night, local residents read out an invitation to stay. 'To defend the land you need to inhabit it,' the letter said.

So they did. A couple of dozen activists moved in at first, squatting evicted buildings and constructing new dwellings – fragile-looking arrangements of corrugated iron, wood panels, odd windows and doors. Then, with time, more sophisticated structures, like the Barn of the Future, a vast meeting hall modelled on medieval architecture, its wood-beamed nave like the ribcage of a whale, decorated with carvings. The Zadists, as they became known, took up farming, working the land using traditional methods. They determined to live 'as if' the airport would never happen, an imaginative commitment that allowed them to develop their homes and communities with the kind of careful craftsmanship I'd seen in the kitchen of *La Rolandière*, in defiance of the fact that the French police could show up and kick them out at any moment. Many of those who have made the ZAD their home are artists and artisans, including Jay and their partner Isa Fremeaux.

Later, Jay takes me on a walking tour of the territory – a 'ZADfari', they call it. Over the years, the Zadists have built a *boulangerie* producing bread from ZAD crops, a cheesemonger, a brewery, a blacksmiths and a sawmill, even a crêperie. Produce is shared among members of the cooperatives, or sold 'free price' – for whatever the buyer can afford. At one time there was a school and, for a period, Zadists broadcast a pirate radio station, which squatted the airwaves of Vinci Radio, the station operated by the corporation responsible for building the airport and also for running the motorway network. The Zadists replaced the anodyne soft rock drive-time playlists with political missives and messages of support.

Four hundred people and seventy collectives called the ZAD home at its peak. Jay and Isa joined them permanently in 2016, having participated in actions at the territory over previous years. While the activists were out working in the fields, the local farmers were opening squats: established identities shrugged off as the logic of this struggle asserted itself, and acts like planting a vegetable garden or making a home became a radical gesture, slowing the progress of the authorities by reinvesting the land with the value they'd been attempting to rob from it. The accounts from the early years at the ZAD are a story of digging in deep, of falling in love with the land in a way I suspect is only possible when you get your hands in its loam.

In the evening, we gather at the huge dining table of *La Rolandière,* members of the collective joined by whoever happens to be passing through. We – the curious and the itinerant – receive a warm welcome here, and a nourishing plate of food, more delicious because it was grown on the land around us. Tonight on the menu is carottes râpées,

roasted celeriac with sweet potatoes and a slice of steak, raised on the ZAD. I have a glass of red wine and decide this is an acceptable context to forget about my vegetarianism. The smell of 'home-grown' hangs in the cool evening air outside.

ZAD stands for *Zone à Défendre* ('Zone to Defend'), a play on the official term for areas earmarked for development, *Zone D'aménagement Différé* ('Differed Development Zone'). Notre-Dame-des-Landes is the first and most prominent of numerous similar 'ZADs' in France, where rural areas have been squatted with the aim of preventing development. For Jay, the ZAD was the destination of a life journey entangled with some of the most significant activist movements of the last three decades – a story entangled with the narrative of this book, too.

Earth First! drew Jay into activism; in 1994 at the site for the new M11 link road, destined to destroy around 300 homes in East London, they had their first taste of direct action, joining the protesters and local residents who squatted a street of Victorian terraced housing to block the road's progress. For six months, Claremont Road became a vibrant temporary community, united by a shared belief, where the creativity and ingenuity of the resistance found form in raves, vibrant murals and a thirty-metre-high scaffolding tower. One house earmarked for demolition was even turned into an art gallery. Reading accounts of Claremont Road, I have the sense of a convivial atmosphere, where – in the words of artist/ activist Tom Cousins – 'tea and sandwiches freely flowed'. Part of the purpose of the action was to give expression to the rich communal life of the street. To live well was a form of defence.

When the police came, the protesters managed to sit out eviction atop Dolly for seven days, blasting the police with the Prodigy over their sound system. Though the M11 was ultimately built, the campaign's determination here, like the resistance at Batheaston, drove the government to cancel the much larger national road-building scheme.

The atmosphere of interwoven creativity and protest at Claremont Road also fostered the re-emergence of the Reclaim the Streets (RTS) movement, which Jay co-founded, in 1995. RTS kicked off their first action in spectacular style when the activists crashed two cars into each other on Camden High Street, blocking traffic: protesters crowded into the road and started to party, dancing to the music of pedal-powered sound systems. A protest for car-free streets and against the privatisation of public space, RTS mounted numerous actions over the next few years, characterised by a witty inventiveness. On Islington's Upper Street, a lorry dumped forty tonnes of sand, creating an impromptu beach. At the M41, a bagpipe-playing walker on stilts with a vast silk skirt concealed members of the group as they drilled holes in the tarmac and planted trees. '(The) parties did not simply free the streets from polluting traffic,' Jay and Isa explain in their book *A User's Guide to (Demanding) the Impossible*, 'more importantly they filled them with dancing bodies, music and a vision of the world where politics was about pleasure not sacrifice.' From there, they were drawn into the anti-capitalism movement, getting involved in organising actions such as the Carnival Against Capitalism.

Significantly, Jay's activism emerged out of their artistic practice. They started out at art school where they became

interested in the extreme end of body-based performance practice: 'I was cutting myself, and I lived in a river for three days.' At the M11, they saw activists hanging themselves from a crane and thought of Stelarc, the Australian performance artist known for his suspension performances – he was once lifted sixty metres above the streets of Copenhagen, held in place only by hooks piercing the skin of his back. At the protest site, Jay says, 'The body was still this metaphor, a beautiful poetic thing, but it was actually making a difference.'

It was a turning point – the beginning of a life committed to the fusion of art and activism. Later, in 2004, with Isa, they founded the Lab of Insurrectionary Imagination (lab of ii), dedicated to 'bringing together artists and activists to co-design and deploy creative forms of direct action, which aim to be as joyful as they are politically effective.' Isa and Jay were responsible for launching the Clandestine Insurgent Rebel Clown Army, the colourful combatants with wigs and red noses seen at the 2005 G8 summit in Scotland. (They were also the first deserters of the group, Jay is keen to point out: 'Most activists just didn't give the time needed and became really bad clowns, which is an aesthetic crime. I'm sure when I die I'll be in purgatory being tortured by bad hippy clowns until the end of time.')

Once, they organised a 'Great Rebel Raft Regatta' (The GRRR . . .) as part of a mass action targeting a coal-fired power station in Kent. Participants were handed maps that guided them to hidden rafts and a bottle of rum hidden in nearby woods. They took to the water, one raft ultimately disrupting the operation of the power station by blocking the water intake pipe. On another occasion, as part of a theatre show, they armed an audience with ants that sabotage

computers and invited them to debate the ethics of going out and letting them loose to infest nearby banks that fund fossil fuels. Cheeky, playful stunts with all the creativity of a great artwork, paired with the disruptive impact of meaningful political action. 'Originally, we had this feeling that activists aren't very creative – it's always, "We'll do a flyer, we'll do a blockade, we'll set up a tripod,"' Jay explains. 'All useful forms – but you need to create new forms, and I think the role of art is – how do you create desire in politics? How do you make politics sexy and desirable and irresistible? And artists are so good at doing that.'

These methods have inspired other artist-activists too. In 2010, Jay was invited to deliver a workshop at the Tate entitled *Disobedience Makes History: Exploring creative resistance at the boundaries between art and life.* In advance of the workshop, a representative of the Tate sent Jay an email, advising them that 'we cannot host any activism directed against Tate and its sponsors.' Jay projected the email on the wall at the workshop and asked participants what they made of it – noting that one of Tate's sponsors was oil giant BP. 'It was the best pedagogic material we've ever been given,' Jay tells me, laughing. 'We asked them, do we want to obey or disobey this email?' After extensive discussion, some participants decided to take a simple action – displaying a sign reading 'art not oil' in a prominent spot in the gallery's windows. After the workshop, they went on to found Liberate Tate, a collective with the mission to 'free art from oil', specifically seeking to bring an end to the sponsorship deal between BP and Tate.

Over the next few years, the collective carried out numerous memorable stunts – on one occasion turning up

in Tate Modern's vast turbine hall with the sixteen-metre-long propeller blade of a wind turbine, making an official request for it to be accepted as part of the national art collection (the trustees were obliged to consider it seriously). On another occasion, a member of the group stripped naked in the middle of Tate Britain, laid down amid an exhibition of figurative sculpture, and had slick, black molasses poured over him from BP-branded cans, spilling out around him on the gallery floor. It was a striking invocation of the damage wrought by BP's disastrous Deepwater Horizon oil spill, one of the worst environmental disasters in world history, and took place on the anniversary of the explosion that caused it.

In March 2016, BP and Tate quietly announced the end of their sponsorship partnership. The actions of Liberate Tate had nothing to do with it, BP insisted, but every major news outlet carrying the story ran it with pictures of Liberate Tate's actions.

In the end, Isa and Jay found the contradiction between their work as activists and the day-to-day demands of everyday existence, shaped by capitalism, too hard to reconcile, and they began looking for an alternative. With their lives packed into a van, they left London, setting out on a road trip across Europe, trying to find a different kind of life for themselves. They sought out the places where groups are building new ways of living – 'despite capitalism,' Jay says, 'because you can't live outside capitalism.' They visited eleven communities, all experimenting with reimagined ways of coexisting, from worker-owned factories in Serbia to a free love commune in the ZEGG eco-village near Berlin, the anarchism of Denmark's Christiania to the egalitarian agricultural cooperatives of France's Longo Maï. Did they

find utopia? 'We found the place where we want to live,' Jay replies. That place was the ZAD.

* * *

'Utopia' is a place where everything is perfect. The word itself tells us it doesn't exist. Utopia comes from the Greek '*ou*' meaning not, and '*topos*' meaning 'place'. 'Nowhere'. Of course it doesn't. The notion of utopia implies a fixed state, where all tensions are resolved and injustice is vanquished. Such stasis is at odds with human nature. Continually questing, the truth of living as part of a society is well captured in the adage that the only certainty is transformation: nothing will stay as it is.

The word is in fact a pun, carrying with it two meanings. Utopia could be taken to mean 'good place' too, as the prefix *eu* in Greek means 'good'. This contradiction might be the very reason why humans can't give up their fascination with the idea. As Oscar Wilde wrote: 'A map of the world that does not include Utopia is not worth even glancing at, for it leaves out the one country at which Humanity is always landing. And when Humanity lands there, it looks out, and, seeing a better country, sets sail. Progress is the realisation of Utopias.' We need utopias, exactly for the distance between here and there. That gap draws attention to the failures in how we live now, and begs a question: why can't it be otherwise? Whether we ever arrive at its shores, as a destination on a map it can guide us to a better way of living.

Utopianism is at its heart a creative project, an imaginative leap just like the ZAD's magic 'as if'. It's no coincidence that

Sir Thomas More, known to history for his plural roles as lawyer, judge, politician, philosopher and religious figure – and for his execution for treason – turned to fiction to give form to his vision for a well-ordered society. In 1516, he published his novel *Utopia,* which gave us the term, set on an imaginary island with a welfare state, communal living, and no private property. He might have been the first to use the term 'utopia', but utopias have been portrayed in literature for thousands of years – including Tao Yuanming's *The Peach Blossom Spring* (written in China in 421CE) and Christine de Pizan's *The Book of the City of Ladies* (France, 1404). Fiction offers a licence to be outlandish in one's visions without admitting to the charge of naivety, while at the same time making art's repeated demand on reality – do you see yourself reflected here?

'If others see it as I have seen it, then it may be called a vision rather than a dream,' wrote William Morris – Victorian artist, author, textile designer, poet, activist, and one of socialist history's most celebrated utopians. Morris set out his vision in his 1890 novel, *News from Nowhere*, charting the journey of protagonist William Guest, who awakes to find himself in a London that has, transformed overnight. The smoggy, fetid, industrialised city has given way to a harmonious, idyllic landscape: human settlements, constructed with attentive craftsmanship, blend into a landscape of fields and woodlands, a topography not entirely different from the ZAD. The people Guest encounters look at him oddly when he asks about class divisions or tries to pay them for goods or services. It is 2090 and Guest has woken up in a country with no private property, centralised authority or international conflict. The Houses of Parliament in Westminster are no

longer required in this society where there is no call for party politics. Instead, they are used to store manure.

Art is present everywhere in Morris's utopia, and while the pictures in the National Gallery have survived as little more than a 'curiosity', a truly vibrant culture is alive in the streets, in the detail of clothes and architecture, the care put into town planning and the design of household objects. Creativity could be considered a philosophical driving force for Morris, with the transformation of society bound together with a totally reimagined meaning and purpose for artistic expression, so much so that this society no longer needs the term 'art', which implies something separate from everyday reality. Instead, 'It has become a necessary part of the labour of every man who produces.' Morris's aesthetics held something in common with Achebe: 'I assert that inequality of condition, whatever may have been the case in former ages of the world, has now become incompatible with the existence of a healthy art,' he wrote in his 1891 essay, *The Socialist Ideal: Art*.

The gentle pace of Morris's novel belies the force of its impact on nineteenth-century society and its influence on socialist politics since. Clement Attlee, Britain's prime minister from 1945 to 1951, who is indelibly associated with the development of the welfare state – the National Health Service (founded in 1948), a far-reaching programme of nationalisation, and the right to free secondary education all being hallmarks of the period – credited the novel with making him a socialist. A less obvious political successor is the centrist leader of New Labour, Tony Blair, who named Morris as one of his three political heroes when he became prime minister in 1997.

Morris's efforts in the real world reflected his literary utopianism. Besides his active involvement in socialist politics, Morris founded Morris, Marshall, Faulkner & Co, a manufacturer that attempted to reconceive attitudes to production amid the era's fast-paced industrialisation. The company committed to centring craftsmanship, removing the alienating division of labour and mechanisation that was becoming common in Victorian factories. He argued that 'without dignified, creative human occupation people become disconnected from life'. Heavily inspired by his hero John Ruskin, through the firm he wanted to prove that everyday objects produced with skill and attention to beauty should be affordable to everyone, not just the luxurious preserve of the affluent elite.

Morris's approach at the company was radical on several fronts. He defied the social conventions of the time by getting involved in the practical aspects of the work himself. As the company took on employees, they recruited boys from the Industrial Home for Destitute Boys, which was established to train young men with few other prospects. Women were also engaged to work, the company's founders bringing family and friends on board to assist with embroidery and tile painting. Morris's biographer Fiona MacCarthy writes: 'The sense of emancipation was as personal as it was artistic. These were young people conscious of the breaking of new ground.'[1]

[1] Some irony, then, that the designs of Morris & Co became a hallmark of tasteful, bourgeoisie living, and remain so even today. 'They have always been the safe choice of the intellectual classes,' MacCarthy writes, 'an exercise in political correctitude.' Morris reportedly complained of 'spending my life ministering to the swinish luxury of the rich'.

Clearly there was a deep connection between Morris's fiction and his attempts to shape a better reality, and I'm curious about the extent to which his writing emboldened and validated his utopianism in the real world. As historian Anna Neima puts it: 'a fictional utopia is a thought experiment, a practical utopia is an experiment in living. But both approaches are ways of questioning the status quo, their visions gesturing powerfully towards other ways of being.' In her fascinating book *The Utopians,* she tells the story of 'six attempts to build the perfect society' in the wake of the First World War, highlighting a 'long tradition of writers-cum-utopians'. Her examples include Japanese novelist, playwright, poet and artist Mushanokōji Saneatsu, who built a utopian socialist commune in the Japanese mountains called *Atarashiki-mura* ('new village'), and Indian poet and Nobel Laureate Rabindranath Tagore, who founded a community intended to present 'an ideal for the whole of India', combining internationalism with deeply rooted localism and communality.

In her account of *Atarashiki-mura* in particular, Neima gives a clear sense that the creation of his vision, first of all, in fictitious form, unleashed the real-world possibilities for Mushanokōji. 'Later in his life, Mushanokōji would say that there was never a clear border for him between the fictional worlds he wrote about and the real-life utopia he was going to build.' He believed that by providing a model for a better way of living, he could ignite a much wider transformation of society. 'Fire from a single match,' he wrote, 'is capable of kindling everything flammable in the word.'

* * *

The point of highlighting these artist-utopians is not to propose that every artist find a patch of land and start digging the vegetable patch (although – why not?). Instead, these rather literal examples illustrate that the creation of alternative ways of living together is essentially an act of imagination, a creative act.

The German artist Joseph Beuys considered the work of building a better world as the most important of all artworks. When he founded the Organisation for Direct Democracy through Referendum (Free People's Initiative) in 1971 he issued a statement declaring, 'EVERY HUMAN BEING IS AN ARTIST who – from his state of freedom . . . learns to determine the other positions in the TOTAL ART WORK OF THE FUTURE SOCIAL ORDER. Self-determination and participation in the cultural sphere (freedom); in the structuring of laws (democracy); and in the sphere of economics (socialism).' He considered human activity as one great artwork that could be moulded through the essentially artistic practice of 'social sculpture'.

What did Beuys' social sculptures look like? Often, they were forums created within academic or artistic institutions where alternative democratic forms could not only be discussed but also modelled – he called them 'a place where revolution originates'. For example, at the contemporary art festival Documenta VI in 1977, he presented *100 Days of the Free International University*, transforming the gallery into a free and open education space, where lectures and workshops on topics such as 'Nuclear Energy and Alternatives' and 'Work and Worklessness' took place.

Surely his most lovely work of art was 1982's *7000 Oaks*, a slow piece that evolved over five years – and beyond – in

Kassel, a city still bearing deep scars from the bombings of the Second World War. At that year's Documenta festival, a vast pile of 7,000 basalt columns appeared on the lawn outside Museum Fridericianum; each represented a sapling, ready to be planted. Over the following months, the columns began to disappear; with the people of Kassel, Beuys was planning and planting the saplings in streets and parks across the city, standing the basalt stones alongside them. By the time the project was concluded, by his son, planting the final tree eighteen months after his father's death, the fifteen species of trees that had been planted included ash, chestnut, crab apple, elm, gingko, hawthorn, locust and walnut. *7000 Oaks* was, in his words, 'a symbolic start for my enterprise of regenerating the life of humankind within the body of society and to prepare a positive future in that context'. He saw it as an act of 'love' because it contributed to a positive environment beyond his lifetime.

And so it was. A symbolic start, and also a real one. Those trees grow there still, shaping the city, cleaning its air, outliving Beuys, outliving, one day, you and me, I suppose. What's that line about old men planting trees whose shade they'll never sit in? I wonder if any other artwork has spawned so many glorious imitators. The Joseph Beuys Tree Partnership in the US has seen hundreds of indigenous trees planted by local residents across three city parks. And on the Celtic new year, 2000, environmental activists planted 7,000 saplings on Uisneach Hill, an ancient ceremonial site in the heart of Ireland. 'It's such a simple act, planting a tree,' author and activist David Levi Strauss, who took part in the action, wrote. 'But it gives one immediate purchase on the human condition: powerful agency, limited longevity. If all goes well,

these 7,000 trees will survive ten generations of their human agents. But for that to happen, someone will have to care for them a little. If there is to be a future, these are its acts.'

My sense about Beuys is that his status as an artist allowed him to advocate for a better reality in a way that is too easily dismissed in other spheres. He was a passionate advocate for art that is fully of the world, integrated into the pragmatics of the everyday, but it is also true that 'art' enabled him to espouse a utopianism that might otherwise be rejected and ridiculed. Art, after all, doesn't *insist* you take it seriously – in almost any other context, a man walking around with his face covered in honey and gold leaf, lovingly cradling a dead hare to his chest and whispering to it, as Beuys did in his work *How to Explain Pictures to a Dead Hare,* would elicit calls to social services. But it allows for the possibility that you might. Beuys understood that it is the dreamtime space of art that makes it such a necessary antidote to the political discourse that happens elsewhere: art allows you to be unguarded, extravagant, ridiculous, playful; it asks you to centre intuition and beauty over the rational – always holding on to the possibility that, at the heart of it all, is something true.

Yet he believed that art was not something separate, to be admired, untouched, behind glass, but rather bound up with the rough and tumble of life. A sculptor who made the earth his clay, it made far more sense to him to shape his society than to attempt persuasion via pretty constructions – or to walk about a gallery explaining the pictures stuck behind the glass to a dead hare.

* * *

When Isa and Jay arrived at the ZAD, their first project was to build a welcome centre. Housed in half of *La Rolandière*'s farmhouse, it has been created with the same careful attention present in the rest of the building. Comfortable sofas are positioned around a wood burner, and a huge hand-drawn map of the ZAD hangs on the wall. Upstairs is a library full of books donated as part of an action in 2016, each carrying a dedication explaining its meaning to the ZAD. Jay lets me in on a secret; they lift a panel in the floor and show me how it has been designed to transform into a shield, ready at hand should the police arrive in their riot gear. Beneath it: a helmet, and a small bottle of lemon juice, known to offset the effects of tear gas.

Next came their lighthouse. *The Illegal Lighthouse Against an Airport and Its World* was created in collaboration with the wider movement against the airport. It took five months, built by – in the words of Jay – 'a ragged crew – including deserting architects, a (no-longer) homeless kid, a ceramicist, a few farmers and a genius welder (whose day job was building the world's biggest cruise liners in France's largest shipyard)'. In part, it was inspired by Dolly, the tower at Claremont Road, and they were also drawn to the mythic origins of Alexandria and the library and lighthouse that stood there.

Built from an old power pylon the Zadists had been gifted by a local farmer, with wooden gangways and platforms and, at the top, a red-and-white-striped lantern, the lighthouse has a kind of spare, skeletal beauty, its angles sharp against the grey autumn sky. At once a striking sculpture and – with its working lamp – a beacon welcoming people to the ZAD. Spurred on by the threat of evictions in 2016, the lighthouse is also a structure of resistance. It is linked to the farmhouse

via a gangway, which means demolishing the building would topple the lighthouse, too – risking the lives of any protesters at the top of it. 'To take that thing down is a big job,' Jay says. It's a work that captures their commitment to the genuine integration of art, politics and the everyday.

Isa and Jay found that the ZAD offered a more sustained version of the transitory, joyous alternative communities they'd experienced in contexts like the M11 road protests, Reclaim the Streets and the Climate Camp. How euphoric it must be for the activists who live here, on the nights when they have held feasts for hundreds of people, to look around and sense that a different way of living together is not only possible but has been made, here, with your own hands. While it is a blueprint for how we might live, it also validates the traditional ways of this rural community, moving with the pull of the seasons and respecting the earth for its sustenance.

I romanticise it: the sweetness in this life has always been precarious, and in October 2012, the government launched an attempted eviction of the squatters, destroying thirteen buildings. A month later, 40,000 people and 400 tractors turned up, responding to a call from the Zadists to reoccupy and rebuild – they constructed a new hamlet, complete with dormitories, meeting rooms, a bar, and even a hot tub. The police attacked again four days later, smashing windows of the new dormitories and assaulting those who defended it with tear gas and rubber bullets. At last, the police left. But, in the words of Jay: 'Bodies don't forget days like that.'

'People are poly-traumatised by what has happened,' they tell me. Some have lost their homes, some have been physically injured by the police, all have lived with being consistently

demonised by their government – and perhaps, too, have lost friends and family along the way. Jay alludes to discord between collectives and repeatedly says how 'intense' living this way can be. It isn't just the disagreements; it's the uncertainty: waking up to one hundred police officers in the garden or wondering whether a communal habitation built with care over months will be pulled down without warning.

But living 'as if' the airport would never happen had an enchantment to it. In their tremendously inspiring account of life at the ZAD, *We Are Nature Defending Itself,* Jay and Isa quote the much-loved anthropologist David Graeber: 'Politics . . . is the art of persuasion; the political is that dimension of social life in which things really do become true if enough people believe them.' Terrifyingly, awesomely, human society is little more and little less than an act of faith. In January 2018, French President Emmanuel Macron announced that the planned airport would be cancelled. The Zadists had won.

The news was bittersweet. This was the outcome the Zadists had long been dreaming of, certainly. But it came with an announcement that they would be immediately evicted from the territory. Shortly after, around 2,500 gendarmes arrived, armed with tear gas and stun grenades, launching an attack on the Zadists and destroying forty dwellings in just three days.

Ultimately, sixty-three of the seventy collectives reached an uneasy accommodation with the authorities, accepting an offer to 'legalise' by making lease agreements to remain on the land – the homes of seven collectives who refused were destroyed by the state almost immediately. There was deep conflict over this decision, with many of those who refused

seeing the agreement to sign the authority's papers as a betrayal of everything the ZAD stood for. One night, a group of disgruntled former Zadists expressed their dismay by burning down the structures of a new school being built there, issuing a searing condemnation of the 'turncoats' and 'opportunists' online.

But for Jay and Isa, among many others, the trade-off – to give up the remarkable territory that they had dedicated their whole hearts to, to watch buildings torn down or turned into luxury villas for affluent city workers – would have been too great. So, the ZAD remains. Now, one of its principal functions is as a base for other movements and struggles, providing a meeting place, resource and expertise. During my visit, the French environmentalist movement *Les Soulèvements de la Terre* (Earth Uprising) is in the headlines: the government is attempting to disband the group following clashes over the construction of new water reservoirs. The movement began at the ZAD, Jay tells me. A photo of one of the group's key members is on the front of the local newspaper. It gets passed around the kitchen of *La Rolandière*, everyone happy to see the face of an old friend.

From the top of the lighthouse, Jay gestures to the expanse of green below us. 'That field would have been the runway,' they say. 'We built the lighthouse almost exactly where the control tower would have been.' When they walk through the forest, they explain, they have a sense of the ghost of the airport that never happened. Where the baggage reclaim would have been, the duty free. 'It's pretty amazing to have that experience and think, we did that. Tens of thousands of us. If I'm ever in danger of losing hope, and I'm like, "Oh my God, the world is terrible and we're not doing anything,"

to have that sense of – "Hang on, this is not an airport. This land is still producing food and flourishing for other species." It's a little injection of hope.'

* * *

How will we find our way to the radically transformed society that we will need to survive our future: one that prioritises community, nature and mental and physical well-being over individual economic gain? The Zadists and their ilk aren't willing to wait for the machinations of the established political channels to play out, gambling on the unfavourable odds that things will work out in our favour. Instead, they are making the reality they dream of now, in whatever pockets they can find: here in the fields of Brittany, and elsewhere too.

Another word for this is 'prefigurative'. The prefigurative refers, as the academic D. K. Leach put it, to 'a political orientation based on the premise that the ends a social move-ment achieves are fundamentally shaped by the means it employs, and that movement should therefore do their best to choose means that embody or prefigure the kind of society they want to bring about.' This indicates that the future isn't down to the workings of chance, but is being seeded in the present, in the very ways we go about the business of change-making. It posits that a genuine transformation will only be achieved if the means reflect the political ideals a movement professes. In the oft-quoted words of Audre Lorde: 'The master's tools will never dismantle the master's house.'

In social movements, the prefigurative is present in consensus decision making, non-hierarchical leadership models, an emphasis on 'regenerative' practices that centre

deep care and wellbeing. Present in meals cooked together and distributed at protest sites, in the communes formed at road-blocking sites. While the term prefigurative is generally connected to social movements, I believe prefiguration is present in less overtly political contexts too, whenever someone enacts a different form of exchange, care and mutual decision making. Community gardening projects and the citizen scientists who help us understand the night sky by volunteering online to help astronomers sift through millions of photos of stars. The email group in my street through which people frequently pass on items of furniture they no longer need, offering up batches of brownies or inviting neighbours to pick fruit from their garden trees. During the pandemic this informal network took on a new purpose, without anyone telling it to – the mechanic of the collective kicked in, and those of us who were able to began fetching groceries or medication for those forced to isolate, ensured there was a system for keeping in touch with those most vulnerable. Acts like these, prefigurative politics hold, form a crack in the capitalist system and offer the evidence that humans are at heart better than our current system makes room for.

The cue for artists is that *how* they make work really, really matters, and as important as the political declamations of their art is the quality of human interactions that occur through it. What Graeber saw at the WTO protests in Seattle, I once saw in a dusty railway arch in Leeds. I was at the arts venue run by theatre group Slung Low, a railway arch in an often-overlooked part of town: it was the interval of the evening's show, and the audience was gathered around red-check-clothed tables eating bowls of vegan sausage stew. Slung Low always fed their

audiences during the interval – something simple, nourishing and tasty. The tickets for the show they were watching that evening were 'pay what you decide', meaning some of those I was sitting next to might have paid £30, some might have paid nothing. Perhaps some of the audience were there because they knew about the free hot meal in the interval, and coming to the theatre was a way of ensuring they had enough to eat that day. They were treated just the same.

A simple gift. It was a meal, and it was also an opening – as we ate, we talked, exchanging ideas about the show, and then, somehow, we found ourselves telling ghost stories. The politics of the audience experience runs through how Slung Low operates – from a salary model that sees every staff member receive the same rate of pay (reflecting the average salary in that part of the country), to their readiness to share resources with other groups that need them, lending out their van or offering free beds in their dormitory for touring artists to sleep in. That atmosphere, I'm sure, coloured our experience of the show we were there to watch, which that night was a programme of short theatre performances from artists across Europe, cultivating a warmth and openness to ideas from different cultures. A crack.

* * *

A note of caution, though. Jay warns of the importance of combining the 'yes' and the 'no' of political struggle. Decoupled from the confrontational aspect of activism, prefigurative projects can soon be recuperated by the capitalist systems from which they might initially appear to be set apart. Artists are particularly drawn to the 'yes', Jay

believes. 'There is a risk you forget who the enemy is,' they say. 'We can build all the community gardens and wind farms we like, but if we don't stop fossil fuels we're still going to be fucked.'

The 'no' is the bite: in the context of art, without it, artists risk offering a kind of radical cosplay to audiences and participants who act out their fantasies of alternative ways of being before returning to the comfort of privileged capitalist lifestyles unperturbed by the exercise. 'They go, "I've ticked my box, now I'm going to work for my bank."' Jay's prescription is for artists to be involved with social movements, gaining a real understanding of what they are fighting for and how their creativity can be of genuine use to achieve their purpose. Conversely the 'yes' of the prefigurative is vital, because it can nourish those depleted by the fight and at risk of becoming weary. 'You need to see the world you want, because if you're always fighting, you tend to get cynical and burn out,' they say. Those glimmers of utopia don't only help to form the better society of tomorrow; they also help activists survive their circumstances now.

In Chile, during the seventeen long years of General Augusto Pinochet's dictatorship from 1973, groups of women in the shanty towns of Santiago gave form to their struggles in the creation of brightly coloured patchwork images called 'arpilleras'. The arpilleristas, as they became known, met in clandestine workshops, often in the basements and back rooms of churches, the only place where it was still legal to gather as a group: many forms of organised meeting had been banned, and even wedding parties required government permission.

The message of the arpilleras was all 'no'. These were women living with the horrific consequences of Pinochet's

regime. Many of them had lost family members among the many thousands who were 'disappeared' by the state during those years, never to be seen again. Others had been pushed into extreme poverty by Pinochet's neoliberal programme of deregulation and the breaking up of the welfare state, which saw unemployment reach 20 per cent by 1982 and class disparity exacerbated. The arpilleras prickle with the violence of that time, portraying burning houses, soldiers with guns, tortured prisoners. The women stitched themselves into the images, holding protest signs demanding 'milk for our children' and 'adequate health care for all'. The ferocity of the images is made even starker by the domesticity of the materials. Sewn on cheap burlap, the women wove the arpilleras with the very fabric of their lives – matchsticks, pieces of tin and plastic. Scraps of cloth taken from the clothing of their missing husbands, even locks of their own hair.

The arpilleristas didn't sign their creations. They knew the kind of risks it could bring to them and their families if they were caught. Smuggled out of the country, the arpilleras were displayed in galleries internationally and distributed by NGOs including Oxfam and Amnesty International, offering a tangible chronicle of the hardship of life under Pinochet and raising awareness of the human rights abuses. The arpilleras played an important practical role for the women too. Many had lost their entire household earnings. Sold worldwide, they provided meaningful income – often their only means of survival.

The 'yes' of the arpilleras is in the process they speak of. A group of women close around a table, heads leaning towards one another as they negotiate the message they want the arpilleras to deliver beyond their nation's borders. As

they focused on the movement of thread through fabric, they spoke more freely than they could anywhere else, sharing the troubles of living under such oppression and seeking camaraderie, support and hope. They organised protests here, made arrangements for community kitchens, healthcare and childcare, and agreed on other practical steps to help one another. In the face of a system that was stripping away structures of support, the arpillera groups enabled many of the women, and their children, to survive those difficult years. With around 200 of these groups estimated to have existed in Santiago alone, this network represented a real clandestine alternative to the state.

Those women were not only saving themselves and their families. They were nurturing an alternative to the state's violence. Author Jacqueline Adams, who wrote the book *Art Against Dictatorship: Making and Exporting Arpilleras Under Pinochet*, argues that the arpillera groups preserved the values of solidarity and unity in Chile throughout those difficult years, and were instrumental in allowing those who participated to rebuild their engagement with democracy when, in 1990, it at long last returned. Indeed, political commentators such as Kelly Boldt and Timothy J. White have noted that women's empowerment through the arpillera groups contributed significantly to the election in 2006 of Chile's first female president, the socialist Michelle Bachelet. As an employee of Vicaria, the humanitarian organisation that facilitated the groups, told Adams: 'There were many, many groups. And basically, if you look at them today, they were all resistance groups. Cultural resistance, some more political than others, but basically cultural resistance, you see? Representing unity, staying together, the value of solidarity.'

The arpilleristas' story offers a salutary lesson in what a fully embodied creative resistance looks like: righteous fury with the state fostered in the atmosphere of its alternative, the spirit of solidarity and care a deliberate ploy to undermine the government's modus operandi, but also the most logical way to survive it. Their art was what made it possible: as Adams points out, the groups attracted women who weren't otherwise politically engaged. One of her interviewees – called Anastasia – explained to her that before joining, she had spent all of her life at home with her children and didn't grasp the full extent of the repression. Here, she 'gained knowledge of things that I was ignorant of, about what was happening outside, about daily life'. As the women gave form to their struggles in the arpilleras, they deepened their understanding of the political circumstances that fostered them. Together, they worked on solutions to the problems they depicted, in the same moment they created their portrayals of them.

Centring creativity, these meetings couldn't have been more different to the brusque, masculine energy of the military dictatorship led by Pinochet, bombastic in his grey army uniform and leather jackboots. Instead, the tempo was set by the steady, persistent movement of thread through cloth. Revolution in increments as small as stitches. The work of many hands.

* * *

On the first anniversary of the cancellation of the airport, the community of the ZAD gathered and, by fire and torchlight, mended a newt's heart. Newts – much-loved residents

216

of the ZAD – can repair their own hearts if damaged; it was apt for these ravaged people to work together to fix one. Two metres across, the heart was crafted in red velvet, lined with silver foil and broken in two. They bound it with rope, weaving about it in a circle as they raised their voices in choral song, then returned it to the body of a forty-metre-long amphibian puppet. The body started to beat and move as the crowd gathered beneath it, dancing as they carried it through the forest, making their way towards a vast banquet laid out for 500 people.

A healing ritual for the battered heart: magic, metaphor, tradition, poetry, ceremony, place. In the wake of the events of the ZAD, Isa and Jay, along with their collaborators h-lab, recognised that this was just what their community needed, and the creation of new rituals became the centre of their practice. 'A tool for clarifying intentions, and a tool for making links and healing,' as they put it. They conjure magic with these rituals, real transformations. Jay recounts the story of the newt's heart as we stand in the field where it happened. A maypole looms over us, its trunk painted white, crowned with a garland of LED lights. That age-old symbol of eroticism and fecundity, erected, for centuries, in the lushest part of the year. On May Day, a young Zadist climbed the pole, and a few days later was pregnant. She called the baby, aptly, Mady Hima Beltane – Beltane being the pagan festival marking the height of spring. 'It doesn't matter if you believe in magic or not,' Jay says, 'it still works.'

Nearby, pigs turn over the soil in their pen, and a Labrador puppy plays near a caravan, watched over by her protective mother. These rituals are the antithesis of what Jay sees as the 'extractivist' practices of so much Eurocentric art, the

consequence of a culture in which success is frequently framed in terms of the 'hypermobility' of an artist's practice, their ability to flit between exhibitions and performances at the great institutions of the world. 'Extractivism takes "nature", stuff, material from somewhere and transforms it into something that gives value somewhere else,' they wrote in *We Are Nature Defending Itself*. 'That value is always more important than the continuation of life of the communities from which wealth is extracted.' Rituals are an antidote to that: a way of transforming reality, not just representing it, ritual is an art made together – the old border between artist and audience dissipating in the shared creation of magic. For Jay and Isa, they are also inseparable from the land upon which they are created, crafted in a specific time and place by and for a particular community.

Later, we drive across the ZAD at night, going slowly, sequins of rain landing heavy on the windscreen. 'The salamanders come out in weather like this,' Jay explains, as they swerve – 'Oh, that was just a leaf.' When we do spot them we stop, and Jay gets out to move them out of the way, inviting me into the damp night air to admire them, slick black creatures with a dazzling arc of white along the spine that catches in the car lights. I'm glad to have seen them. These salamanders – like their relative the gecko – are honoured residents of the ZAD, and have become a symbol for it.

Such attentiveness to the life of this territory is as much a part of Jay's concept of art as the lighthouse they built. As they highlight, the word 'culture' shares the same etymology as 'agriculture': both come from the Latin word *colere*, meaning to take care of, inhabit and cherish. What this means is that while the stark sculptural beauty of the lighthouse,

and the theatricality of the rituals – the spangly capes, puppet reptiles and pig masks – are the most obvious examples of their art, it is in fact their whole life here, the whole life of the ZAD, that they consider their artistic practice. The logical extension of this view is that the art of the ZAD belongs not only with those like Jay and Isa who have degrees from art college or have exhibited in galleries. Instead, it is the work of all that have fought for this place with its dirt beneath their fingernails, refusing 'the world of the airport' and its insatiable hunger for departures. An art of love, that has secured the future of the ZAD, not as a place of never-ending leave-taking, but as a home for flora and fauna, 'human and more than human'.

Such an art is a rallying call to the soul. To me it feels like homesickness for a way of inhabiting this earth I've never experienced, but that is right in a way that makes my bones sing and my heart call out.

Rituals at the ZAD (photo by Dark Blue)

Afterword

CODA

Sometimes I have a pain in my heart so taut I could run my finger along it and make it sing. The pain is like a love falling apart, caused by my own lack of care. It is the pain of witnessing the destruction of the planet. We are at the party's finish, I think. The lights are coming on and things have passed here that cannot be undone.

It would be easy to be paralysed by it: the weight of history pressing down on the smallness of being just one person, just one life. Just an artist. But an old acquaintance upbraids me for this grief; it is the privilege, she says, of one who 'doesn't get it on an experiential level'. She has lived through wildfires in Australia and lost her home. A writer I know reports a panel discussion on environmentalism where a representative of the Kraków kids' climate strike responded to the doom of the older panellists: 'You are old and will be dead soon,' they said. 'It is different for us.'

There's no time for despair, their brusque optimism suggests, in a world on fire. Hope is not a state of mind but a survival strategy. Fatalism can easily become an excuse for giving up; how tempting it is to write off tomorrow and live

in the old, bad way as if what you do doesn't matter at all. But if we see that we hold the future in our hands, that we can and will reshape it as humans always have, then we have the responsibility to act differently.

Our art can sometimes seem small in the face of the magnitude of the times. But experience has taught me that we do best what we love. Through activist friends, I have learned about the old Japanese philosophy of *ikigai*, which comes from the words *iki*, meaning 'life', and *gai*, meaning 'benefit' or 'worth'. This concept of a worthwhile life has inspired the creation of a Venn diagram, which places in three circles the questions: What are you good at? What is the work that needs doing? What brings you joy? At the point where the three circles overlap lies your 'reason to be'. For those with an artistic impulse, this suggests, to ignore it in favour of what may seem a more serious-minded approach is a false economy of sorts – because you will end up doing the work badly, or not at all. Instead, the secret is to understand how passion can contribute to righting the ills of society, and ensuring a sustainable and socially just future for life on earth.

Yet the way to that future is not always clear. When I started writing this book, I was looking for examples of individual artists and artworks that have demonstrably made change. I found those, of course – *The Monkey Wrench Gang,* The Plastic People of the Universe, *POWER,* Gran Fury and *Blood of the Condor* among them. But with time, I came to understand that the power of the art of resistance runs much deeper than those obvious victories, and the ways it shapes our societies and communities are far more varied than I knew. The art of resistance can be a thread that weaves collectives together; a way of telling new stories and seeing the world afresh. It can

be an expression of solidarity and an assertion of the human spirit against the forces that seek to destroy it. It can be a way to give up waiting and make the future we want to inhabit a reality right now.

That expansiveness reflects something else I now know to be true: that the workings of a society are vast, complex and cast in shadow – far beyond the scope of any individual truly to grasp. Once, I would have found that thought so overwhelming, it could have stopped me from doing anything. Now, strangely, I find it empowering. We cannot understand the ways our actions today will shape the future. None of us can. But we can all recognise virtue in ourselves: the point where our gestures angle towards the bright. I am learning to be guided by that.

Now, I think that making the future we want might be a bit like writing a book, making a play, composing a song or painting a picture. You begin with a hope. Next, you draw a sketch, or map a structure. Along the way, the unexpected happens: the doorbell rings and its note is a clarion; red boots on wet concrete, a snatch of conversation. A willing heart fosters happy chance. You find friends and collaborators because inspiration comes easier when you're not alone. Some days, it is tempting to give up, to sit on the sofa and watch telly instead. But you keep going, because you know that good things are not always easy.

May the lightning bolt of imagination strike, move through you. Heed this cacophonous world, and let its poetry astonish you. What you end up with is rarely what you expected, but if you've allowed yourself to be transformed in its making, it's possible that what you hold is something beautiful and true.

Let's start now. Let's begin with a hope.

The Illegal Lighthouse Against the Airport and its World (photo by Nina Lombardo)

Bibliography

The Light and the Dark

- Berger, John, *The Shape of a Pocket* (Bloomsbury Publishing, 2002)
- Foucault, Michel, *Discipline and Punish: The Birth of the Prison* (Penguin Classics, 2020)
- Shiner, Larry, *The Invention of Art: A Cultural History* (University of Chicago Press, 2003)
- Solnit, Rebecca, *Hope in the Dark: Untold Histories, Wild Possibilities* (Canongate Canons, 2016)
- Wilding, Jo, *Don't Shoot the Clowns: Taking a Circus to the Children of Iraq* (New Internationalist Publications Ltd, 2006)

The March

- Baldwin, James, *Creative America* (Ridge Press, 1962)
- Bayat, Asef, *Revolution Without Revolutionaries: Making Sense of the Arab Spring* (Stanford University Press, 2017)
- Chenoweth, Erica and Maria J. Stephan, *Why Civil Resistance Works: The Strategic Logic of Nonviolent Conflict* (Columbia University Press, 2012)
- Doron, Roy and Toyin Falola, *Ken Saro-Wiwa* (Ohio University Press, 2016)

- Finkelstein, Avram, *After Silence: A History of AIDS Through Its Images* (University of California Press, 2017)
- Kurlansky, Mark, *1968: The Year that Rocked the World* (Vintage Digital, 2010)
- Lowery, Jack, *It Was Vulgar and It Was Beautiful: How AIDS Activists Used Art to Fight a Pandemic* (Bold Type Books, 2022)
- Pilkington, Ed, 'Shell pays out over $15.5m over Saro-Wiwa killing' (*Guardian,* 9 Jun 2009)
- Popescu, Lucy and Carole Seymour-Jones, *Another Sky: Voices of Conscience from Around the World.* (Profile Books, 2017)
- Saro-Wiwa, Ken, *A Forest of Flowers* (Pearson Education Limited, 1995)
- Saro-Wiwa, Ken, *Sozaboy* (Longman, 1994)
- Saro-Wiwa, Ken, 'The Trial Speech of Ken Saro-Wiwa' https://en.wikisource.org/wiki/Trial_Speech_of_Ken_Saro-Wiwa
- Sharp, Gene, *From Dictatorship to Democracy: A Guide to Nonviolent Resistance* (Serpent's Tail, 2012)
- Thomson, Mike, *Tunisia's El General: The rapper who helped bring down Ben Ali* (BBC, 20 July 2023)
- Wark, McKenzie, *The Beach Beneath the Street: The Everyday Life and Glorious Times of the Situationist International* (Verso Books, 2011)

The Hill

- Abbey, Edward, *Confessions of a Barbarian: Selections from the Journals of Edward Abbey* (Bower House, 2020)
- Abbey, Edward, *The Monkey Wrench Gang* (Penguin, 2004)
- Adams, Tim, 'The timing was impeccable': why it took a TV series to bring the Post Office scandal to light' (*Guardian*, 13 Jan 2024)

- *An Inconvenient Truth*. Directed by Davis Guggenheim. Paramount Classics and Participant Productions, 2006
- Bishop, Claire, *Artificial Hells: Participatory Art and the Politics of Spectatorship* (Verso Books, 2012)
- Bishop, James, *Epitaph for a Desert Anarchist: The Life and Legacy of Edward Abbey* (Atheneum Books, 1994)
- Bruguera, Tania and Claire Bishop, *Tania Bruguera in Conversation with Claire Bishop* (Fundacion Cisneros, 2020)
- Cooperrider, Allen Y. and Reed F. Noss, *Saving Nature's Legacy: Protecting and Restoring Biodiversity* (Island Press, 1994)
- Foreman, Dave and Bill Haywood, *Ecodefense: A Field Guide to Monkeywrenching* Earth First Books, 1987)
- French, Marilyn, *The Women's Room* (Virago, 1997)
- Gabriel, Peter, *Solsbury Hill* (1977)
- Holiday, Billie, *Strange Fruit* (1939)
- Macfarlane, Robert, 'Rereading: Robert Macfarlane on The Monkey Wrench Gang' (*Guardian*, 26 Sep 2009)
- Macy, Joanna and Chris Johnstone, *Active Hope: How to Face the Mess We're in with Unexpected Resilience and Creative Power* (New World Library, 2022)
- Margolick, David, *Strange Fruit: Billie Holiday and the Biography of a Song* (Ecco Press, 2001)
- Moran, Joe, 'Earthrise: the story behind our planet's most famous photo' (*Guardian*, 22 Dec 2018)
- *Mr Bates vs The Post Office*. Directed by James Strong. BBC, 2024
- Poole, Robert, *Earthrise: How Man First Saw the Earth* (Yale University Press, 2010)
- Roelstraete, Dieter and Antwaun Sargent (eds.), *Rick Lowe* (Gagosian Gallery, 2023)
- *Solsbury Hill bypass protests*. Directed by Undercurrents. Undercurrents, 1995

- *The Cracking of Glen Canyon Damn with Edward Abbey and Earth First!* Produced by Christopher (Toby) McLeod, Glenn Switkes and Randy Hayes. Earth Image Films, 1982
- *Wrenched: The Movie.* Directed by ML Lincoln. ML Lincoln Films, 2015
- https://www.youtube.com/watch?v=d_21XJqrKcQ

The Power Station

- *Bank Job.* Directed by Daniel Edelstyn and Hilary Powell. Optimistic & Dartmouth Films, 2021
- brown, adrienne maree, *Emergent Strategy: Shaping Change, Changing Worlds* (AK Press, 2017)
- Bruguera, Tania, 'Immigrant Movement International Mission Statement' http://immigrant-movement.us/word-press/mission-statement/
- Florida, Richard, *The Rise of the Creative Class* (Basic Books, 2019)
- Florida, Richard, *The New Urban Crisis: How Our Cities Are Increasing Inequality, Deepening Segregation, and Failing the Middle Class, and What We Can Do About It* (Basic Civitas Books, 2017)
- Graf, Stefanie, 'The Political Art of Tania Bruguera' (*The Collector*, 2022)
- Hollander, David et al., *Notes from a Revolution: Com/Co, The Diggers and the Haight* (Foggy Notion Books, 2012)
- Kaprow, Allan, *Essays on the Blurring of Art and Life* (University of California Press, 1993)
- Kimmelman, Michael, 'In Houston, Art Is Where the Home Is' (*New York Times,* 17 Dec 2006)

- Lowe, Rick and Mark J. Stern, 'Social Vision and a Cooperative Community' in Tom Finkelpearl (ed.) *What We Made: Conversations on Art and Social Cooperation* (Duke University Press, 2013)
- Pettifor, Ann, *The Case for the Green New Deal* (Verso Books, 2019)
- Sontag, Susan, *Styles of Radical Will* (Penguin, 2009)

The Village

- Beskow, Cristina Alvares, 'A Combative Cinema with the People. Interview with Bolivian Filmmaker Jorge Sanjinés' (Comparative Cinema, 2016)
- *Blood of the Condor*. Directed by Jorge Sanjinés. Ukamau Group, 1969
- Campbell, Joseph, *The Hero with A Thousand Faces (The Collected Works of Joseph Campbell)* (New World Library, 2012)
- Hanlon, Dennis Joseph, 'Moving cinema: Bolivia's Ukamau and European political film, 1966–1989' https://iro.uiowa. edu/esploro/outputs/doctoral/9983777215302771
- Litt, Toby, 'How to Tell a Story to Save The World' (Writers Rebel, 2021)
- Loach, Mikaela, *It's Not That Radical* (DK, 2023)
- Sanjinés, Jorge, *Theory and Practice of Cinema with the People (Art on the Line)* (Curbstone Press, 1989)
- SaSuWeh Jones, Dan, 'How American Indian Storytelling Differs From the Western Narrative Structure'(*School Library Journal*, 15 Dec 2021)
- *The Courage of the People*. Directed by Jorge Sanjinés. Ukamau Group 1971

- Winch, Tara June, 'The Australian book you've finally got time for: Carpentaria by Alexis Wright' (*Guardian*, 3 Jun 2020)
- Wood, David M. J., 'Indigenismo and the Avant-garde: Jorge Sanjinés' Early Films and the National Project' (*Bulletin of Latin American Research,* 2006)
- Wright, Alexis, *Carpentaria* (Constable, 2009)
- Wright, Alexis, *Plains of Promise* (University of Queensland Press, 2000)
- Wright, Alexis, 'The Ancient Library and a Self-Governing Literature' (*Sydney Review of Books,* 28 Jun 2019)
- Wright, Alexis, 'The Inward Migration in Apocalyptic Times' (*Emergence Magazine,* 26 Oct 2022)
- Wright, Alexis, *The Swan Book* (Constable, 2015)

The Island

- Anon, 'Sentenced to Death by Island Nazis: The Story of Two Gallant Frenchwomen' (*Jersey Evening Post*, 30 Jun 1945)
- Barrett, Duncan, *When the Germans Came: True Stories of Life under Occupation in the Channel Islands* (Simon & Schuster UK, 2018)
- Carr, Gilly, *Nazi Prisons in the British Isles: Political Prisoners during the German Occupation of Jersey and Guernsey, 1940–1945* (Pen & Sword Military, 2020)
- Crispin, Jessa, *The Dead Ladies Project: Exiles, Expats, and Ex-Countries* (University of Chicago Press, 2015)
- Freeland, Cynthia, *Art Theory: A Very Short Introduction* (Oxford University Press, 2002)
- Hopkins, David, *Dada and Surrealism: A Very Short Introduction* (OUP Oxford, 2004)

- Hopkins, David (ed.), *A Companion to Dada and Surrealism* (Wiley-Blackwell, 2016)
- Jackson, Jeffrey H., *Paper Bullets: Two Artists Who Risked their Lives to Defy the Nazis* (Algonquin Books, 2020)
- Lewis, John, *A Doctor's Occupation: The Dramatic True Story of Life on Nazi-occupied Jersey* (Seeker Publishing, 2013)
- Shaw, Jennifer L., *Exist Otherwise* (Reaktion Books, 2017)
- Thynne, Lizzie, 'Indirect action: politics and the subversion of identity in Claude Cahun and Marcel Moore's resistance to the occupation of Jersey' https://www.academia.edu/70662295/Indirect_action_politics_and_the_subversion_of_identity_in_Claude_Cahun_and_Marcel_Moores_resistance_to_the_occupation_of_Jersey

The Siege

- Beckett, Samuel, *The Complete Dramatic Works* (Faber and Faber, 1986)
- DeMott, Benjamin, 'Lady on the Scene', (*New York Times*, 23 Jan 1966) http://movies2.nytimes.com/books/00/03/12/specials/sontag-against.html
- Caygill, Howard, *On Resistance: A Philosophy of Defiance* (Bloomsbury, 2013)
- Demick, Barbara, *Besieged: Life Under Fire on a Sarajevo Street* (Granta Books, 2012)
- Di Giovanni, Janine, *Madness Visible: A Memoir of War* (Bloomsbury, 2004)
- Diklić, Darko, 'Theatricality vs Bare Life: Performance as a Vernacular of Resistance' cited by Silvija Jestrovic *The Grammar of Politics and Performance* (Routledge, 2014)
- *Godot – Sarajevo*. Directed by Pjer Žalica. Saga Productions, 1993

- Gontarski, S. E. (ed.), *Edinburgh Companion to Samuel Beckett and the Arts* (Edinburgh University Press, 2014)
- Gontarski, S. E. (ed.), *On Beckett: Essays and Criticism* (Anthem Press, 2014)
- Kushner, Tony, *Tony Kushner in Conversation* (The University of Michigan Press, 1998)
- Leibovitz, Annie, *A Photographer's Life 1990–2005* (Jonathan Cape, 2006)
- Munroe, Jeff, 'A. J. Muste: Radical for Peace' (*Reformed Journal,* 19 Apr 2021)
- Myers, Kevin, 'I wish I had kicked Susan Sontag', *Daily Telegraph* https://www.telegraph.co.uk/comment/personal-view/3613939/I-wish-I-had-kicked-Susan-Sontag.html
- Pomfret, John, 'Godot Amid The Gunfire', *Washington Post* https://www.washingtonpost.com/archive/lifestyle/1993/08/19/godot-amid-the-gunfire/db1937de-88d8-478b-8b28-3df4150d87af/
- Rollyson, Carl, *Understanding Susan Sontag* (University of South Carolina Press, 2016)
- Rosbottom, Ronald, *When Paris Went Dark: The City of Light Under German Occupation, 1940–44* (John Murray, 2014)
- Sami, Mohammed, https://www.instagram.com/p/CyeebxmNx4v/?hl=en
- Schreiber, Daniel, *Susan Sontag: A Biography* (North West University Press, 2014)
- Sontag, Susan, *Against Interpretation* (Penguin, 2009)
- Sontag, Susan, *Styles of Radical Will* (Penguin, 2009)
- Sontag, Susan, *Where the Stress Falls* (Jonathan Cape, 2002)
- *The Death of Yugoslavia.* Directed by Norma Percy (BBC, 1996)

- United Nations Commission of Experts, 'Study of the battle and siege of Sarajevo – part 1/10', Internet Archive Wayback Machine https://web.archive.org/web/20010 222115037/http://www.ess.uwe.ac.uk/comexpert/ANX/ VI-01.htm
- Sarajevo Artistic Survival Group, The (21 June, 1993) [Fax to Susan Sontag] UCLA (612 Susan Sontag Papers Box 45, F.11) UCLA Library Special Collections, Charles E. Young Research Library, University of California, Los Angeles

The Concentration Camp

- Adorno, Theodor W., *Prisms (Studies in Contemporary German Social Thought)* (MIT Press, 1983)
- Brauer, Juliane, 'How Can Music Be Torturous?: Music in Nazi Concentration and Extermination Camps' (*Music and Politics*, 2016)
- Carey, John, *What Good Are the Arts* (Faber & Faber, 2006)
- Fackler, Guido, 'Music in Concentration Camps 1933–1945' (*Music and Politics*, 2007)
- *Kapela Oświęcimska*, Directed by Ignacy Szczepański. Wytwórnia Filmów Oświatowych i Programów Edukacyjnych (Łódź), 1981
- Karoub, Jeff, 'Michigan professor unearths inmates' music from Auschwitz' (*Associated Press*, 26 Nov 2018)
- Langbein, Hermann, *People in Auschwitz* (The University of North Carolina Press, 2004)
- Lasker-Wallfisch, Anita, *Inherit the Truth 1939–1945: The Documented Experiences of a Survivor of Auschwitz and Belsen* (Giles de la Mare Publishers, 2012)
- Levi, Primo, *If This is A Man/The Truce* (Penguin, 1987)

233

- Müller, Filip, *Eyewitness Auschwitz: Three Years in the Gas Chambers* (Ivan R. Dee, 1999)
- Rees, Laurence, *Auschwitz: The Nazis and 'The Final Solution'* (Penguin, 2005)
- Ružicková, Zuzana (eds.), *One Hundred Miracles: Music, Auschwitz, Survival and Love* (Bloomsbury Publishing, 2019)
- Schmid, Rebecca, 'Remembering Music's Saving Powers at Auschwitz' (*New York Times,* 13 Aug 2020)
- *Shoah.* Directed by Claude Lanzmann. Les Films Aleph, Ministère de la Culture de la Republique Française and Historia Films, 1985
- Steiner, George, *In Bluebeard's Castle: Some Notes Towards the Redefinition of Culture* (Yale University Press, 1977)
- *The Last Survivors.* Directed by Arthur Cary. Minnow Films and BBC, 2019
- *The Maestro, In Search of the Last Music.* Directed by Alexandre Valenti. Les Bon Clients, 2017

The Party

- Baker, Keiligh and Connor Boyd, 'Hundreds of thousands of Notting Hill Carnival revellers adorned in glitter and feathers strut their stuff in sequinned Caribbean costumes for day two of the world's biggest street festival' (*Daily Mail,* 27 Aug 2018)
- Bakhtin, Mikhail, *Rabelais and His World* (Indiana University Press, 2009)
- Blagrove, Ishmahil Jr. and Margaret Busby, *Carnival: A Photographic and Testimonial History of the Notting Hill Carnival* (Rice N Peas, 2014)

- Bogad, L. M., 'Carnival Against Capital: Radical Clowning and the Global Justice Movement' (*Journal for the Study of Race, Nation and Culture*, 2010)
- Cohen, Abner, 'Drama and Politics in the Development of a London Carnival' (*MAN,* Mar 1980)
- Cowley, John, *Carnival, Canboulay and Calypso. Traditions in the Making* (Cambridge University Press, 1996)
- Crichlow, Michaeline Michaeline A. (ed.), *Carnival Art, Culture and Politics: Performing Life* (Routledge, 2013)
- Emerson, Caryl, *The First Hundred Years of Mikhail Bakhtin* (Princeton University Press, 2000)
- Fydrych, Major Waldemar *Lives of the Orange Men: A Biographical History of the Polish Orange Alternative Movement* (Minor Compositions, 2014)
- Green, Garth L. (ed.) and Philip W. Scher (ed.), *Trinidad Carnival: The Cultural Politics of a Transnational Festival* (Indiana University Press, 2007)
- Holt, Mack P., *The Politics of Wine in Early Modern France: Religion and Popular Culture in Burgundy, 1477– 1630* (Cambridge University Press, 2020)
- Horvat, Srećko, 'The easiest way to the Gulag is to joke about the Gulag' (*Open Democracy,* 2013)
- Humphrey, Chris, *The Politics of Carnival* (Manchester University Press, 2001)
- Joseph, Yasmin, *J'Ouvert* (Bloomsbury, 2019)
- Ladurie, Emmanuel Le Roy, *Carnival In Romans: Mayhem and Massacre in a French City* (W&N, 2003)
- Law, Sophie and Bhvishya Patel, 'Notting Hill millionaires build barricades around their mansions to protect them from carnival revellers as police search the area and prepare acid attack kits' (*Daily Mail,* 25 Aug 2018)

- Miller, Kei, 'The Law Concerning Mermaids' (*The Missing Slate,* 1 Jun 2014)
- Orwell, George, *Reportage* (The Folio Society, 1998)
- Owusu, Kwesi, *Behind the Masquerade: The Story of Notting Hill Carnival* (Arts Media Group, 1988)
- Scott, James C., *Weapons of the Weak: Everyday Forms of Peasant Resistance* (Yale University Press, 1987)
- Waterlow, Jonathan, *It's Only A Joke, Comrade!: Humour, Trust and Everyday Life under Stalin (1928–1941)* (CreateSpace, 2018)

The Trial

- Achebe, Chinua, *Things Fall Apart* (Penguin, 2006)
- Achebe, Chinua, 'Africa and her Writers' (*The Massachusetts Review,* Summer 1973)
- Anon, 'Medical Sciences Protest Against New "Art"' (*Washington Times,* 9 Oct 1921)
- Atkinson, Brooks, 'Waiting for Godot'; Mystery Wrapped in Enigma at Golden The Cast' (*New York Times*, 20 Apr 1956)
- Bair, Deirdre, *Samuel Beckett: A Biography* (London: Simon & Schuster, 1990)
- Bolton, Jonathan, *Worlds of Dissent: Charter 77, The Plastic People of the Universe, and Czech Culture Under Communism* (Harvard University Press, 2012)
- Cronin, Anthony, *Samuel Beckett: The Last Modernist* (London: Flamingo, 1996)
- Davies, William (ed.) and Helen Bailey (ed.), *Beckett and Politics* (Palgrave Macmillan, 2020)

- Dembin, Russell M., 'Nothing but Time: When "Godot" Came to San Quentin' (*American Theatre,* 22 Jan 2019)
- Farber, Jim, '"It didn't adhere to any of the rules": the fascinating history of free jazz' (*Guardian*, 7 Sep 2021)
- Friedman, Dustin, *Before Queer Theory: Victorian Aestheticism* (Johns Hopkins University Press, 2019)
- Gontarski, S.E. (ed.), *Edinburgh Companion to Samuel Beckett and the Arts* (Edinburgh: Edinburgh University Press, 2014)
- Gontarski, S.E. (ed.), *On Beckett: Essays and Criticism* (London: Anthem Press, 2014)
- Havel, Václav, *The Power of the Powerless* (Vintage, 2018)
- Hensbergen, Gijs van, *Guernica: The Biography of a Twentieth-Century Icon* (Bloomsbury, 2005)
- Keats, John, *Letters of John Keats: A Selection* (Oxford Paperbacks, 1970)
- Knowlson, James, *Damned to Fame: the Life of Samuel Beckett* (London: Bloomsbury, 1996)
- Pater, Walter, *Renaissance: Studies in Art and Poetry* (University of California Press, 1980)
- Ruderman, Evan, 'Both Directions at once: Free Jazz's Dual Ventures into Musical Experimentation and Political Involvement' https://english.umd.edu/research-innovation/journals/interpolations/fall-2019/both-directions-once-free-jazzs-dual-ventures
- Smith, David, 'In Godot We Trust' (*Guardian*, 8 Mar 2009)
- Stoppard, Tom, *Rock 'n' Roll* (Faber and Faber, 2006)
- The Ornette Coleman Double Quartet, *Free Jazz: A Collective Improvisation* (1961)

- The Plastic People of the Universe, *Egon Bondy's Happy Hearts Club Banned* (1975)
- Vulliamy, Ed, '1989 and all that: Plastic People of the Universe and the Velvet Revolution' (*Guardian*, 2009)

Utopia

- Adams, Jacqueline, *Art Against Dictatorship: Making and Exporting Arpilleras Under Pinochet* (University of Texas Press, 2013)
- Beuys, Joseph and Volker Harlan, *What is Art?: Conversation with Joseph Beuys* (Clairview Books, 2007)
- Birch, Cyril, *Anthology of Chinese Literature: Volume 1: From Early Times to the Fourteenth Century* (Avalon, 1994)
- Bishop, Claire (ed.), *Participation* (Whitechapel Ventures, 2006)
- Boldt, Kelly and Timothy J. White, 'Chilean Women and Democratization: Entering Politics through Resistance as Arpilleristas' (*Asian Journal of Latin American Studies,* 2011)
- Caplan, Lindsay, 'Framing Artwork' (*e-flux,* Jan 2014)
- Claeys, Gregory, *Utopia: The History of an Idea* (Thames and Hudson, 2020)
- Cousins, Tom, 'The Art House, Claremont Road, London 1994 No M11 Road Protest' https://www.tomcousins.co.uk/Clare.html
- De Pizan, Christine, *The Book of the City of Ladies* (Penguin, 1999)
- Fremeaux, Isabelle and Jay Jordan, *We Are 'Nature' Defending Itself: Entangling Art, Activism and Autonomous Zones* (Pluto Press, 2021)
- Lorde, Audre, *The Master's Tools Will Never Dismantle the Master's House* (Penguin, 2018)

- MacCarthy, Fiona, *William Morris: A Life for Our Time* (Faber & Faber, 2010)
- Mesch, Claudia, *Joseph Beuys (Critical Lives)* (Reaktion Books, 2017)
- More, Thomas, *Utopia* (Penguin, 2012)
- Morris, William, *News from Nowhere* (Thames and Hudson, 2017)
- Morris, William, *William Morris on Art and Socialism* (Dover, 2003)
- Neima, Anna, *The Utopians: Six Attempts to Build the Perfect Society* (Picador, 2021)
- *Paths Through Utopias.* Directed by Isabelle Fremeaux, John Jordan and Kyp Kyprianou. Zones/La Découverte, 2011
- Raekstad, Paul and Sofa Saio Gradin, *Prefigurative Politics: Building Tomorrow Today* (Polity, 2019)
- Sargent, Lyman Tower, *Utopianism: A Very Short Introduction* (OUP Oxford, 2010)
- Strauss, David Levi *From Head to Hand: Art and the Manual* (OUP USA, 2010)
- Wilde, Oscar, *The Soul of Man under Socialism* (CreateSpace, 2016)

Acknowledgements

A huge thank you to Fritha Saunders, Vidisha Biswas and all at Footnote Press, and Amy Cherry, Huneeya Siddiqui and WW Norton, for giving this book a home, and for your sensitive care in bringing it into the world. My agent Anna Power at Johnson and Alcock, for all your wise guidance. Tom Chivers of Penned in the Margins, Candida Lacey and Becky Thomas, who were early custodians of this book's journey.

Creative Nonfiction Club is truly one of the best bits of my life: Cailey, Serena, Georgie, Andy, Dan R, Dan L, Laila, Octavia, Alex, Kirsty, Kate, Yiota, Ellie, Hazel et al. – love you lot. The brave writers of Writers Rebel including Toby, Liz, Jessica, Alex, Gully and Sharon, and my UEA pals who nurtured the first tendrils of this book: Marinah, Katie, Jon, Liz, Caroline D, Elli, Pyae Pyae, Rosa, Judith and tutors Katherine, Ian and Helen who encouraged me to persist.

I wrote this book while working at Complicité. There couldn't be a better setting for thinking deeply about the power of art. Simon, Tim and all the team – Shaadi, Natalie, Rima, Sarah, Amy, Lucy, Josie, Louise, Jane, Emma, Khai, Annabel, Jodie, Mike. Plus Tom, Frances and the board for supporting me to pursue two dreams at once. I'm so proud of what we made.

Thank you to Peter Francis, Louise Yates and Gladstone's Library where I spent the most blissful month writing, drinking red wine and sitting by the fire (and hanging out with Suzanne, Herb and Frances); Tom Dingle and Arthouse Jersey who were the most generous hosts one windswept January. Rich Mix and Brixton House were both partners on the development of the book and I loved running writing workshops with groups of young people exploring the power of resistance.

This book was made possible by a much-needed project grant from Arts Council England – thank you.

Tom Kalin – our conversation was so fun and touching, Antonio Eguino – for offering a window to another world during lockdown, Alexis Wright, who helped me understand the power of listening differently. Yasmin Joseph for giving me a taste of the carnival. Dan Edelstyn and Hilary Powell: you are my heroes. My friend, Riham Isaac, whom I admire so much.

In Jersey I loved my afternoon with the irrepressible, irresistible Bob Le Sueur. RIP. Louise Downey was a great guide to the archive, and I'm grateful to the current custodian of La Rocquaise and her friendly Labrador for letting me explore. Thanks to my brilliant mum Dawn for translating Cahun's account of her time in prison from the French for me.

In Sarajevo, Haris Pašović, Gordana Knežević, Nihad Kreševljaković, Izudin Bajrović, Allan Little and Senada Kreso were all so generous in sharing their stories. The essay on *Waiting for Godot* in Sarajevo first appeared in the *Times Literary Supplement* with the title 'Something to Be Done', where it received the most sensitive and elegant edit from Robert Potts.

Jay Jordan and Isa Fremeaux, I will never forget the welcome I got at the ZAD. Your commitment to the political power of art is a lodestar.

My dear friends and family have demonstrated endless patience and support over the last few years. Mum, Dad, Debbie, Mark, Rosie, Ashley, Hannah, Thea, Lydia, Maddy, Goo, Becca, Tom and Dan – you're the best.

Ben. I'm grateful for all of it: your sensitive reading of the book as it has developed, our invigorating chats about art, your companionship on the adventures. All the Sundays. It is a remarkable thing to have found a love who is so persistent and tenacious in upholding my dreams.

And our daughter, Juniper, who inspires me every day. I love you. This is for you.